Painting Techniques of the Masters

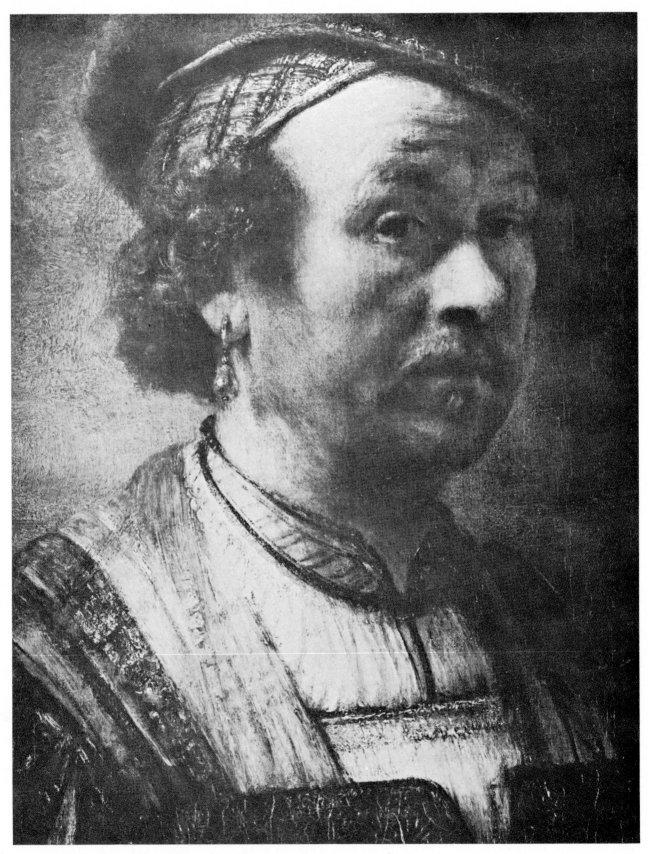

Rembrandt van Ryn *Self-Portrait (Detail)*

Painting Techniques of the Masters

A REVISED AND ENLARGED EDITION OF
PAINTING LESSONS FROM THE GREAT MASTERS

by Hereward Lester Cooke

Curator of Painting, the National Gallery of Art

Published in Cooperation with the National Gallery of Art

Watson-Guptill Publications / New York

Published 1972 in New York by Watson-Guptill Publications,
a division of Billboard Publications, Inc.,
165 West 46 Street, New York, N.Y.

Manufactured in Tokyo, Japan

First Edition, 1967
　First Printing, 1967
　Second Printing, 1969

Revised, Enlarged Edition, 1972
　First Printing, 1972

Library of Congress Cataloging in Publication Data

Cooke, Hereward Lester.
　Painting techniques of the masters.

　"Published in cooperation with the National Gallery
of Art.
　"A revised and enlarged edition of Painting lessons
from the great masters [published in 1967]"
　Bibliography: p.
　1. Painting—Study and teaching. 2. Painting—
Technique. I. U. S. National Gallery of Art.
II. Title.

ND1120.C6 1972　　751.4　75-188323

ISBN 0-8230-3863-7

Foreword

This book should be made required reading for graduation from anywhere—like the swimming test some colleges make you pass before they give you a degree. Granted, every citizen should know how to swim; but, in this image-flooded world, in this age of visual illiteracy, it is no less vital that every citizen also know how to see.

One good way to learn to see is to learn to paint. It is to painters of every kind, master or neophyte, that this book is principally addressed. But I submit that for the non-painter, a category in which I sheepishly must include myself, this book is equally indispensable.

Take the painter first. The mere fact that so many of the most successful painters of every age have followed the principle of this book, rigorously studying the masters that preceded them, should in itself be persuasion enough that the system works. The illustrious precedents that have used this approach are too soundly treated in Dr. Cooke's introduction for me to belabor them here. The reason why the system works is perhaps harder for all us up-to-date, modern-thinking, late-twentieth-century contemporaries to understand.

Part of the problem lies in our natural attitude toward technology. We are wedded to a belief in Progress. Ring out the old. *On a changé tout cela.*

The key is that in great art the means and the ends are, ultimately, indivisible. Techniques come and go; but the technique by itself is never the point of a work of art. Art is essentially a human, rather than a mechanical activity. Human nature changes very little. In art, the concept of progress simply does not apply. This makes the past continuously relevant. The lessons of the masters do not obsolesce. However old the technology involved, all painting is, in essence, contemporary art.

A student of the visual arts should rejoice that such is the case. In any art form, the learner seeks to study under the most accomplished practitioner he can find and can afford. The student dancer is pretty well limited to living teachers. The painter, on the other hand, has access to each of the greatest masters that history has produced.

What I find surprising is that the principle is not more widely followed. Modern education in many other fields has come to recognize the virtues of what some graduate schools call the Case Method. A law student, rather than be taught The Law, learns to *think* like a lawyer, by exposure to specific cases and rulings of the past. The system recognizes that some things can never be taught; they can only be learned.

Surely art is one of these. Why not use the pictures that have come down to us as cases in artistic problem-solving? The point is not to copy for the sake of pla-

giarism; the point is to learn how to *think* like an artist.

To think like an artist, you have to be able to see like an artist. That is where the non-painter comes in. I myself have done some of the exercises suggested here, working with Dr. Cooke before this book was conceived, as a non-painter exploring paintings. In a summer course here at the National Gallery for high school teachers and administrators, we have seen to it that everyone took a studio course in the techniques of the masters. Whether or not you even take a brush in hand, you can still benefit by all the nuances of vision of the most sensitive eyes our race has produced. Paintings communicate directly, across every barrier of language. They are continuously available to unlock their secrets to anyone who presents himself with the kind of acuity of observation Dr. Cooke asks us to share.

Lester Cooke's own eye has been trained both as an art historian and as a professional artist, and his intimate knowledge of the National Gallery collection has been deepened by daily contact with the original paintings. It is little wonder, then, that he can make us see these pictures, no matter how well we might have known them, as if for the first time.

Francis Henry Taylor, the late director of the Metropolitan Museum in New York, once defined an art museum as "a gymnasium for the eye." This book not only defines the exercises, but puts the whole apparatus into the home.

When I went to study art history with the late Bernard Berenson in Florence, he gave me one piece of advice. "You must look, and look, and look, until you are blind with looking; and out of blindness will come illumination." Berenson had a theory about the ultimate value of learning to look at pictures. "It teaches you," he would say, "to become *your own artist.*"

Since this book is largely a book of advice, I should like to add a small piece of my own. That is: visit the National Gallery in Washington—preferably with this book in hand. For the serious artist who brings his paints and comes here to make studies of the great masters, we are delighted to offer easels and other aids without charge. It is in this way that the painter learns to distinguish that razor's edge which separates a good painting from a great one; his eye, his hand, his work cannot help improving from the experience. For any citizen, however, who would like the exhilaration of seeing greatness first hand, and, through that greatness, the joy of becoming his own artist, our halls stand open, the pictures on display.

J. CARTER BROWN
Director
National Gallery of Art

Acknowledgments

My first debt is to the men of vision who brought the paintings reproduced on these pages to a gallery where they are available to the public. This book is based on the assumption that painters will be able to study at first hand the final mysteries of great painting, and without the generosity of the National Gallery of Art donors, this would never have been possible.

My second debt is to Mr. J. Carter Brown, Director of the National Gallery, who laid down guidelines for the part the book might play in the training of painters.

I also want to thank Rear Admiral Ernest Feidler, formerly General Counsel of the National Gallery of Art, who negotiated the agreements leading to publication.

I wish to express my gratitude to Mr. Henry Beville and Mr. Stanley Manzer, of the National Gallery Photographic Laboratory, who made, or helped me to make, the black-and-white photographs.

An important factor in the preparation of the text has been the cooperation of Mr. Donald Holden, Editorial Director of Watson–Guptill, whose training both in the museum field and as a practicing artist made questions of content easy to solve.

My thanks also go to Miss Susan Meyer, Editor of *American Artist,* who prepared the manuscript for printing, and Diane Casella Hines, Watson–Guptill Associate Editor, and to Mr. James Dean, director of educational programs for the National Air and Space Administration, who made the schematic diagrams.

Lastly, I am overwhelmingly indebted to Dott. a F. Bonajuto, of Harvard University, who prepared the text for the printer, checked and rechecked the proofs, and helped to formulate many of the ideas.

HEREWARD LESTER COOKE
Washington, D.C.

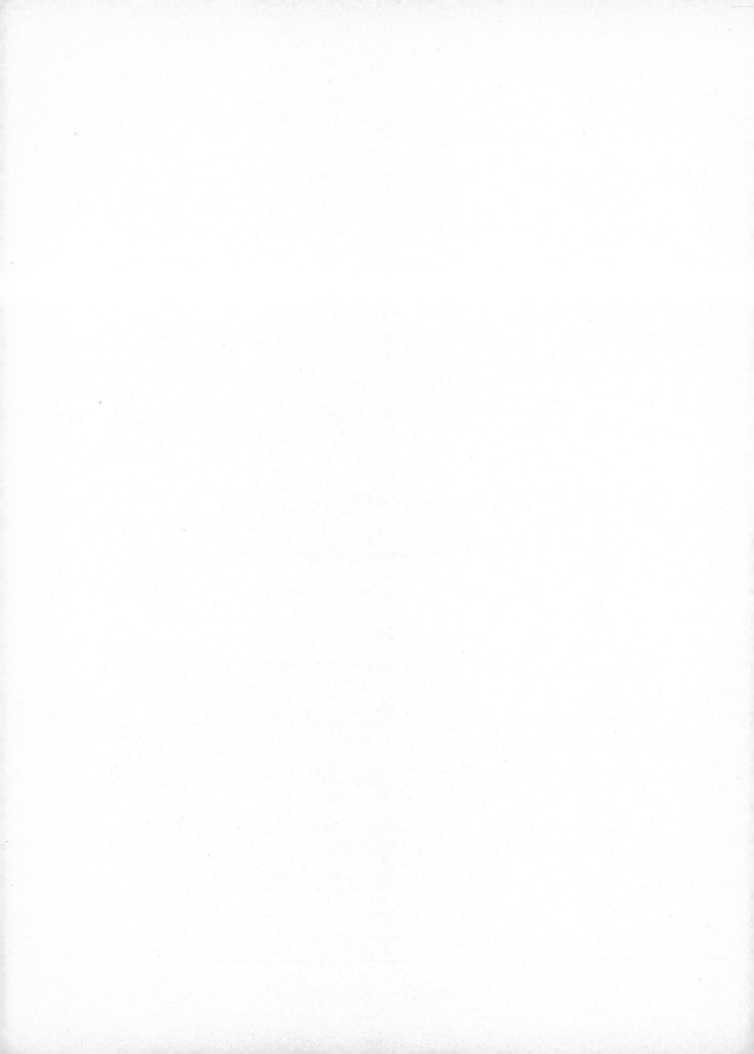

Contents

Text Illustrations

Color Plates

Introduction

"IT IS IN THE MUSEUM that one learns to paint. . . . One must paint the pictures of one's own time, but it is in the museum that one gets this feeling of painting, a feeling which Nature alone cannot give."

(Auguste Renoir)

Two quite separate introductions could be written to this book. One could prove that it is dangerous and unintelligent for a young artist to absorb too much from other painters, past or present, and that the painter would do well to look only at nature and the recesses of his own mind. The second introduction could also use the history of art to prove conclusively that most painters who have made a mark in history have trained themselves largely by studying and learning from the great masters. The truth lies much nearer the second point of view than the first.

The Great Masters as Teachers

Since the earliest records, artists have studied and learned from their predecessors, and the greatest artists have often learned the most. Today it is unfashionable to confess that you owe a debt to the past; eclecticism has become a term of abuse. That does not mean, however, that artists are not availing themselves of the past as much as they ever did. With the good reproductions that are available today, the artist can spread the history of art out before him, and can pick and choose with an ease unknown to artists who preceded him.

Until about a hundred years ago nobody would have questioned the value of learning from the old masters. Copying recognized masterpieces was an integral part of the painter's training. Henry James, the American writer, noted that in the *pensione* where he was staying in Florence, there were painters from all over Europe who had waited months for their turn to copy the works of Raphael and Titian in the Florence museums. In fact, the majority of the world's great museums (the Prado in Madrid, the Louvre in Paris, and the National Gallery in London, for example) were founded for the express purpose of providing artists with the means to learn from the great masters. Today art educators tend to smile at this approach, and yet the study of the old masters is still the easiest and most profitable way to train a painter's eye and hand.

During the seventeenth century there was a widely accepted theory that a painter should first acquire a solid groundwork of technical training, then should choose a painter from among the accepted old masters whose work particularly appealed to him, and should copy his works until he had learned the secret of this particular painter's excellence. This age produced Rembrandt, Rubens, Poussin, Guercino, Vermeer, Claude Lorrain, and a host of other great names in painting. The seventeenth-century theory, therefore, is worth careful consideration.

A Self-Imposed Course

Let us apply the theory to a young painter today. He starts by going to an art school and learns how to prepare a canvas, mix the paints, and handle the brushes. He may decide that he does not want to paint like any of his instructors, but feels a strong attraction to the subtle color harmonies of Degas' work.

The student then would find out as much as he could about the materials Degas used, what media he preferred and how he prepared them, what kinds of pigments he used, how he built up the surface, etc. The student could get most of this information in general

form from text books available in most libraries (Mayer, Doerner, etc.).

Next, if the young painter did not live close to a museum where a work by Degas was available for study, he would get the best color reproductions he could find, and try to duplicate at least a section of a Degas painting. Last—and this is the crowning touch—the student would have to go to a museum where a Degas was on exhibition, get permission from the authorities to make a copy, and spend several weeks, if necessary, trying to duplicate exactly the same subtle color harmonies and other features of Degas' work which had appealed to him in the first place.

After completing this self-appointed course, the student would have learned more about the handling of paint, and would be further towards realizing his other ambitions as a painter than by taking any other kind of course for the same length of time.

The old masters are dead and gone long ago, but as teachers they are still very much alive. Their paintings embody lessons which any intelligent student can learn.

The Great Masters and Changing Tastes

A great advantage in learning from the old masters is that the lessons are never out of date. As anyone knows, an artist's fame in the modern age is fleeting and fickle. Painters who enjoy great reputations in one decade are apt to be forgotten in the next, even though they are painting as actively as ever. A student who bases his style too closely on the work of a *contemporary* artist is taking chances. By the time he has completed his training, his idol may have fallen and may have taken all his imitators down in the crash.

The artists represented in this book are not subject to changing tastes. Many have had their ups and downs, but the status of artists like Renoir, Corot, or Rembrandt is not questionable. Their paintings have survived the changes of taste. By learning from them you are making a gilt-edged investment in your time and education, and you will never have to worry that you are wasting your time and money.

Selecting the Style and Subject

One of the most difficult and important things you will ever have to do is to decide just what kind of a painter you want to be. No two people react in the same way to the world around them. Some derive their satisfaction and pleasure from the marvels of nature; others are interested primarily in human beings, their problems, foibles, dignity, and sorrows; others are fascinated by the play and interplay of color, whether on a peacock's tail or chance harmonies on a painter's palette.

It is important that you find out where your heart lies, because your art will surely follow. This is an invariable rule of art history: only when a painter is painting what appeals to him, in a way that appeals to him, is there a chance of producing a worthwhile picture.

This book can help you make up your mind. Without advice from teacher, parent, or fellow student, go through the book and mark the pictures which really appeal to you—paintings which you wish *you* had done. It is vitally important that this choice is yours, and yours alone, and that you are not—unconsciously perhaps—following somebody's leadership.

Next, decide what subject you would really like to paint if you had a free choice. Some people are naturally drawn to landscapes, others to flowers, abstract shapes, birds, machines, portraits, nudes; the range of subjects is almost infinite. Again, be honest with yourself. You will never be able to alter your instinctive preferences, because these originate deep down in the recesses of your mind and memories and it is fatal for you as an artist to force yourself to paint either a subject, or in a style, which does not come naturally to you. For an artist the road to hell is paved with pictures which are not sincerely felt.

Having made up your mind about the subject and the style, follow your convictions. If you really feel a preference for Corot's landscapes, for example, don't let anyone tell you it is out of date or out of style. A good painting is never out of date, and if you follow your convictions without deviation, the world eventually will beat a path to your doorstep. If you climb onto a bandwagon, you will always be painting second hand, and probably second rate, pictures; in the long run, you will probably quit painting altogether. Therefore, have the courage of your convictions and paint *what* and *how* you like. All of the painters whose works are reproduced in this book did just this, in spite of discouragement and varying fortunes.

Different Types of Imagination

The romantic urge to escape from the humdrum is a constant factor among artists in every generation. The Renaissance artist was convinced that a return to the ideals of ancient Rome was the best hope; the Baroque artist wanted to go even further back, into the classical past of ancient Athens. French nineteenth-century artists wanted to escape to the exotic East of moonlit deserts, hooded sheiks, and perfumed harems. Many American artists couldn't wait to get on the boat to Paris during the nineteenth and early twentieth centuries. Many painters of today want to escape into outer space.

There is nothing wrong with the romantic urge to escape. Countless artists have reached their peak performances only when trying to recapture some exotic,

far-away or semi-legendary existence: we have only to look at the work of Delacroix, Veronese, or even Manet. Therefore, if you happen to have a romantic imagination, don't fight it: it is a gift. The ability to represent what is not but *might be*, is a service to the world: you can lift people out of their everyday lives, presenting them with experiences and vistas which they probably would never know. The artist has always provided one of the escape routes into the realm of imagination, and this is an important function.

Representational Examples

You will note that practically all the examples chosen for this book are representational—that is, based on the visible world. This does not mean that the author has any bias against non-objective art. It *does* mean that the basic principles of non-objective art have always been present in the works of the masters.

These principles were taken for granted by all the great artists of the past. Dynamic space, expressive brushwork, the science of color contrast—and all the other features of non-objective art which have been isolated, extracted, and enlarged in recent years—were all present in seventeenth-century painting. The difference is that a Rembrandt used his technical wizardry as a means to an end, never as an end in itself.

Therefore, it has not been necessary to include in this book non-representational, abstract, or any other kind of contemporary experimental painting, because all of the principles can be illustrated from the older masters.

Best Evidence

You will notice that the word *probably* is used throughout, particularly in the section dealing with color and techniques. The reason is that we cannot be sure just what system or medium was used by a certain painter at a certain time.

Chemical analysis can pinpoint some pigments; literary references may describe many systems and color palettes. Scientists, with an ever-increasing array of spectrographs, solvents, and microscopes, can analyze oils and varnishes up to a certain point. However, even when we can refer to an artist's memoirs as a guide, there are always gray areas of doubt; hence the use of the word *probable*.

We do our best to give accurate information, but no one can be absolutely certain.

Unchanging Principles

Another purpose of this book is to make the artist realize that there are principles in art which do not change from one epoch to the next. Each generation tends to think that it has broken through barriers and cast off chains forged by old fashioned artists, and has found a brave new world of artistic freedom and expression. Looking back on these revolutions in style we realize that what seemed a new horizon was, in fact, a mirage, and that the break-through was only a special application of principles as old as the Pharaohs.

The principles of art, like those of human character, do not change from one age to the next. They are universal, and can be applied equally to Chinese ink paintings, Rembrandt drawings, abstract expressionist paintings, or Renaissance religious art.

Usually it is impossible to express in words the emotional and esthetic reasons why a certain artist has the power to move and inspire the viewer. Often it is possible only to indicate historical or technical reasons for the painter's success in achieving these effects. With this knowledge a student can perhaps apply the same principles to his own work. After all, a surgeon who takes out an appendix has looked carefully at the work of other surgeons faced with similar problems, and has (hopefully) discovered what is best for the patient.

As I pointed out before, there is nothing new in this method of teaching. Since the earliest records in art history, more painters have trained themselves by studying, asking questions, and unlocking the secrets of the great masters who preceded them, than by all the other teaching methods combined.

The Age Factor

The term "old masters" conjures up an image of bearded figures as remote as the founding fathers. And yet many of the old masters were not old. Raphael died when he was 37; Géricault when he was 33; Watteau when he was 37; Giorgione when he was about 33; van Dyck when he was 42. Others, by contrast, lived to a ripe old age, like Titian who died at 99.

An interesting point emerges from the study of the lives of the masters: the peak of an artist's career—that period when all his energies and talents are brought to a sharp focus, and his creative abilities are fully realized—can occur at any time. It can come between the age of 25 and 60, and usually does not last for more than a few years. In other words, if all the works of an artist were lost except those of his peak years, his standing in the history of art would not, in most cases, change significantly. With Rembrandt the peak came late; with Degas in middle age; with George Bellows it was early.

This point is very important because painters who do not achieve success in their youth, often give up. The history of art proves that these young painters are

wrong to be discouraged so early. A painter may have to search for many years before he finds the right combination of style, theme, and motivation which will realize his potentialities.

The words *talent* and *genius* are misleading. According to romantic philosophers, talent is the only essential quality for a great painter. According to the artists themselves, talent is less important than hard work, persistence, sound training, and a good eye for color.

Equipment and Supplies

Many of the captions conclude with suggestions and exercises for trying out the techniques and ideas described in the individual pictures, most of which are oil paintings. In order to do these exercises, you will need a few basic oil painting supplies.

Gesso panels Wooden panels were used as painting surfaces by many of the old masters. Several manufacturers make Masonite panels (or other types of panels made of pressed wood fibers), sprayed with gesso. These will do, although sometimes it is advisable to brush on another layer of gesso (a mixture of chalk and glue, available in art supply stores) and sand it down, because the texture of the panel as it comes from the manufacturer is too smooth and perfect.

Canvas A variety of linen canvases, with different weaves and textures, can be obtained from your local art supply store. It is a good idea to buy a 2′ x 2′ sample of each of the different kinds of canvases they carry in stock; then try them all. If the stores do not carry a wide variety, you may request samples of major brands directly from the art supply manufacturing house. In this way you can become acquainted with what is available on the market. The canvas must be mounted on some type of stretcher or support, of course.

Brushes You will need an assortment of round brushes, both bristle and sable, in addition to the more usual flat brushes. Remember, the flat brush is a fairly recent innovation. Most of the painters represented in this book used either round or oval types. The so-called *filbert* is a good compromise: this has a flat body and a rounded tip.

Painting and glazing mediums Several art materials supply firms make painting and glazing mediums which, although they may not be identical with the blends used by the old masters, will give substantially the same effects. You must do some experimenting before you find the painting and glazing mediums you like best. I advise you to buy small amounts of each of the mediums on the market and experiment with different combinations.

The most widely used mediums are combinations of damar or copal resin, linseed oil (raw, sun thickened, or stand oil), and turpentine. The mediums developed by Frederic Taubes have been based on the study of old master methods and are commercially available. Recipes for making your own mediums are given in books by Mayer, Taubes, Doerner (the three most widely read authorities), and a new compilation by Robert Massey.

Wax mediums Several manufacturers are putting out mediums—in tubes—which have a wax content. For many of the exercises in this book you will have to add a little wax medium to the pigments. There are some "underpainting whites" which have a certain amount of wax in them; you can save yourself the trouble of mixing by experimenting with the pre-mixed underpainting whites.

Colors Although no two artists agree on the ideal color selection, a good basic palette for the purpose of this book would include flake white, cadmium yellow light, yellow ochre, Venetian red, cadmium red medium, alizarin crimson, ultramarine blue, viridian green, burnt sienna, burnt umber, and ivory black. This is a fairly standard palette, not a large one by contemporary standards but far richer than the range of colors available to most of the old masters.

1 Line in Painting

LINES DO NOT EXIST IN NATURE. What you interpret as a line is the place where two areas of different color or tone come together, and your imagination supplies the line between them. So when a child picks up a crayon and draws matchstick figures, he is producing an abstract form of art, because the line is abstracted from the image, or rather *added* to what the eye sees.

The inclination to see nature in terms of line seems to be a universal trait of human beings whenever they start to represent things. The prehistoric cavemen, the aborigines in Africa and Australia, the pre-Columbian Indians, primitive adults, and children, all start by using lines to represent what they see.

In its purest form, line is the hallmark of *drawing,* and a case could be made for not including a section on line in a book about painting. However, the pencil, the pen, the brush, and the palette knife, all have common characteristics from a technical point of view, and what is true of one applies more or less to the others. Most great painters have used line in one way or another to achieve certain effects. Line, in fact, is one of the key elements of painting, and a painter who is a master of line can achieve greatness without mastering any other branch of his art: Ingres and Paul Klee, among many others, are examples of this.

Expressive Lines

Brushwork, which is the painter's use of line, is his handwriting. As any student of handwriting knows, a person expresses his character and mood when he writes even a single word. A painter does the same. Every time you make a brush stroke, you leave a miniature record of your mood and character, and there is very little you can do to disguise either. The way in which pure line—or brushwork—expresses a mood is something an artist should study, as many of the great masters have done in the past.

To test your own capacity to express mood with line, I suggest you take a pen, preferably one with a flexible point, and make a series of lines on paper. Try to express the following emotions: anger, love, jealousy, hatred, despair, and serenity. To test your success, show the lines to your friends and see whether they can tell what emotion each expresses. If you sincerely feel the emotion at the time you are drawing the line, the results will be much more convincing, since emotions and the lines expressing them are not easy to fake.

The theory that a painter unconsciously portrays his own mood and character when he draws or paints was first proposed by Chinese philosophers during the late middle ages. The same theory, in slightly varying forms, occurs in Western art from the seventeenth through the twentieth century. So there is nothing new in this emphasis on brushwork.

Brushwork can also be used to express the character of the subject being depicted. Thus, if you are representing a runaway horse, obviously it would be most appropriate to use brush strokes which express fear and swift action. Study Figure 1 to see how Magnasco used brush strokes to express motion. Obviously, this kind of brush stroke would be completely inappropriate if you were painting a reclining nude, for example.

Many of the masters in this book, particularly those of the seventeenth century, made careful studies of the expressive power of brushwork. Compare the brushwork of van Gogh (Figure 2) with that of Leonardo (Figure 3), Fragonard (Figure 4), or Rembrandt (Figure 5). This comparison will help you realize the vast range of possible expressions.

Imaginary Lines

We usually think of a line as a continuous mark linking two actual points. However, a line can be created in the imagination. For example, look at the drawing by Luini in Figure 7. Even though the line along the contour of the cheek disappears—is lost, in the language of art—we know exactly where the contour is. If you have a starting point, a finishing mark, and some intermediate guides, the imagination will usually fill in the gaps. This allows the spectator to share in the process of creating, giving him pleasure as a result. Imagining the line also heightens a sense of the surrounding atmosphere and light, which gives a certain feeling of space.

A contour can be as effectively lost in painting as in drawing; for example, notice the blade of the sword in the detail of Rembrandt's painting (Figure 6). As an exercise in the use of lost contours and lines, take a painting or drawing of your own and take out as many outlines as you can. You will be surprised to discover how few lines are really necessary to convey all that you wanted.

Lines Expressing Texture

Another use of line is to express texture. For example, in the detail of the Renoir painting (Figure 8) the contour of the woman's face has been deliberately softened so that it is more blurred than even the cat's fur. The reason Renoir used this kind of line was to express not only the physical texture of the woman's skin, but also his *feeling* about this texture. Renoir's impression was of a soft, warm, and yielding surface and he used line to convey this sensation.

Yet another use of line may be seen in the Toulouse-Lautrec detail (Figure 9). Brush strokes have been smeared and dragged over the woman's face. This creates a disagreeable and repulsive sensation and makes the woman appear even more pig-like than her physical appearance would suggest. Toulouse-Lautrec undoubtedly did this on purpose, to reinforce his characterization of the subject.

Lines Expressing Rhythm

There is one more important function of line which you should understand, and that is rhythm. Lines mark boundaries of space and, thus, of time. In other words, as your eye travels from one area to another in a picture, the *tempo* of your viewing is usually marked by lines separating the sections. If there is a considerable number of lines to be traversed, the pace will slacken. On the other hand, your eye generally travels over an area of flat color relatively fast. This factor of rhythm can be used by a painter to introduce changes of pace and to enhance the spice of optical excitement.

Look at the detail from a Neroccio de'Landi altarpiece (Figure 10), and see how important the rhythm of lines can be. Contrast this with the detail from Rubens' *Daniel in the Lions' Den* (Figure 11), which shows an entirely different type of linear rhythm, thus producing an entirely different emotional and psychological effect.

Paul Klee, the great German artist, once used the expression "going for a walk with a line." This sums up an important aspect about line that must be remembered: namely, that a line can be an independent factor in a picture. It can have a life, an expression, and a personality of its own, and if you can control it, you have one of the most valuable slaves in the artist's repertoire at your command.

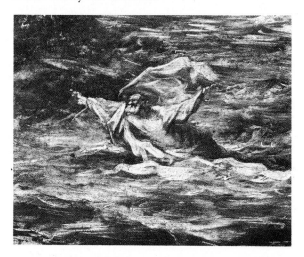

Figure 1: Alessandro Magnasco, Christ at the Sea of Galilee *(Detail), National Gallery of Art. The slashing brushwork seems to duplicate the tempestuous wind and waves.*

Figure 2: Vincent van Gogh, The Olive Orchard *(Detail, X-Ray), National Gallery of Art. The brushwork here reveals the artist's passionate and impulsive nature.*

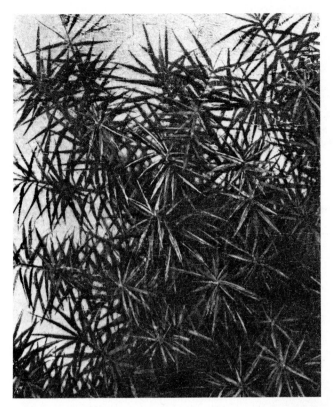

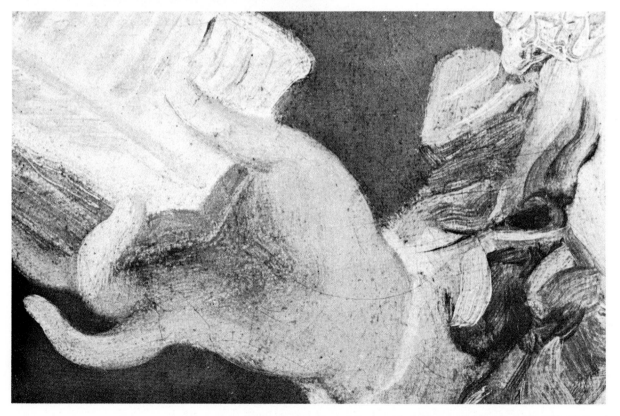

Figure 3: Leonardo da Vinci, Ginevra de' Benci *(Detail), National Gallery of Art. This enlarged detail of Leonardo's work shows the artist's precise, logical approach.*

Figure 4: Jean-Honoré Fragonard, A Young Girl Reading *(Detail), National Gallery of Art. The rhythm of the brushwork gives a lyric quality.*

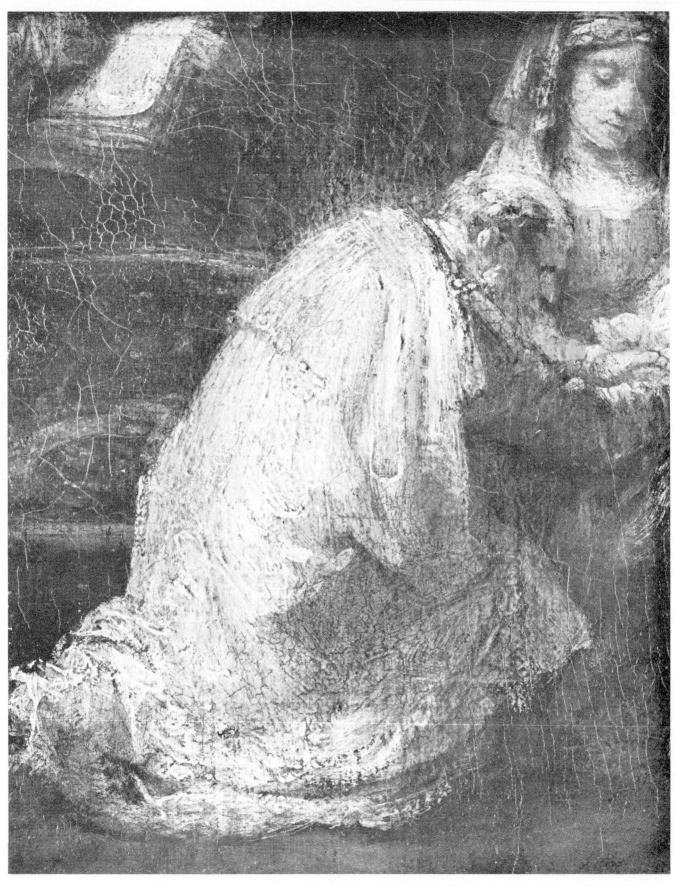

Figure 5: Rembrandt van Ryn, The Circumcision *(Detail), National Gallery of Art. The brilliant control of Rembrandt's brushwork reduces descriptive detail to a minimum.*

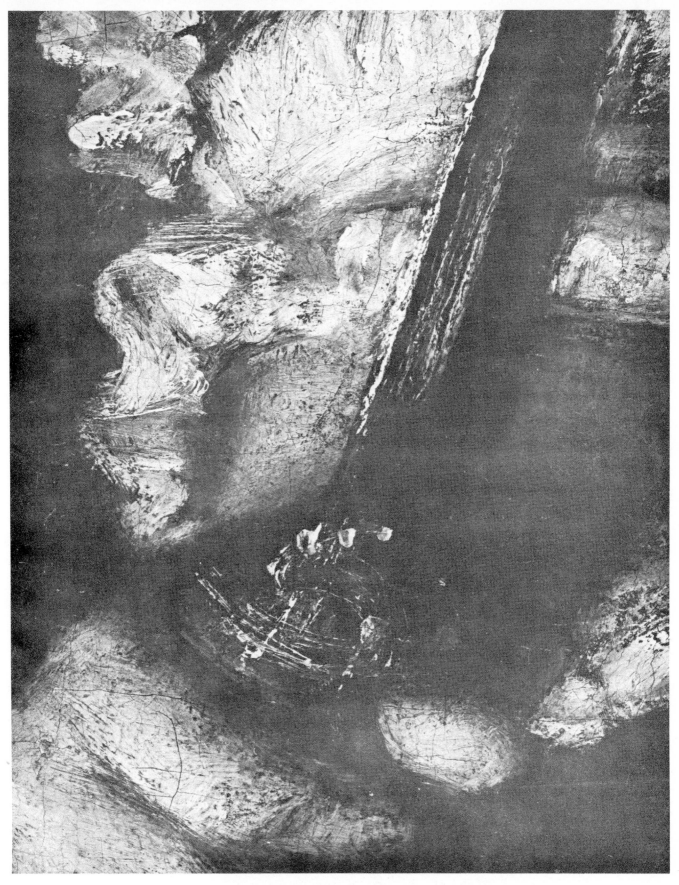

Figure 6: Rembrandt van Ryn, Lucretia *(Detail), National Gallery of Art. Apparent simplicity masks a complex technique.*

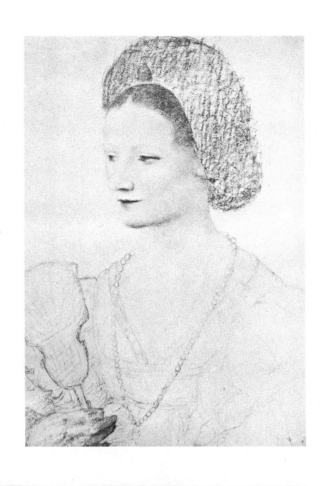

Figure 7: Bernardino Luini, Portrait of an Unknown Woman with a Fan, *Albertina, Vienna. Contour lines are deliberately suppressed.*

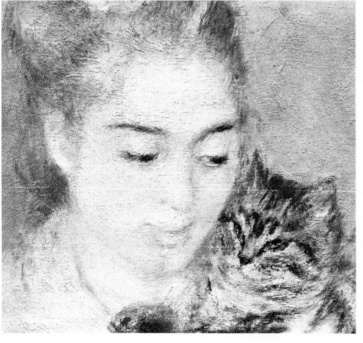

Figure 8: Auguste Renoir, Woman with a Cat *(Detail), National Gallery of Art. Contour lines are made vague to give an impression of softness.*

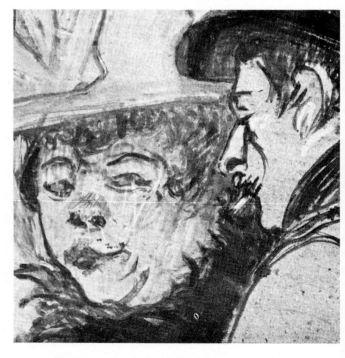

Figure 9: Henri de Toulouse-Lautrec, Alfred La Guigne *(Detail), National Gallery of Art. The smeared lines here emphasize character.*

Figure 10: Neroccio de' Landi, Madonna and Child with Saint Anthony Abbot and Saint Sigismund *(Detail), National Gallery of Art. The rhythm of lines has been carefully studied to give a feeling of grace and charm.*

23

Figure 11: Peter Paul Rubens, Daniel in the Lions' Den *(Detail), National Gallery of Art. The flame-like rhythm is a source of motion and life.*

2 Rendering Three-Dimensional Form

A HUMAN BEING normally sees with stereoscopic vision: the two eyes, with overlapping fields of vision, actually give *two* slightly different images, which the brain has learned to interpret in order to judge varying distances and perceive solid forms. If you have ever looked at stereo photographs, the process is familiar: you are given two pictures side by side—almost identical, but not quite—which your mind assembles into one image, converting two flat images into a three-dimensional one.

Some animals and birds, lacking stereoscopic vision, must look first with one eye and then with the other. With stereoscopic vision, the human has depth perception and is therefore able to interpret the world about him in three-dimensional space and form.

The painter usually works on the flat, two-dimensional surface of paper or canvas; in order to achieve an illusion of three-dimensional form on this flat surface, he must add to, or alter, the images he sees, and thus artificially create space and mass. Those who have not faced this problem of converting a three-dimensional image to a two-dimensional surface often think that if an artist reproduces exactly what he sees *with one eye* he will achieve "realism." This is a mistaken idea. What he has achieved is only the flat vision of a one-eyed man.

Historically speaking, there are four ways in which a painter can create an illusion of three-dimensional form. The first is by light and shade. The second method is by making the brush strokes follow the shape of the objects being depicted. A third method (see the Chapter on Line) is by modulating the outlines or contours. And, finally, a fourth way is by the use of color. Some colors advance, others recede, and a sense of mass and volume can be suggested by color alone. This final method is not discussed here, but in the Chapter on Color and in the comments concerning Cézanne's paintings.

Form Expressed by Light and Shade

The first, and most common, method of rendering three-dimensional form is by means of light and shade, or tone. The use of tone to achieve a sense of form was perfected during the Renaissance, and Leonardo da Vinci is generally considered its greatest exponent.

Leonardo ruled that there are five basic tone values. Look at the photograph of an egg (Figure 12). At 1 is the highlight, facing directly towards the light source. (A good artist usually will have one principal highlight and the other light areas less intense.) At 2 is the halftone, still receiving direct light but at an oblique angle, and therefore less intense. The shadow edge appears at 3, cut off from both the direct light and reflected light, and therefore usually dark and dense. At 4 there is reflected light. Depending on the surroundings, surfaces facing away from the light source will usually have some light bounced back on them from other sur-

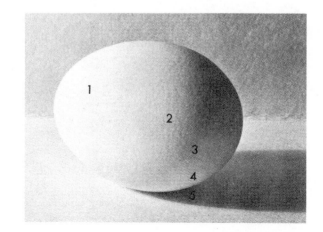

Figure 12: Egg. *A photograph reveals clearly the five degrees of light.*

faces. This light will vary greatly in color and intensity, and is the most complex of the different types of light. The cast shadow falls at 5. This receives neither direct light nor reflected light, and is therefore dark and usually neutral in color.

Figure 13 is a drawing by Leonardo, showing how the principle has been applied to a portrait. Figure 14 shows the principle used in painting.

Form Expressed by Hachure Lines

The second method of achieving form is by *hachuring,* or using contour lines which follow the shape being represented. If you cover an object with a network of lines following the underlying shape, you supply a sort of grid map, which your spectator can easily follow. Look at Dürer's drawing (Figure 15). You have no doubts about the shape of any part. This is of course a linear, draftsman's approach, but the same technique can be used with brushwork.

The great masters consistently used this method of conveying form by brush strokes expressing contours, and it can be useful at times to a painter today. Notice how Rembrandt used his brushwork to express the form of the eye in Figure 16. A point to remember is that you do not have to cover the shape with a whole network of lines in order to convey the sense of form. Often a single line will achieve the desired effect, and the spectator's imagination will supply the rest. Notice, in Figure 17, how Rubens used only a few lines to convey the form. Most of the masters represented in this book at times availed themselves of this system of using hachure lines for expressing three-dimensional form, and the painter today would do well to remember how effective this kind of line can be.

Form Expressed by Modeled Contour Lines

The third method of achieving a sense of three-dimensional form is by using a modulating outline. The

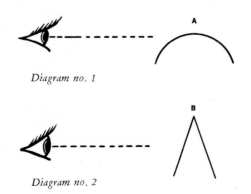

Diagram no. 1

Diagram no. 2

theory of this, briefly, is that a human's two eyes see an edge—particularly one that is close—at very slightly different angles. In Diagram no. 1 the two lines of vision intercept the rounded form at two different places and the artist interprets this by making the contour line for this type of shape slightly blurred. If the same spectator looks at a narrow edge, however—see Diagram no. 2 —both eyes will see the edge at the same place, and the contour will be sharp. In this case the two lines converge at almost exactly the same place; in order to convey this the painter makes a sharp line. Of course this theory is applicable in theory only, because the principle would not apply for objects seen on a horizontal plane. However, the human eye has learned to interpret nature in these terms, and a good artist can achieve a remarkable effect of form by altering and manipulating the contour line. Among many great masters who used this type of line were Raphael and Ingres. Study Figures 18 and 19 which show this technique of modeled contour used in both a painting and a drawing. The variations of the outlines are almost imperceptible, and yet the spectator has a clear and convincing impression of the shapes, textures, and almost the feel of the surfaces.

Using modeled contours is the most difficult way to render form, and very few artists have ever achieved it. If you have a feeling for line as well as a sense of form, try it. The results can be almost magical.

Test Your Sense of Form

It is important for you as an artist to find out early in your career whether you have a feeling for form or not. One method of finding out is to place your left hand on a table and draw the thumb of that hand, using the five values described above. The chances are about one in ten that you will achieve a convincing sense of form.

Then draw your thumb using contour lines, like those of Dürer. Again, about one out of ten students will be successful.

Last, try to get a sense of form by using only a modeled outline, in the manner of Ingres or Raphael. The chances are about one in twenty you can do this.

Now try to do the same with brushes and monochrome oil (just one color and white).

Then try it with full color.

It will take a long time before you produce anything which will satisfy you. If you have no feeling for form, don't be discouraged. It is not one of the essential elements in art. There are many other aspects of art in which a painter can excel. For centuries the Chinese have produced masterpieces without stressing three-dimensional form, and many of the painters in this book neither knew nor cared about the third dimension, surprising as that may sound.

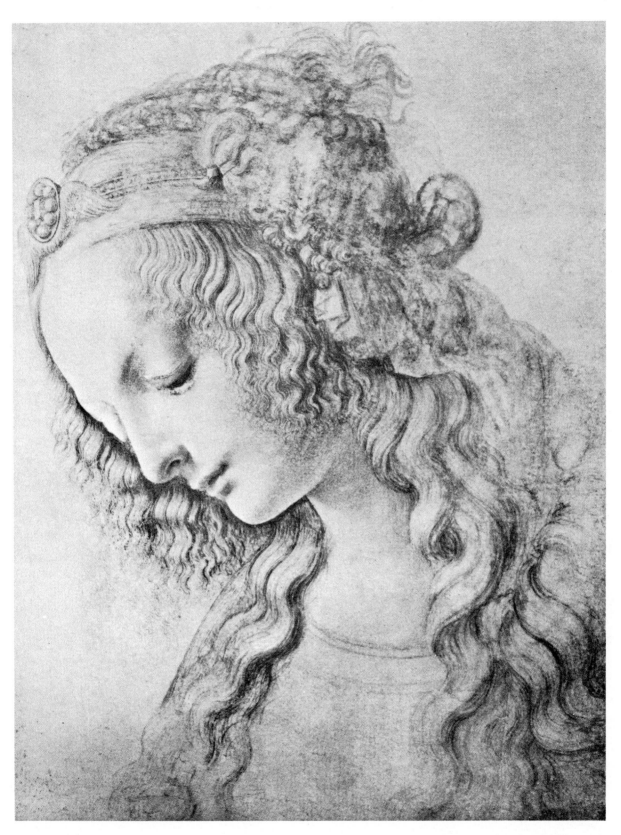

Figure 13: Leonardo da Vinci, Head of a Woman, Uffizi, *Florence. The precise control of light and shade is shown here in five values.*

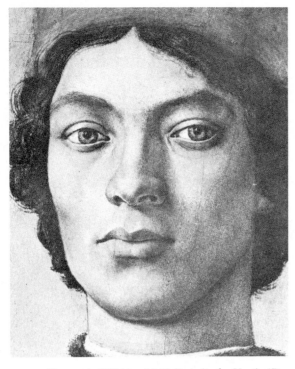

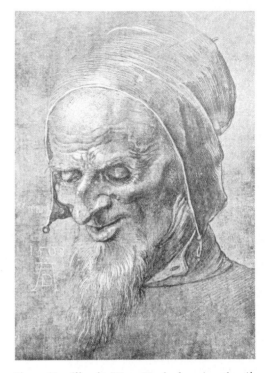

Figure 14: *Filippino Lippi,* Portrait of a Youth *(Detail), National Gallery of Art. An exacting rendering of tonal values.*

Figure 15: *Albrecht Dürer,* Head of an Apostle, *Albertina, Vienna. The hachure lines provide accurate information about the form.*

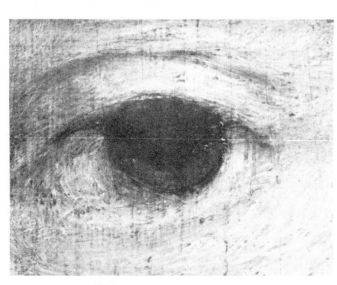

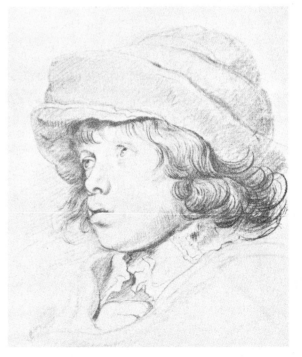

Figure 16: *Rembrandt van Ryn,* Saskia van Uilemburgh, the Wife of the Artist *(Detail), National Gallery of Art. The brush strokes follow the forms very accurately.*

Figure 17: *Peter Paul Rubens,* Head of the Artist's Son Nicolas, *Albertina, Vienna. Only a few modeling hachure lines are used to express the form.*

Figure 18: Jean-Auguste-Dominique Ingres, Madame Moitessier *(Detail), National Gallery of Art. The precisely modulated contour describes the shape accurately and simply.*

29

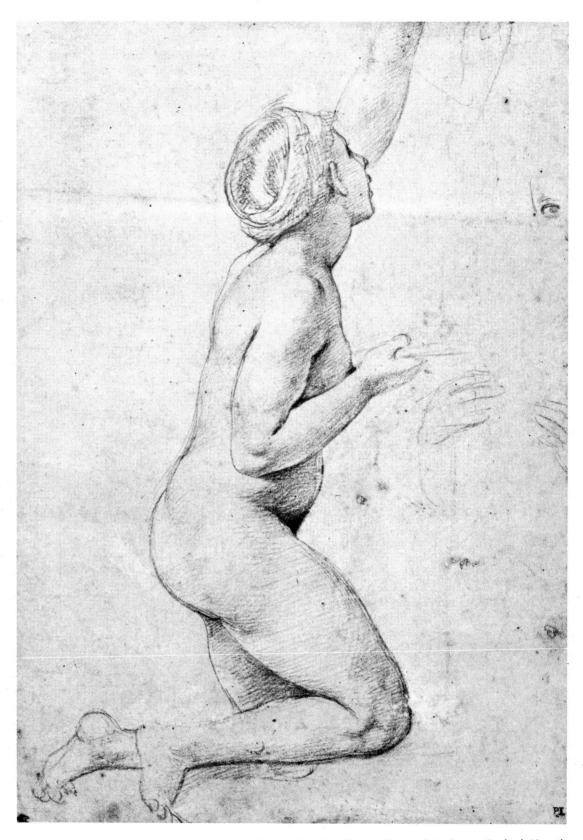

Figure 19: Raphael, Kneeling Figure, *Chatsworth Settlement, England. Note the variations in line which express the changing form of the back.*

3 Creating the Illusion of Space

I N A PAINTING, space is the illusion of distance, either between the different objects *within* the picture itself, or between the *spectator* and objects in the picture. This illusion of distance is one of the important elements of painting.

There are four basic means by which artists have achieved this effect of distance. First, by geometric perspective; second, by optical perspective; third, by depth of focus; and fourth, by haloing.

Geometric Perspective

The first method of achieving distance, and the easiest to understand, is with geometric perspective. We all know that parallel horizontal lines appear to converge on an imaginary point on the horizon; think of railroad tracks. If you superimpose an imaginary receding checkerboard pattern—a grid—over the ground or floor plan of your picture, you will have a neat and easy way of measuring the distance between any two points; simply measure between the receding lines.

This system was widely used in the Renaissance, when artists first began to understand the laws of geometric perspective, and is as valid today as five hundred years ago. You do not have to provide a grid of equal squares (as in Figure 20). A meandering river winding into the distance will achieve the same effect (see Figure 21). Trees of the same type and size repeated at different intervals in diminishing sizes will give an index of space and receding distances. Anything which is recognizable as being of a known size—a person or building, for example—will give a means of measuring distance, and therefore of the space between.

In the seventeenth century Dutch theorists stated that an artist could paint alternating bands of shadow and sunlight on a flat landscape, and thus create space,

because the spectator would *imagine* a perspective checkerboard on the ground and unconsciously measure the squares in the mind's eye. Try this system sometime, and see how effective it is. Any time you have a problem in conveying the illusion of space, it is safe at least to experiment with a solution based on the grid system or repeat motifs.

Optical Perspective

The second system for creating space in a picture is based on the theories of optical or aerial perspective. Whereas geometric perspective is a mathematical solution to space, optical perspective is *visual*. This theory, first codified by Leonardo da Vinci in the early fifteen hundreds, is founded on the fact that the atmosphere which surrounds us at all times is not completely transparent, and is slightly bluish in color. Therefore, an object in the distance is apt to be more blurred than foreground objects, and also more bluish in color. Study Figure 22 to see how Fragonard achieved this effect of distance.

Of course, the effect is apt to vary with atmospheric conditions. On a misty day a tree 100 yards away from you will seem like only a gray blur. The same tree on a dry clear day will seem crystal clear at 500 yards. Regardless of local conditions, however, the tree will tend to be more indistinct and bluish gray as the distance increases, and our unconscious understanding has learned to interpret this as a measure of space. Therefore, if you want something to recede in space, paint it a bluish gray and make the outlines vague and blurred.

In the Baroque period they used to teach this law of optical perspective in art academies by hanging three curtains of blue-tinted, transparent silk from the studio ceiling. These veils represented the atmosphere. They

then placed models of figures and objects behind each veil so that the student could study the effect of distance inside the studio, and learn how optical perspective modifies color and outline. If this problem interests you, buy some lengths of blue gauze and hang them on a clothes line stretched across your studio (or hang them outdoors, if you prefer). Place familiar objects between the first, second, and third veil. This will teach you just how important the atmosphere can be in changing the appearances of objects, and how you can duplicate these effects in your painting when and if you want to achieve an illusion of space.

Depth of Focus

The third way to achieve an illusion of distance between objects is based on the fact that the human eye can focus at only one distance at a time and, for this reason, objects which are not at this distance from the eye will be out of focus, and therefore blurred. Hold up your hand in front of your face and look at your fingertips. You will see them distinctly, but your sleeve in front of your hand will be out of focus, and the room behind will also be indistinct. The farther away objects are from this *focal distance,* the more indistinct they tend to be.

Thus, if you want one object to recede in space behind another, make one object sharp and clear and the other blurred and indistinct. The mind will read this as a difference in focus, and therefore a difference in space. See how Vermeer used this method in Figure 23.

Haloing

A fourth technique for creating space around an object is the *halo.* If you find that an element or object does not stand out enough against its background, try putting a band of blurred light around it, sharp along the edges of the object and gradually fading out against the background. Optically, this is what happens in nature, and it can be an effective way of isolating an object, both physically and psychologically, from its surroundings.

Notice the haloing around the head in the El Greco painting (Figure 24). Also study Figure 25 for the way Raphael haloed his outlines. And you can also see how Tintoretto used haloing in his painting, *Christ at the Sea of Galilee.* Many portrait painters as well have availed themselves of this device with particularly good effect.

What We Know vs. What We See

The techniques described so far are all based on interpreting what the mind *knows* must be in nature—actually *putting in* spatial elements that might be invisible in nature—rather than recording exactly what the eye sees, which may confuse, rather than clarify space. It was only after photography was invented in 1839 that artists began to concentrate on what the eye *sees,* looking at space purely in terms of color areas and tone relationships.

The Courbet landscape (Figure 26) is an example. The Renaissance painter would have found this interpretation of space confusing and false, because there are no geometric or optical space clues; and yet, visually, it is truer than any prior type of space treatment. Courbet has made no effort to help the spectator thread his way along the stream and through the underbrush. According to his standards, the apparent confusion of space was an aspect of truth in nature; he painted what he *saw* and it was not the artist's job to clarify spatial relationships for the benefit of the spectator.

Experiment with Space

There have been many masters in the history of art who have been fascinated with the problem of rendering space and the interplay of space in painting. They have achieved their effects by understanding and using one or more of the above systems.

As an exercise in space, make an arrangement on the top of a table, using whatever objects you wish, either from the garden, kitchen, or studio. Now paint these, altering the space relationships between them, making some objects recede into the far distance along an imaginary horizon, others appear to be in the middle distance, and some in the foreground. You will be surprised how the mind's eye will respond and how an illusion of space will emerge if you will follow one or the other of the above principles consistently and intelligently.

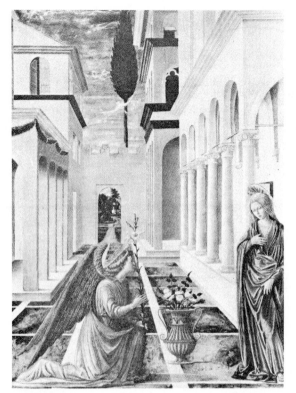

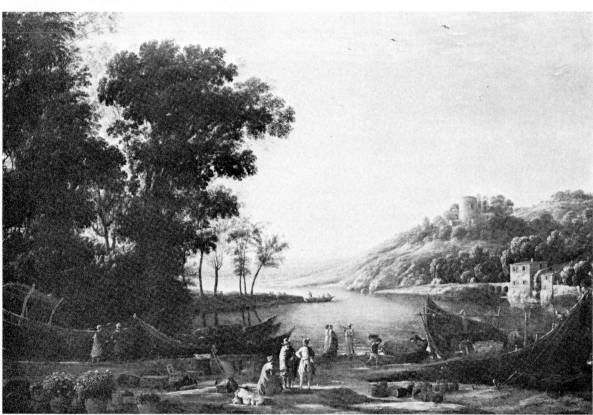

Figure 20: Master of the Barberini Panels, The Annunciation, *National Gallery of Art. The grid in this painting gives an accurate measure of space.*

Figure 21: Claude Lorrain, Landscape with Merchants, *National Gallery of Art. The winding river and trees indicate distance.*

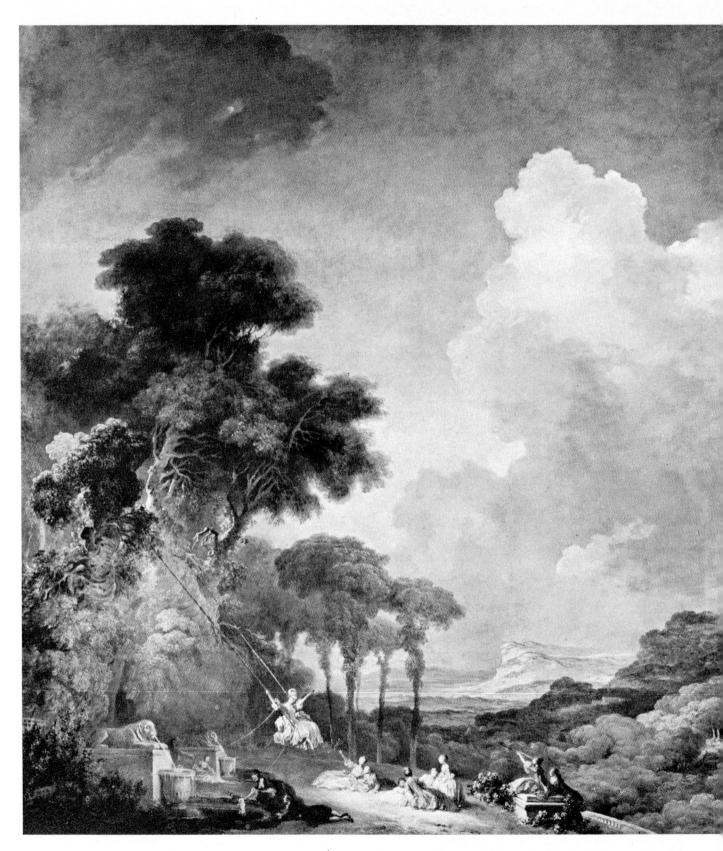

Figure 22: Jean-Honoré Fragonard, The Swing, *National Gallery of Art. The tones are paler as the distance increases.*

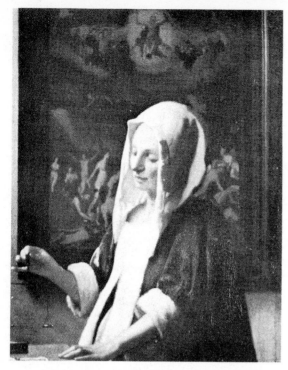

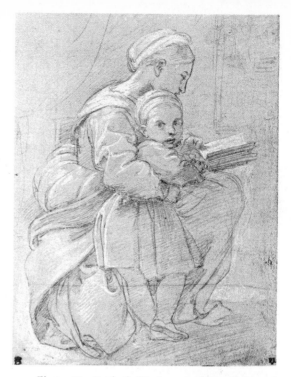

Figure 23: Jan Vermeer, A Woman Weighing Gold *(Detail)*, National Gallery of Art. *The gold scales are in sharp focus, and the picture in the background is out of focus.*

Figure 25: Raphael, Virgin and Child, *Chatsworth Settlement, England. The bands of white around the figure create an illusion of space.*

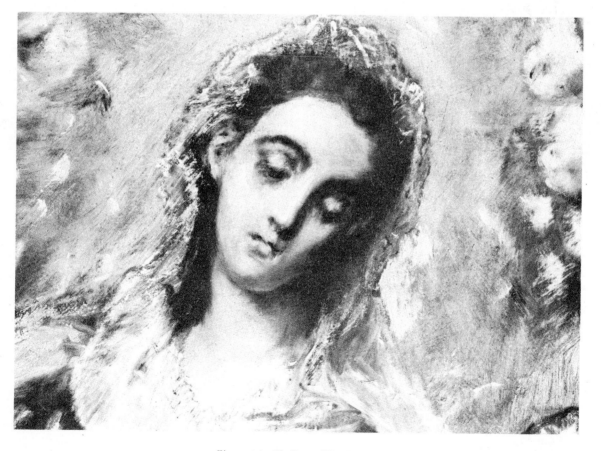

Figure 24: El Greco, The Virgin with Saint Inés and Saint Tecla *(Detail)*, National Gallery of Art. *The light area around the head isolates the main figure from the background.*

35

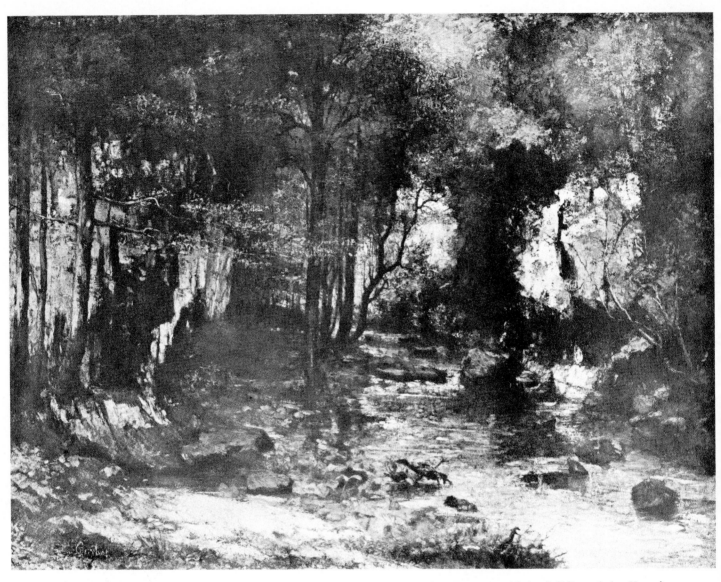

Figure 26: Gustave Courbet, The Stream, *National Gallery of Art. Here there are no artificial aids measuring distance.*

4 Color in Theory and Practice

COLOR is the most difficult subject you will have to deal with as a painter because there are no hard-and-fast rules. Although certain guidelines can be developed from a study of the past, the history of art proves conclusively that color is in the eye of the beholder.

One thing you must do early in your career is to find out what color harmonies come naturally to you. No two painters have the same sense of color harmonies, and it is very important that you find out where your instincts lie.

Your Personal Color Sense

To help you find the color harmonies most natural to you, take a rectangular surface, either canvas or paper, and divide it into twenty-four equal parts. Now squeeze out a full range of colors on your palette. (It is easier to do this in oils, but pastels or even poster colors will do.) Fill in each square with a color which seems to harmonize with both your wishes and with the other colors. The colors may be various shades of blue, if you have a very decided preference for blue to the exclusion of other hues. Or they may be fifteen squares of different blues, with nine squares of brown, red, or gray. Or they may all be primary colors.

No one can help or guide you in this exercise; you must reach down into the inner recesses of your mind's eye, and record the colors you find there. It might be wise to repeat this exercise a number of times over a period of weeks, and average out the results. You will be surprised how constant your choices of colors will be, and how unlike any one else's they are.

Once having found out which colors come naturally to you, be careful about departing too far from these combinations in your paintings. This constitutes your

norm, and if you go outside it you will find that your personal, delicate balance of harmonies will be upset, and you will be dissatisfied with the results.

The history of art proves that the great masters—with only a few exceptions—found and kept to a rather narrow color range during most of their active careers. For Turner it was the pearly grays and yellows, with a few dark brown or black accents. Rembrandt preferred golden browns, blacks, silvery grays, and, occasionally, dark greens. Van Gogh used apple green whenever he could. Degas showed a marked preference for certain russet reds, blacks, and viridian greens. (His greatest works used combinations of these colors, without exception; when Degas departed from them, his work tends to be more forced and less natural.)

If you do not know already what your instinctive preferences are, the great masters can help you make up your mind. Go through this book; try to ignore subject matter (to do this, it may be easier to hold the book upside down); concentrate on color harmonies only. Some colors will appeal to you much more than others. Try to remember these as accurately as possible, because your own destiny in color is probably much the same.

Laws of Color

Each generation evolves principles and rules about color, and the prophets of these theories are convinced that they have established universal laws which must apply to all artists. The succeeding generation throws away the rules of the preceding one, and evolves a new and contradictory set of principles.

For example, the color principles of Chevreul and Helmholtz were held to be absolute law a hundred years ago. The principles of Maratta supplanted them about

1900 and artists like George Bellows were convinced that Maratta at last had shown the true way to color. Today few people have heard of H. G. Maratta, and we have a new group of color apostles preaching entirely different theories.

The history of art proves beyond doubt that there are no hard-and-fast rules, and that a painter is gullible if he believes there are. One reason it is so difficult to legislate about color is that there is an enormous range within a single hue. For the layman, red is the color of the stoplight on the street corner, and he lets the matter rest there. However, the trained eye of an artist can distinguish about seventy different shades of red. Add to this the variations in tone (light to dark), and within the red color range alone you have perhaps seven hundred color variations. Each of these reds, in combination with a blue—of which there are also at least seven hundred varieties—produces a unique and separate harmony.

Since the eighteenth century, theorists have been comparing color harmony to music, but the comparison is only vaguely applicable. If the composer were forced to write using a scale with seven hundred notes in it, there might be some common ground; but as it is, there is very little.

Not only is the *number* of colors an overwhelming factor, but one's painting medium affects the color as well. A transparent oil color is entirely different from an opaque oil color; both are different from a pastel color; pastel is unlike a watercolor, and so on. You realize how naive it is to think that there can be anything more than the most general rules about color. The combinations run into the millions, and each one has a peculiar effect, unlike any other.

In spite of the almost infinite elasticity of color harmony, however, there are a few principles which the artist should bear in mind.

Emotional Qualities of Color

Certain colors have nearly universal emotional overtones. Bright red, for example, means fire and danger; it is the color to attract attention, and has been used as such since the dawn of art. Green is the color of growing plants, and generally connotes restfulness and freshness. Blue is the color of the sky and tends to symbolize peace and quiet. Yellow is the color of sunshine, and connotes warmth and joy. In the western world black is usually associated with fear and death.

I must warn you, however, that one could go on almost forever with associations which men at different times in history have had for various colors, and if you follow them all, there are so many contradictions that any color can mean almost anything, and symbolism loses its meaning. Psychologists have done considerable

research on the subject of color association. Thus we are told that small boys generally like red best, little girls like blue, and most college students also prefer blue; most people over forty like green. We are told that it is more satisfying to overtake and pass a red car on the highway than a car of any other color. A famous football coach, on retiring, confessed that one reason for his long string of victories was that he painted the walls of his team's locker a fiery red, and those of the visiting teams a dull gray.

Obviously, colors have emotional meanings and overtones which vary from person to person, from generation to generation, and from country to country, and it is very risky to draw up any codes which are supposed to have universal meanings. Besides, a great painter can always throw away rules; for example, an artist like Degas can paint portraits using only shades of red and orange, and still achieve a mood of peace and quiet.

In short, it is wise to bear in mind the symbolism and connotations of colors—but don't take them too seriously.

Color Contrasts

In the broadest sense, colors can be contrasted with one another—that is, played against one another—in eight different ways, which have been well described by the famed teacher Johannes Itten:

(1) *Contrast of hue* This, basically, is the contrast of pure or undiluted colors (or hues) at their full intensity; for example, the action of a bright red on a bright green and the optical effects resulting from the contrast.

As an exercise in the contrast of hue, take fifteen pieces of cardboard (2″ or 3″ square), and paint each piece with a color at its full intensity as it comes from the tube or jar; include white and black. Cut the pieces up into 1″ squares so that you have at least sixty squares to choose from. Now try to arrange not more than twenty squares within a rectangular format like a checkerboard. You will soon discover how complex the principles of color harmonies can become. Certain colors will kill, eat into, or become absorbed by others. Tensions develop; you will find that peace and quiet in the color family is both rare and difficult to obtain.

(2) *Light-dark contrast* Sometimes called contrast of values. This is the opposition between white and black and of their intermediate gradations when mixed with various colors.

As an exercise, prepare ten different shades of gray, ranging from pure white to jet black. Cut these into 1″ squares and then try to arrange twenty-four of these squares within a rectangular format to express different

sensations and rhythms. This is much more difficult than it sounds. You will discard most combinations as unsatisfactory, meaningless, and discordant. However, if you can develop an ability to work with black and white, the use of color will be easier.

(3) *Cold-warm contrast* Consciously or unconsciously we are aware that some colors are warm (like red, yellow, and orange) while others are cold (like blue and green). A single hue may vary in *temperature*: a purplish blue is warmer than a greenish blue, and a purplish red is cooler than an orangey red. Cold-warm contrast is the opposition between warm and cold colors (reds and yellows vs. blues and greens) and between warm and cool tones of each of these colors (warm greens, cool yellows, etc.).

Warm colors have certain emotional overtones; they are associated with the sun, stimulating impulses, opacity, the earth, density, nearness, heaviness, and dryness. Cold colors, on the other hand, are associated with shadow, quiet and calm, the air, distance, lightness, and wetness. As I have already said, it would be hazardous to extend this list too far; a great artist can conjure up color harmonies to express whatever emotion he wants, and it is not a good policy to start with any hard-and-fast rules. However, a painter should realize that the division between warm and cold is fundamental in color, and can be used to express a wide variety of relationships in both space and emotions.

As an exercise, try assembling a checkerboard of twenty-five 1" squares, playing warm and cold colors against one another. You should also take each color on your palette and try warming or cooling it by placing other colors adjacent to it.

(4) *Complementary contrast* Colors which are diametrically opposite to one another on the color wheel are called complementaries, and they have the power to bring out the maximum effectiveness of their opposites when placed side by side. Thus, yellow will emphasize an adjacent purple; red reinforces a nearby green, etc.

The remarkable fact about complementaries, which science so far has not explained, is that the nerves in the eye will create an illusion of the opposite color. Thus, a bright patch of red will seem to suffuse the surrounding area with green. If the surrounding area is green, it will seem even greener. A painter should remember this, particularly if he is planning to use intense color: or, if he wants maximum effect for a certain color, there is no better way to achieve this than by surrounding it with its complement. If you want a red to really register, surround it with green; surround blue with orange, yellow with purple, etc.

(5) *Simultaneous contrast* The optic nerve is always trying to alter colors—in the eye—to maintain a certain

equilibrium. In effect, each color tends to push a neighboring color in the direction of the first color's complement or opposite.

To understand how this works, paint a 3" square of vermilion red and, in the center, place a ½" square of neutral gray (using ivory black and white in equal proportions). The eye, seeking the balance of opposites, makes the gray square appear bluish. Similarly, an ultramarine-blue square surrounding gray will make the gray appear reddish; a green will produce the impression of orange in its neighbor, etc.

The painter who makes a special study of color effects should note these facts. For example, if he wants a gray really to appear gray when juxtaposed to a bright red, he should add just a little red to the gray to compensate for the eye's tendency to add blue.

(6) *Contrast of saturation* A color at its maximum purity (or maximum saturation) can be contrasted with the same color diluted with white or black (thus, less saturated) to produce a very effective type of harmony.

To understand how this works, take a 7" x 7" square and divide it into 49 smaller squares. Paint the square in the middle vermilion red, and the twenty-four squares around the edge gray, using ivory black and lead white in equal proportions. Paint the sixteen squares just inside the gray border with a mixture of two parts gray and one part red. Paint the eight squares surrounding the central red square with an equal mixture of the gray and the vermilion. In this exercise, it is

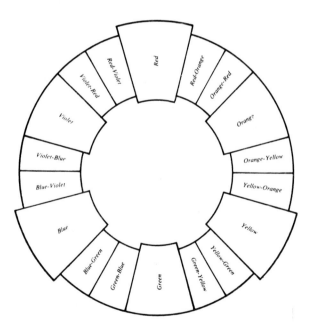

Figure 27: Color wheel. *Courtesy, David Friend. The color wheel simplifies the problem of finding color harmonies and contrasts.*

important to try to keep the values of all the squares about equal. You will note how the border squares intensify the central red, and how the red mixed with black tends toward purple. Try this same experiment with green, blue, and yellow for the central square, and you will see how the addition of gray will change pure color, either enhancing or deadening the pure hue.

(7) *Contrast of extension* Certain colors have more impact on the eye. Thus, a square inch of brilliant yellow is almost three times as powerful as the same area of violet. (The German poet, Goethe, was the first to examine and codify this phenomenon.) For this reason, the painter must decide how much of each color will appear on his painting surface—playing small areas of some colors against larger areas of other colors.

The relative strength or impact of colors may be expressed by drawing a circle and dividing it into 36 segments. Paint three segments yellow, four segments orange, six red, nine violet, eight blue, and six green. In other words, three units of yellow are as powerful as nine units of violet; green and red are about equal, etc. Naturally, this fact is only true when the colors are at their maximum purity.

A painter should remember the relative strength or impact of color when placing accents and planning color harmonies. For example, a small area of yellow or orange will go a long way. How many landscapes have been ruined by an overpowering orange sky!

(8) *Contrast of transparency* Color can be transparent like colored glass, semi-transparent like cloudy glass, or opaque like a thick layer of house paint. Transparent color—like the stained glass of a cathedral—is most powerful of all. In the same way, transparent paint (called a *glaze* in oil painting) is more powerful than an opaque passage.

To understand this phenomenon, squeeze out some pure colors onto your palette and apply them to a white gesso surface, first undiluted, then with a drop of glazing medium, making the paint more transparent and more brilliant.

The artist should be aware of these eight possible ways of enhancing his colors by contrast. Whether he decides to use them or not is a different matter; but it is important to remember that they exist and must be controlled.

Color and its Surroundings

An artist should always bear in mind that a color is relative to its surroundings, and to the light that falls on it. Thus a square inch of cadmium red surrounded by gray-green is going to shine out like a lighthouse;

surrounded by cadmium orange, this same color will hardly be noticeable.

Another point to remember is that a color can be altered radically by throwing different colored lights onto it, as any stage designer knows. A blue light can make the cadmium red look deep purple, and its surrounding green almost black. The artist should remember that his picture will probably be exhibited, purchased, and hung in somebody's home, under artificial tungsten light—a warm yellow light, far warmer than the northern light which painters traditionally use. Most painters have had the nasty shock of seeing their work under neon light and realizing how the harmonies they worked so long to achieve can be completely mangled by different wavelengths of light. Therefore, you should at least check your painting under artificial light before you send it out of the studio.

Limited Palette

The painter today can go into an art supply store and be overwhelmed by a galaxy of alluring colors on the color charts. I often think that some promising painters, swamped by the flood of colors available, give up in confusion. From a study of the great masters, it is tempting to say that the greater the master, the fewer the colors he used. Rembrandt's palette consisted of yellow, black, white, some warm browns and reds, and occasionally a green. Rubens had a few more colors, but his palette also was very simple. Even an artist known as a great colorist like Titian used only a few basic colors.

One thing the old masters had in common: they used bright colors with the greatest care, like playing trump cards at bridge. They surrounded their key colors with neutral or contrasting low-keyed tones in order to make the powerful notes more effective. Practically all the great masters applied their bright colors toward the end of their work. In other words, they built up to them; they did not put in the most intense colors first and try to make the rest of the picture harmonize.

Most great painters up to around 1700 began by painting their pictures first in neutral monochromes, and then glazed the colors over the neutral underpainting. This method had the great advantage of separating the problems of color from those of drawing, design, etc. I recommend such a procedure, because painting is such a vastly complicated process that it is obviously easier to meet the difficulties one by one.

If you are having difficulties in arriving at a satisfactory use of color, reduce your palette to ivory black, white, and one warm color like yellow ochre. Using only these three, paint subjects you know well: portraits, landscapes, still lifes, or non-objective themes. The subject is unimportant. Make one color count for

as much as a full range of hues. You will find that the gray formed by black and white will seem blue in comparison to the yellow, and that an illusion of green can also be achieved by a similar process. By concentrating on the range of a single color, you will come to realize the vast possibilities in a starved color scheme, and also the great power of the spectator's imagination in supplying the missing colors.

For centuries the Chinese have believed that a painter need use only black ink on white paper, and the imagination of the spectator will supply all the colors in the universe. Although this is perhaps an extreme point of view, there is a great deal of truth in the belief. Therefore, be careful of the orgy of color offered to you in the art supply stores. Most of it is fool's gold; you should begin by exploring the infinite possibilities of practically no color at all.

Preselected Palette

Take another good bit of advice from the masters: mix your colors beforehand on the palette. From literary sources we know that many great painters—particularly portrait painters—once they knew what their subject was, mixed all the colors they expected to use for a day, even in subtle gradations of tones and off-key combinations, and had them ready on the palette. Again, the advantage of this is obvious: you have one less step to worry about while you are actually working on the picture.

Another point is worth remembering. None of the artists in this book painted on a pure-white surface. Although the canvas or panel may have been white originally, they covered it with a layer of neutral color or tone before starting on the final painting. It is asking too much of the painter's human eye to conjure up rare and beautiful harmonies while being blinded by a big area of pure white. Always use an *imprima-*

tura, as this base layer of color is called, and be fair to yourself.

During the eighteenth century theorists used to describe color as a courtesan, because, like a courtesan, color appealed directly to emotions and could not be made to fit into any rational system. This simile is worth bearing in mind.

Color, Science, and Imagination

Edwin D. Land, the scientific genius who invented the polaroid camera among other devices, pointed out that the eye "does not need nearly so much information as actually flows to it from the everyday world. It can build colored worlds of its own out of informative materials that always have been supposed to be inherently drab and colorless."

In other words, color is a product of the imagination, and we still do not know exactly what happens when the wavelengths of color are received by the optic nerve and deciphered by the brain. Apparently, the decisive factor is the imagination; also important are the surroundings and relative colors. A white card will look white if seen in a room lit by sunlight. Strangely, the card still looks white if the same room is flooded gradually with red light: to the viewer it is white even though the scientist can prove by his wavelength analysis that it is red.

This is something an artist knows by instinct. Every color can be modified and changed by natural circumstances and the artist will still have his own interpretation of it. The work of the scientist in this field is interesting but, from the artist's point of view, peripheral and generally unimportant. Color is so delicate and changeable that the scientist is apt to be like a bull in a china shop when he tries to define it mathematically. As we said at the beginning of this chapter, color is in the eye of the beholder.

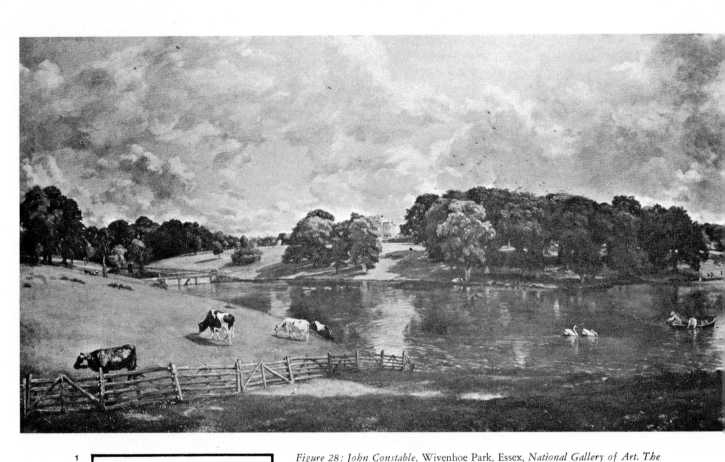

Figure 28: John Constable, Wivenhoe Park, Essex, *National Gallery of Art. The horizontal lines create an impression of peace and calm.*

5 Some Basic Design Principles

DESIGN (or composition) is the arrangement of elements within the picture format. These elements can consist of lines, light and shade, color, or mass. This chapter, therefore, cuts across the preceding chapters which deal with these subjects in more specific and isolated aspects..

Many artists think of design strictly in terms of line; however, this viewpoint is too limited. The composition in a picture may start in the center of a light area, then proceed along the edge of a prominent shape, then go to the center of a dark mass, then back to a contour, and end up with a bright accent of color. Therefore, learn to think in terms of *all* these elements together when you design a picture. Each element is capable of carrying the design load and of making or breaking your efforts.

Seven Principles of Design

There are a few universal principles relating to design which an artist should always bear in mind.

First, a picture designed with strong horizontal emphasis usually implies restfulness, peace, and calm. The reason for this mood, of course, is that lying down is the normal human way of resting. (See the first diagram and Figure 28.)

Second, diagonals usually connote motion or action in a picture. The reason again is physical. In order to support an object in a diagonal position, some effort or motion is normally required. (See the second diagram and Figure 29.)

Third, a pyramid design usually implies stability and permanence. The reason is that pyramidal shapes do not upset or roll; furthermore, mountains and other large objects often have this general form. (See the third diagram and Figure 30.)

Fourth, jagged shapes usually connote pain and tension, for obvious reasons. (See the fourth diagram and Figure 31.) Rounded shapes, on the other hand, usually have restful and soothing associations. (See the fifth diagram and Figure 32.)

Sixth, a V-shape is unstable. Perhaps because it has the overtones of outstretched wings, or arms raised in supplication, it also carries a certain menace with it. Very few people like insecurity, and a shape which is incapable of self-support, like a V, gives an unconscious feeling of danger. (See the sixth diagram and Figure 33.)

Seventh, a circle generally connotes perfection and completeness. The sun, the moon, and innumerable plant forms are round, and therefore a circular form tends to imply the cosmic power of nature.

There is a definite association of shapes with emotions and ideas, and one can go on listing them almost indefinitely. But it is unprofitable to go beyond the basic principles listed above. A great painter can always throw away the book of rules, and prove that all preconceptions are wrong. Bruegel, for example, can take a horizontal composition and make it into one of the most gruesome, sinister, and evil pictures imaginable. So these rules cannot be adamant. They are general guidelines—derived from the history of art—which a painter should know at least, before he decides to ignore them.

Importance of Contrast

There are two other basic ideas related to design which an artist should never forget. The first is the power of contrast. If you want to make a shape seem soft and rounded, place it next to a shape which is hard

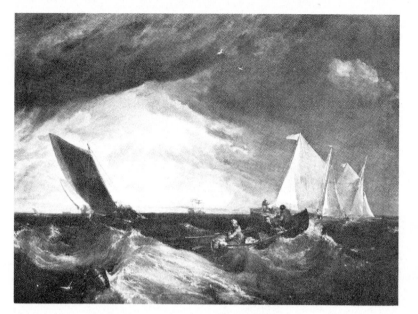

Figure 29: Joseph Mallord William Turner, The Junction of the Thames and the Medway, *National Gallery of Art. The diagonals give a sense of violent motion and unrest.*

and jagged. If you want to make a certain color stand out, surround it with its opposite. If you want to make something seem beautiful, surround it with ugly objects. If you want to make something bright, surround it with darkness. If you want to make something seem alive, surround it with dead, inanimate objects. The unusual always stands out, and an artist should never lose sight of this fact.

Alternating Rhythms

Related to the principle of contrast is the theory of the rhythm of motion. Michelangelo is said to be the first artist who pointed out that all living creatures have a serpentine rhythm to their limbs and actions, and that this contrasting rhythm should be emphasized in order to make the living form seem alive. Look at the drawing in Figure 34. Note how the artist has placed accents first on one side of the limbs, then on the other, and how this seems to give a sense of energy and supple strength to the body. Notice how Guercino —in Figure 35—used these accents in a very different way to convey life. Seventeenth-century theorists compared this contrasting design to the flicker of a flame or the winding of a river through a plain, and maintained that without it a figure lacked life. Perhaps. In any case, if you find that your figures look wooden and lifeless, try placing accents or active lines along the edges in alternate contrasting rhythms, and see how this will change the effect.

As an exercise, take an 8"x 10" (or larger) photograph of a figure—with or without clothes—and draw in these accents along the contours. You will soon realize how the figure seems to come alive and to move. As an added application of this idea you can even control the direction in which a figure appears to move by placing accents in the direction of motion. (The past master in using accents in this way was Watteau.)

Consonance

Another useful and important principle of design is consonance. Often you will find that a picture you have painted lacks unity. One way to unite the elements of a composition is to take a design motif and work it into different parts of the picture. For example, a simple V repeated in the foreground, figures, landscape, and sky of a painting can appear to stitch together the different parts which otherwise would form a discordant and uncoordinated composition. This principle has been illustrated in a number of the pictures analyzed in the text. If you have trouble producing unified compositions, it might be a good idea to try this method.

A final point to remember. For some reason, the human being craves equilibrium, order, and symmetry in what he sees. This does not mean that you *must* try to incorporate these features in your painting; but if you do not incorporate them, you should have a good reason for not doing so. Your viewer does not like to be upset or excited unless there is a reason.

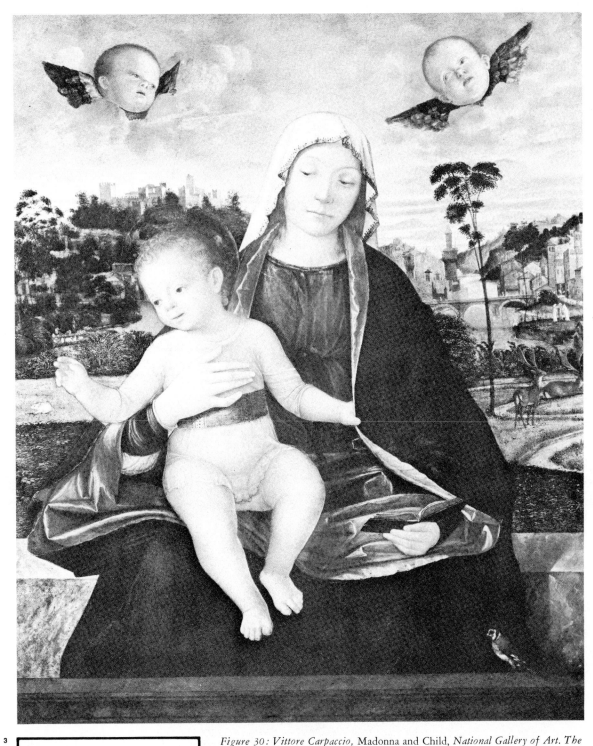

Figure 30: Vittore Carpaccio, Madonna and Child, *National Gallery of Art. The pyramid design creates stability and security.*

Figure 31: Domenico Veneziano, Saint John in the Desert, *National Gallery of Art. The jagged forms give an impression of hardship and pain.*

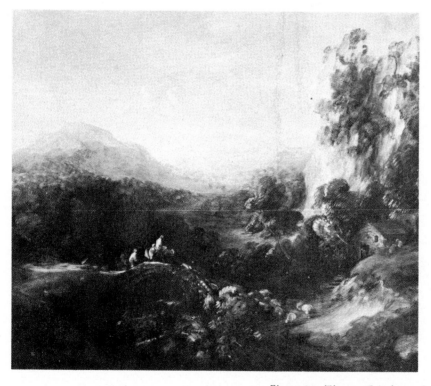

Figure 32: Thomas Gainsborough, Landscape with a Bridge, *National Gallery of Art. The rounded shapes create a mood of peace and calm.*

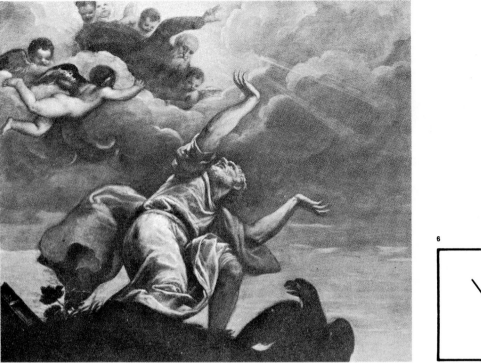

Figure 33: Titian, Saint John the Evangelist on Patmos, *National Gallery of Art. The V-design creates upward motion.*

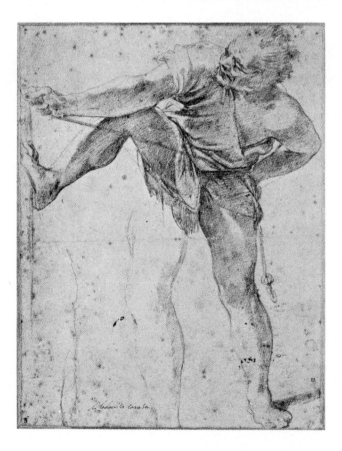

Figure 34: Lodovico Carracci, Man Pulling on a Rope, *Chatsworth Settlement, England. Study the alternating rhythm of the standing leg.*

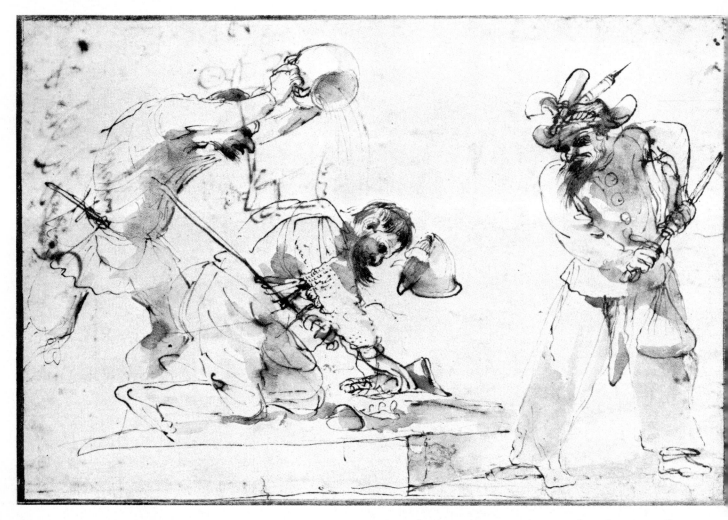

Figure 35: Guercino, Satirical Subject with Characters from the ''Commedia dell'Arte,'' *Chatsworth Settlement, England. Note how the dark accents emphasize important features.*

6 Studying Old Master Techniques

"ET YOUR TECHNIQUE be so perfect," advised a medieval Chinese master, "that neither you nor those who look at your painting are aware of it." In other words, technique should be second nature, as spontaneous as breathing, a tool in your hands so perfectly attuned to your needs that you never have to give it a thought. Most of the artists represented in this book were so expert in their craft that they could afford the luxury of treating techniques in this manner. Perhaps one of the fundamental lessons to be learned from the history of art is that the great masters were invariably experts in their craft. A few experimented and occasionally made mistakes, but none were incompetent.

Not all of the media used in Western art are discussed in this chapter. The main stream of painting in Europe and America has centered around the tempera and oil techniques and the various combinations and refinements of these two. Watercolor, on the other hand, has a separate development, which is important for the history of art but which will not be discussed in this book.

Tempera

Historically speaking, the oldest medium is tempera. The pigments are mixed with the yolk—or the yolk and white—of an egg and usually combined with either water, varnish, or a combination of these ingredients. The first examples of tempera come from ancient Egypt, and the technique was widely used by artists throughout the Greek, Roman, and medieval periods. Tempera has several important advantages. After the paint has been applied to the surface, it dries almost at once and the artist, therefore, does not have to worry about the drying time of his work, or about whether

the surface is too wet, or too dry, or too tacky. Changes can be made at any time. Another advantage is that tempera permits extremely fine work; a tempera line can be as thin as a hair and razor sharp. (Notice the fine lines in Figure 36.)

The disadvantages of tempera are, first, that it dries almost as fast as water, and therefore blending colors is difficult. The masters of the Early Renaissance usually "blended" by *hatching* fine brush strokes one over another, varied slightly in color or tone. (See Figure 37.) Second, since the colors are not the same when wet as they are after drying, the artist has to know beforehand exactly what color will result from a given mixture. Thus the masters of tempera were also masters of careful planning, knowing before they started precisely what colors should be placed where. This limitation tends to discourage spontaneity and the free development of a painting while it is being worked on. Although tempera, like watercolor, does actually permit great freedom of brushwork (see Figure 38, for example), very few of the early masters were interested in exploiting this aspect of the medium. Brush strokes were tight, small, and precise.

The chief reasons that Western artists began to abandon tempera for oil were the difficulty of blending tempera while wet—it simply dries too fast—and the fact that tempera lacks that glowing transparency which gives richness and depth to oil paintings. No matter how well tempera paint is applied, the surface stops the light and reflects it from the topmost layer. (See Figure 39.)

Oil Painting

About five hundred years ago, painting with oil gradually replaced tempera for two main reasons which

are still valid today. First, the oil colors could be made transparent, so that the light penetrated the outer layer and was reflected back from a lower surface, thus giving the luminous quality of enamel or a stained-glass window. (See Figure 40.) To judge the importance of this effect place a few pieces of colored glass, colored gelatin, or transparent plastic over a white surface, and observe the effect of the light reflected back from the layers underneath. This reflection gives the painting a third dimension, and greatly increases the range of expression available to the artist.

The second great advantage of oil painting over tempera is that colors can be blended much more easily because the surface does not dry at once. Depending on the oils used, the painting surface can be kept more or less fluid for several days. Therefore, the artist can combine colors, allow them to interpenetrate, and blend them in order to achieve an almost infinite range of subtle effects. (See Figure 41.)

Mixed Technique

A method preferred by many of the great masters— which today has regrettably fallen into disuse—is the so-called mixed technique. This combines the advantages of both tempera and oil. Working in this way, the artist can paint the intended picture first in a pale tempera monochrome, and then "glaze over" in oils with transparent veils of color.

Many of the pictures in this book were painted with this combined medium technique. It has the great advantage of separating the problems of drawing from those of color, and thus allows greater concentration on each problem.

Preparing the Materials

An important point to remember is that the old masters (painters who worked before about 1820) were closely involved with the process of preparing almost every item they used. The paints for oil or tempera were usually ground in the studio and prepared under the watchful eye of the master; even brushes were sometimes made in the studio. The supports, whether wood panels or canvas, were primed most carefully in the studio to give a suitable surface for the picture.

The actual process of painting was usually a methodical evolution, rather than a spontaneous act of creation. In the early stage, the artist carefully worked out the preparatory drawings, often down to the smallest folds of drapery. These drawings were usually supplemented by a color sketch, so that before the artist started, he would know almost precisely what he intended to do. The surface on which he was

planning to paint was often prepared with the finished picture in mind. For example, if the composition called for a placid sky, in the upper section the white undercoating would be applied to the canvas or panel in smooth, even layers so that no roughness would disrupt the impression of serenity. Conversely, if the artist planned a scene of battle, or a storm, the canvas or panel might be left with a rough texture. (Notice, for example, the rough surface of Figure 42, an expression of turbulence.) Thus the painting was taking form even before any paint or drawing had been applied.

This policy of evolving a picture from its earliest stages can be imitated by the modern painter. The next time you start an oil or tempera painting, try laying in the broad mass of your composition first in very thin layers of white, perhaps on a lightly toned canvas. You will start with a ghost of a picture, but the end result will have more structure.

Understanding the Medium

Another point to learn from studying the studio practices of great masters is the importance of knowing the exact characteristics of each pigment. Painters who ground their own pigments were much more aware of the essential qualities of each color than a painter who squeezes the same pigments out of a tube. Although the great masters had an intimate knowledge of the mediums and pigments they used—far more than painters during later periods—this intimacy did not breed contempt. On the contrary, the knowledge led to an exploitation in depth of the means available.

Today many students are taught to think strictly in terms of just one standard oil technique: pigments squeezed from tubes, mixed with cold-pressed linseed oil and turpentine. However, this is *only one of many ways* in which oils can be used. Mixed with sun thickened linseed oil, or stand oil and a resin varnish, for example, the paint can be applied in glazes, which gives a glowing transparency few modern painters have achieved.

The re-awakened interest in traditional techniques has prompted several of the leading art supply manufacturers to put on the market prepared mediums which can duplicate, to all intents and purposes, the effects obtained by the great masters of the Renaissance and the seventeenth century. I recommend that you try at least one of the glazing mediums, and one of the wax-oil-resin mediums available on the market, to find out what kind of effects can be obtained.

Technical Experiments

As an exercise, prepare a 2′ x 2′ Masonite panel cov-

ered with at least two layers of gesso and smoothed down with a fine sandpaper. (A prepared gesso panel may be used.) To make the gesso less absorbent, apply a thin layer of damar retouching varnish. Next, divide the area into ten equal rectangles, and use the following materials, one in each rectangle. (Remember to label clearly what oils and pigments you have used in each section.)

(1) Oil paint squeezed directly from the tube and applied without additional oils.
(2) Oil paint mixed with cold-pressed linseed oil.
(3) Oil paint thinned with turpentine.
(4) Oil paint mixed with stand oil or sun thickened linseed oil.
(5) Oil paint mixed with an oil-resin medium.
(6) Oil paint thinned with a glazing medium and applied in a *transparent* layer.
(7) Oil paint thinned to transparency with a glazing medium and applied over an underpainting made with an oil-wax-combination medium.
(8) Oil paint thinned to transparency with a glazing medium and applied over an underpainting made with egg tempera.
(9) Oil paint thinned to transparency with a glazing medium and applied over an underpainting of oil paint and cold-pressed linseed oil.
(10) Oil paint mixed with a glazing medium and applied over an underpainting consisting of a pen-and-ink drawing.

When you have finished this panel, take a canvas of the same size, and repeat the exercise.

Next, varnish half of each square on the two painting surfaces (when dry) with either damar or an equivalent synthetic varnish. This will enable you to judge the effect varnishing can have on a finished painting. When finished, you should have *forty* different examples of how oil paint can be used. I advise you to hang these two panels in your studio and study them carefully, remembering that each of the techniques demonstrated has been used in the past by at least one of the great masters. No one technique is better than another, but it is important that you find techniques which are best adapted to your particular needs.

Very few great artists of the past have been masters of more than one painting technique, because early in their careers they found out what type of painting was best suited to their temperament, needs, and ambitions. They worked within the framework of this medium, refining and developing it for the rest of their lives. I advise you to do the same.

Glazing Techniques

The old masters' glazing techniques exploited the fact that some pigments are transparent, some semi-transparent, and others opaque. If you intend to use a glazing technique, you must be careful about preserving the transparency of your colors in the areas where you plan to have this transparent effect. The traditional transparent pigments are: ultramarine blue; viridian green; burnt sienna; alizarin crimson; ivory black; and golden ochre. There are other transparent colors, particularly in the artificial chemical groups (like phthalocyanine blue), but these are newcomers to art.

If you want to check the relative transparence of pigments, squeeze out a little paint onto a pane of glass and hold it up to the light. You may be surprised to see that colors like cobalt blue, cadmium red, and Naples yellow will not allow any light to pass. However, almost any color can be made somewhat transparent if you add enough glazing medium; you may not get a crystal clear glaze, but you can produce a veil of color which may be useful.

A final point to remember after all this discussion on technique: many talented young painters have failed to achieve their potential stature as artists because they have become so involved in technique that they have failed to see the forest for the trees. Technique is, and always has been, a means to an end—never an end in itself. The history of art is littered with painters who have been past masters of technique, but have not gone beyond. If you find yourself in danger of becoming too involved with technique, pause and ask yourself whether you are confusing the means with the end.

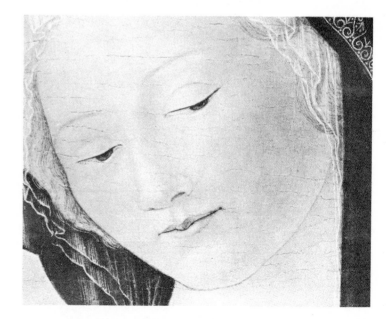

Figure 36: Neroccio de' Landi, Madonna and Child with Saint Anthony Abbot and Saint Sigismund *(Detail), National Gallery of Art. The tempera technique permits very fine and precise lines.*

51

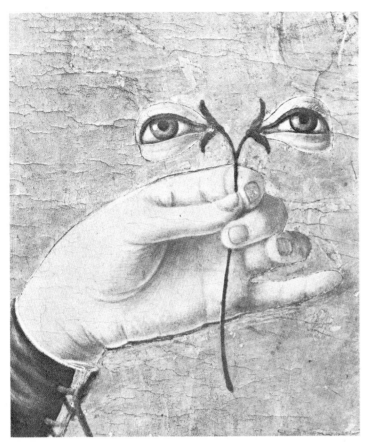

Figure 37: Francesco del Cossa, Saint Lucy *(Detail), National Gallery of Art. Tempera colors are blended by using overlapping brush strokes.*

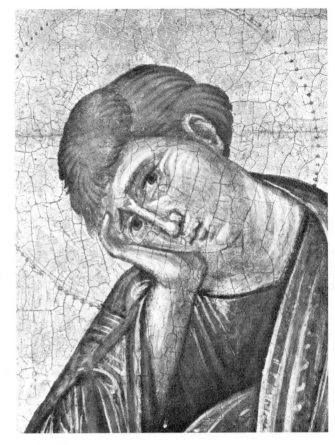

Figure 38: Master of the Franciscan Crucifix, Saint John the Evangelist *(Detail), National Gallery of Art. Tempera brush strokes can be free and fluid.*

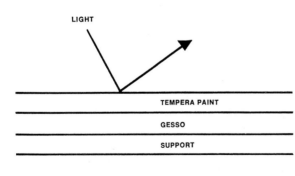

Figure 39: The light is reflected from the surface.

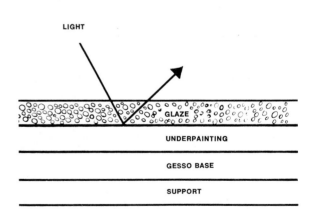

Figure 40: The light penetrates and is reflected from the underpainting.

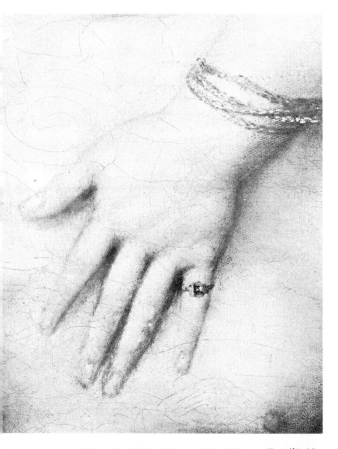

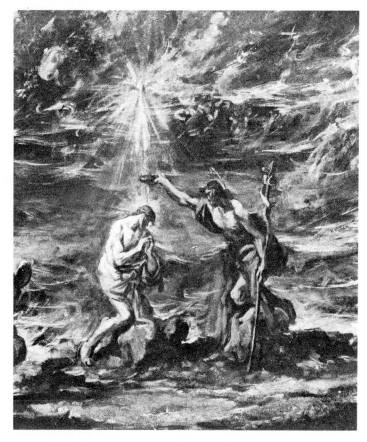

Figure 41: Titian, Venus with a Mirror *(Detail), National Gallery of Art. Layers of glazes and slow drying permit a great range of modeling refinements in oils.*

Figure 42: Alessandro Magnasco, The Baptism of Christ *(Detail), National Gallery of Art. Both the underpainting and the first coating express turbulent action.*

Figure 43: To achieve maximum transparency, the particles of pigment must be suspended.

Figure 44: Transparency is usually lost if the pigment settles in a solid mass.

Figure 45: Unknown Florentine, Uffizi, Florence. Quick sketches of ideas.

54

7 Advice from the Great Masters

THE CREATIVE PROCESS is a subject which involves every artist. From literary sources we can reconstruct the thoughts of many great masters on this all-important phase of their work.

The Artist's First Fire

There are frequent references to the "first fire" of the artist's imagination, and the importance of preserving this flash of imagery in a quick sketch. The sudden vision of the inner eye was a recognized phenomenon to painters as far back as Michelangelo's age. Every painter knows that there are times when his imagination is triggered—either by something he sees, or by some chance encounter, or by an emotional experience—and that during this time he sees images with crystal clarity.

It is a peculiar form of heightened perception. In a split second the artist creates pictures in his imagination, and in another moment they are gone. There is, however, a memory image left; it is very important for an artist to get into the habit of trying to recapture as much as he can of these fleeting visions. This is the time when he seems to be attuned to something higher than himself, and these are the images which artists, from time immemorial, have defined in one way or another as "inspiration."

Sisley, the French impressionist, once said that his landscapes were little segments of the world with which he had fallen in love. The irrational and sudden impulse to keep a vision forever is a part of the creative process and should not be discarded. For centuries the Chinese have regarded the brief moments when an artist sees images in his mind's eye, as times when the painter is in tune with the "Tao," the mysterious harmony or rhythm which activates all nature. Maybe. In any case, these mental pictures are the heartbeat of the artist and, without them, the desire to become an artist probably would never take root.

Because it is necessary to capture images, it is important to have paper and pencil always with you, day and night. Many artists evolve a sort of personal shorthand for remembering their mental pictures: a few lines, a few color notes, a few accents—and at least the shadow of the original moment is preserved. (See Figures 45 and 46.)

Sequence of Creative Processes

The second stage in the classic creative process is translating the image of the inner eye into a workable preparatory sketch. The cold light of reason is applied to the fugitive image of the "first fire" and the painter tries to work out the composition in detail. This is usually done with drawings. (See Figure 47.) The great masters sometimes made dozens of preparatory drawings in order to arrive at solutions which pleased them. After settling the broad areas of composition to their satisfaction, they worked out drawings of individual figures and other elements. Then they made more preparatory drawings of hands, heads, folds in drapery, cloud formations, trees in the landscape. (See Figure 49.) Color notes were frequently included in these drawings. (See Figure 48.) By the time they had finished their drawings, the picture was finished except for the actual painting.

Having secured approval from patrons and trusted advisers, the design was transferred to canvas, and the actual painting started. (See Figure 50.) The first stages were often in monochrome (one neutral color), and later the artist would add glazes, planned accents, and impasto highlights.

Nine out of ten pictures in this book were conceived

and painted more or less in this way. This is the classic process of creating a painting. It is the tried and tested method.

Spontaneous Evolution

There is another entirely different process of creating a painting, which also has been followed by many great masters. It is based on the fact that there are always unknowable elements in any work of art, which the artist *feels* rather than plans. He creates without really knowing how or why he has arrived at a particular solution.

Since antiquity, both theorists and artists have recognized this unknowable element. Leonardo spoke of being inspired by the stains on a crumbling wall. Medieval Chinese artists spoke of the marvelous effects which flinging ink on the silk could produce. Eighteenth-century French philosophers listed the *je ne sais quoi* (I-don't-know-what) as an integral and important element in painting. Recently, many psychologists have found that "happy accidents" in painting are keys to understanding hidden emotions and deep lying personality traits.

A painter applying these ideas begins by painting directly on his canvas or paper, without any preconceived idea of what he wants to express or represent. The first stages are usually kept fluid and vague. As the painting progresses, certain ideas and images are suggested. The painter refines and develops these, painting out what he doesn't want, and adding to and building up what appeals to him. In due course, the picture emerges from the amorphous ganglion of happy accidents, and can be carried as far as the painter wants. It might even end up as a completely realistic scene with fine detail.

This process of painting has an honored past. Turner at times used it, also Renoir, and probably Rembrandt. More recently, Paul Klee, Tanguy, Max Ernst, Arp, Jean Miró, and the abstract expressionists have used variations of this system. I suggest that sometime, if you have not already tried it, you experiment with this process. It requires imagination, control, an ability to improvise, and of course an ability to draw.

Importance of Drawing

There is one point about which the great masters have been unanimous: the importance of drawing. Those who have expressed themselves on this subject have stressed the fact that drawing is the first tool of the artist's trade. Without skill in drawing, the painter is lost. It is the means by which he arrives at his goal. Go through this book, and try to realize what these paintings would have been like if the different artists had

not been good draftsmen. They would never have qualified for this book in the first place.

The great artists, and the good artists, were drawing continuously. They thought and created in terms of drawing. Therefore, never be without a pencil and paper. Once a week, if you can, attend a life class. Throughout the history of Western art, the human body has been the touchstone of an artist's drawing ability. It is the most difficult subject he can hope to interpret, and if he can draw a good nude, he can draw anything.

Marriage and the Artist

Theorists during the seventeenth and eighteenth centuries debated whether an artist should be married. The simile used was that an oak tree never grows to its full height if it is encumbered by clinging vines. The profession of painting, they argued, was an all-consuming one, and an artist should not divide his loyalties.

Of the artists represented in this book, about one third were unmarried, probably a higher percentage than the average in any other profession. The reasons for this lie partly in the realm of psychology, but a strong contributing factor is the desire of artists to remain free of everyday routines. The creative impulses are unpredictable, and there is no assurance that they can be dovetailed into domestic life.

Evaluating Criticism

Other people's opinions of what you are doing can be of decisive importance. An artist tends by nature to be sensitive, and criticism can have long lasting and profound effects, often out of all proportion to the worth of the opinions given.

The study of art history indicates that the best policy is to ignore unsolicited advice while you are working on a painting. A painting is the result of an intimate association between you and the spirits of your inner eye; a third party present at the meeting is unwelcome and disruptive. The creative process does not need a chaperone. Once the picture is completed, again there will be criticism, and the history of art also provides interesting sidelights about how the great masters reacted to criticism. In general, they listened, but did not change their course.

During most of the epochs covered by the pictures in this book, a critic who was not also a practicing artist would have been laughed at and given the classic rebuff "Shoemaker, stick to your last." During the eighteenth century in France, a few distinguished literary figures began to write criticisms of painting exhibitions, basing their claim on the theory that all forms of art were governed by similar principles. During the nine-

teenth century the privilege of criticism was extended to many other groups. Today almost anyone can claim to be an art critic, and get incensed if the claim is challenged.

The artist, therefore, works in a glass house, and anyone, with or without qualifications, can throw stones at him. Again, the best advice is to listen, weigh the worth of the critic, but in general not be thrown off your course. Always remember that criticism is as much an examination of the knowledge and perception of the critic as it is of the work being criticized.

Remember also that your picture will be bought, and looked at, probably by someone who has no training in art, and therefore it is important to know what the *layman* thinks. There are many stories in art history about painters who made arrangements to eavesdrop on the public when their pictures were put on exhibition. What a person will say to a close friend about art, and what he will say for the record, are often widely separate.

Judging from the history of art, practicing painters generally do not make good critics. Although convinced that they are impartial, subconsciously they always see the art of others in terms of their own work, and are attracted by features which reflect their own accomplishments. Professional critics also, from a study of history, have a spotty record. More often than not they have overlooked the painters who subsequently have emerged as the key figures of their generation. Many artists live in terror of what professional critics will say about their work, and it is true that a good review can result in good sales. Some critics believe it is their mission to educate the public; others feel they should educate the artist. In either case, the long range benefits are doubtful.

There is a third source of criticism which is more important than the first two. Many great painters in the past have cultivated one or more persons who could follow their artistic thinking with insight and understanding. Sometimes they were members of the family, sometimes fellow artists, sometimes servants, or friends. Usually they were persons who had been closely associated with the artist for years. Such a person can be like a guardian angel to the artist, and criticism from this source can be trusted. It is one of the most valuable assets an artist can have. Every painter should try to find such a familiar spirit, and treasure the judgments of that person.

Reaching Your Audience

When painting, an artist should always remember that he is communicating something to another person. The artist who claims to be painting only for himself, or herself, is daydreaming. The audience may not be born yet, but it must exist. Since you are speaking to others, try to make your statements interesting. In other words, say something worth saying and don't say it too often or too loud. To be boring in paint is like being boring in any other form of communication. For the painter, however, an audience is never captive, because the viewer can always shut his eyes. Therefore a painter has to be even more careful than a musician or a lecturer. You may hold attention by novelty or technical trickery, but this is only a short term policy. Shock for shock's sake is annoying, and technique for technique's sake is boring. "Read a hundred books, paint one picture," is an old Chinese saying, which may or may not apply, but the idea is sound. Think of a good reason for painting before you begin a picture. The artist who works without thought is "like a squirrel in a wheel cage," said a seventeenth-century writer on art, and this observation is still true today.

Writers on art during the Baroque period used to compare painting to speaking. A good speaker can hold people's attention by using the right words, altering the timbre of his voice, giving meaningful inflections, timing his phrases for best effect, making use of pauses, emphasizing important points with gestures; most important, the speaker should say something worth hearing. A painter, they argued, should do the same. This theory is worth careful thought. Make your picture a worthwhile experience for your spectator so that he will explore it with pleasure and excitement. Give him wonderful harmonies of color, fascinating suggestions of space, compelling accents to lead his eye, subtle challenges to his imagination. Make him want to come back and retrace his optical journey with renewed pleasure. Make him catch his breath; this way he will remember your work and search for other works by you with keen anticipation. Bore him, and he is gone.

Undefinable Elements

One final point. When evaluating criticism, remember that the most important aspects of art can never be expressed in words. There is a mystery about great painting which is closer to magic than to logic, and which can never be imitated or fully explained.

The study of art history began as a means of helping artists. It was thought that by analyzing the lives and works of great masters, certain keys to success and greatness could be found, and that artists could profit from the knowledge. In time, art history evolved into an independent discipline, more closely allied to cultural history. However, the original concept is not outmoded or dead. This book is an effort to return to an earlier principle.

Advice from the Masters

Most great artists left very few spoken or written records. However, there are contemporary sources, both first and second hand, which give valuable insights into a painter's working methods.

Cennino Cennini (c. 1365–1440)

"Now, you of noble mind, who love this profession (of painting), be guided by these basic principles: love (of art), respect for it, willingness to abide by the rules, and perseverance. As soon as you can, place yourself under the guidance of a master and remain with him as long as possible."

"Know that painting cannot be learned in less time than the following. First of all, you must study drawing on paper for at least one year. Then you must remain with a master in his studio, a master who understands all aspects of art. You must begin by grinding the colors; learn to boil the glues; learn the technique of laying grounds on panels and to work in relief upon them; you must learn how to rub the panels smooth and how to lay on gold leaf and how to incise designs in them. This will take you six years. Next, you must learn the art of coloring: to embellish with mordants; to make golden raiments; and to learn the art of mural painting. This will take at least six more years. But all this time you must always keep drawing without interruption, both on holidays and on workdays. In this way, through long habit good practice becomes second nature."

(The Book of Art)

Leon Battista Alberti (c. 1404–1472)

"Since an outline or contour is nothing else but drawing the edge around a shape, if this is done with too heavy a line the effect will be that there is a break, rather than an edge of a surface. I would recommend that, when drawing a contour, the artist confine himself to making an exact outline and nothing else. I assure you that in this respect the greatest care must be used. . . . A good drawing—that is, a good outline—is often a very pleasing thing in itself."

"A mirror is a good judge for you to have. It is marvelous how every weakness in a painting is so clearly revealed in a mirror."

(On Painting)

Leonardo da Vinci (1452–1519)

"Painting is concerned with all the ten attributes of sight: darkness and light, solidity and color, form and design, distance and nearness, motion and rest."

"The young student should learn about perspective, so that he will be able to give each object its proper placement. Next, he should put himself under the guidance of a good master, so that he will gradually acquire an ability to draw the different parts of the human body. Next, he must study nature, in order to fix in his mind and understand the reasons for the various precepts he has learned. He must also spend time looking at the works of the masters, so as to train his eye and his judgment. In this way he will be able to put into practice what he has been taught."

"A painter who has no doubts about his own ability will attain very little. When his work exceeds his judgment, the artist learns nothing. But when his judgment is superior to his work, he will never cease to improve, unless his love of money interferes or retards his progress."

(A Treatise on Painting)

Albrecht Dürer (1471–1528)

"He that would be a painter must have a natural ability for it."

"Love and pleasure in painting are better teachers than compulsion."

"If a man is to become a really great painter, he must be trained for it from his very earliest years. He must copy much of the works of good artists until he has acquired the ability to draw easily."

Raphael (1483–1520)

(As recorded by Giorgio Vasari [1511–1576], *The Lives of the Painters*) "[Raphael] knew that equal attention should be given to the hair and the head of figures, as well as to vases, trees, rock formations, fires, atmospheric effects, either stormy or serene, to clouds, rain, tempests, to the darkness of night, to the moonlight, to sunshine, and to an infinite variety of other subjects. It was his belief that painting required that the right amount of attention should be given to a great variety of different objects."

Fra Angelico (1387–1455)

(As recorded by Giorgio Vasari, *The Lives of the Painters*) "[Fra Angelico] used to say that he who practices

the art of painting must have quiet, and should live without cares or anxious thoughts."

"It was the custom of Fra Giovanni to abstain from retouching or improving any painting once he had finished it. He would not alter anything, but left all as it was done the first time, believing, as he said, that such was the will of God. It is also said that he would never take his pencil in hand 'till he had first offered a prayer."

Jacopo Tintoretto (1518–1594)

(As recorded by Carlo Ridolfi [1594–1658], *On the Marvels of Art*) "Tintoretto used to say that painting was hard work, and it became more difficult the more a painter learned about it. He said that young students, if they wanted to profit, should never depart from the path laid out by the great painters, especially Michelangelo and Titian, the first being a marvelous draughtsman, and the second a marvelous colorist.

"When asked which were the most beautiful colors, he said black and white, because the first gives force to the figures by deepening the shadows, and the other gives a sense of form.

"And he said that whereas beautiful colors were sold in the art stores along the Rialto, drawing was only to be learned from the box of talent, and that it required a long study, often late into the night, and therefore drawing was practiced and understood by only a few painters."

Jean-Baptiste-Camille Corot (1796–1875)

"I pray every day that God make me like a child, that is to say that he will let me see nature in the unprejudiced way that a child sees it."

"In a painting there is always one luminous point; but this point must be one of a kind. You may place it wherever you wish: in a cloud, in the reflection of the water, or in a hat. However, there must be only one single point with this degree of brightness."

"I work on all parts of my painting at the same time, improving it very slowly until I find that the effect is complete."

(*From his correspondence*)

Camille Pissarro (1830–1903)

". . . Sometimes I am terribly afraid to turn around canvases which I have piled facing the wall; I am always afraid of finding monsters where I thought there were precious gems. . . ."

"Painting, art in general, enchants me. It is my life. What else matters? When you put all your soul into a work, all that is noble in you, you cannot fail to find a kindred soul who understands you, and you do not need a host of such spirits. Is not that all an artist can hope for?"

(*From a letter to his son Lucien*)

Édouard Manet (1832–1883)

"Color is all a question of taste and sensibility. You must have something to say—if not, you might as well pack up. One isn't a painter if one doesn't love painting more than anything else in the world, and it isn't enough to know your job; you've got to be excited by it. . . ."

"To be concise and short in painting is both necessary and in good taste. The man who is concise makes one think; the talkative man just irritates you. . . . Also, train your memory, for nature will never give you more than hints."

(*Portrait of Manet, by Himself*)

Auguste Renoir (1841–1919)

"I arrange my subject as I want it, then I go ahead and paint it, like a child. I want a red to be sonorous, to sound like a bell; if it doesn't turn out that way, I add more reds and other colors until I get it. I am no cleverer than that. I have no rules and no methods; anyone can look at my materials and watch me as I paint—he will see that I have no secrets. I look at a nude; there are thousands of tiny color tones. I must find the one that will make the flesh on my canvas live and quiver. Nowadays they want to explain everything. But if they could explain a picture, it wouldn't be art. Shall I tell you what I think of the two qualities of art? The first is that it cannot be described in words, and the second is that it can never be imitated. . . . A work of art must seize you, wrap you up in itself, carry you away. A painting is the means by which an artist conveys his passions; it is the current which he puts forth which sweeps you along in his emotions. . . ."

Paul Gauguin (1848–1903)

"Go on working, freely and furiously; you will make progress, and sooner or later your worth will be recognized, if you have any. Above all, don't sweat over a picture. A strong emotion can be jotted down at once: dream about it and seek to express it in its simplest form."

(*From a letter to Emil Schuffenecker*)

Robert Henri (1865–1929)

"[The art student] never studies drawing simply because it will come in useful later, when he is an artist. He has no time for that. He is an artist in the beginning and is busy finding the lines and forms to express the pleasures and emotions with which nature has already charged him. . . ."

"The great artist has not reproduced nature, but has expressed by his extract the most choice sensation it has made upon him."

"A teacher should be an encourager. . . ."

"An artist must have imagination. . . ."

"An artist who does not use his imagination is a mechanic."

(From an address to the students of the School of Design for Women in Philadelphia—1901)

Wassily Kandinsky (1866–1944)

"A work of art consists of two elements, the inner and the outer. The inner is the emotion in the soul of the artist; this emotion has the capacity to evoke a similar emotion in the observer."

"The artist's life is not one of pleasure. He must not live irresponsibly; he has a difficult work to perform, one which often proves a crown of thorns. He must realize that his acts, feelings, and thoughts are the undefinable but fundamental material from which his work is created; he is free in art, but not in life."

"The artist is a king, . . . not only because he has great powers, but also because he has great obligations."

(Concerning the Spiritual in Art)

Henri Matisse (1869–1954)

"Thus it is that simple colors can act upon the inner feelings with all the more force because they are simple. A blue, for instance, accompanied by the shimmer of its complementaries, acts upon the feelings like a sharp blow on a gong. The same with red and yellow; and the artist must be able to sound them when he needs to."

(La Chapelle du Rosaire)

Lionel Feininger (1871–1956)

"Monumentality is not attained by making things larger. How childish! But by contrasting large and small in the same composition. On the size of a postage stamp one can represent something gigantic, while yards of canvas may be used in a smallish way and therefore wasted."

(From his correspondence)

Pablo Picasso (1881–)

"I do a picture—then I destroy it. In the end, though, nothing is lost: the red I took from one place turns up somewhere else. . . ."

" . . . Basically a picture doesn't change; the first 'vision' remains almost intact, in spite of appearances. . . ."

"A picture is not thought out and settled beforehand. While it is being done it changes as one thoughts change. And when it is finished, it still goes on changing, according to the state of mind of whoever is looking at it. A picture lives a life like a living creature, undergoing the changes imposed on us by our life from day to day. This is natural enough, as the picture lives only through the man who is looking at it. . . ."

"When you begin a picture, you often make some marvelous incidental effects. You must be on your guard against these. Destroy them, and do the passage over several times. Each time he destroys an incidental effect, the artist does not really suppress it, but rather transforms it, condenses it, and makes it more substantial. What comes out in the end is the result of discarded finds. Otherwise, you become your own connoisseur. I sell myself nothing. . . ."

"Actually, you work with only a few colors. But they seem like a lot more when each is in the right place."

(From an interview by Christian Zervos.)

Georges Braque (1882–1963)

"I would much rather be in harmony with nature than copy it."

"In art there is only one thing of value, that which cannot be explained in words."

(Aphorisms)

Figure 46: Raphael, Studies for a Painting of the Madonna and Child, *Albertina, Vienna. A great master tries out some ideas.*

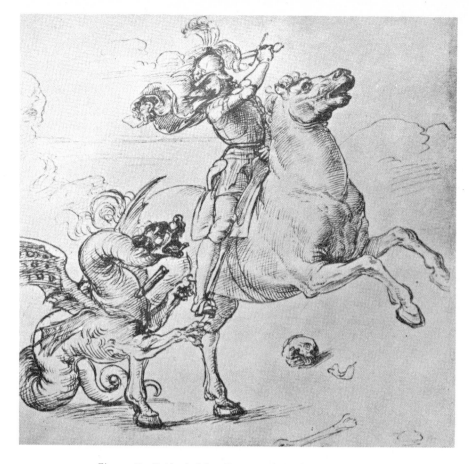

Figure 47: Raphael, Saint George and the Dragon, *Uffizi, Florence (Drawing for picture now in the Louvre). The original idea is worked out in detail.*

Figure 48: Pieter Bruegel The Elder, Sketch of Peasant with Color Notes, *Liechtenstein Collection, Liechtenstein. Color notes and outlines give most of the necessary information.*

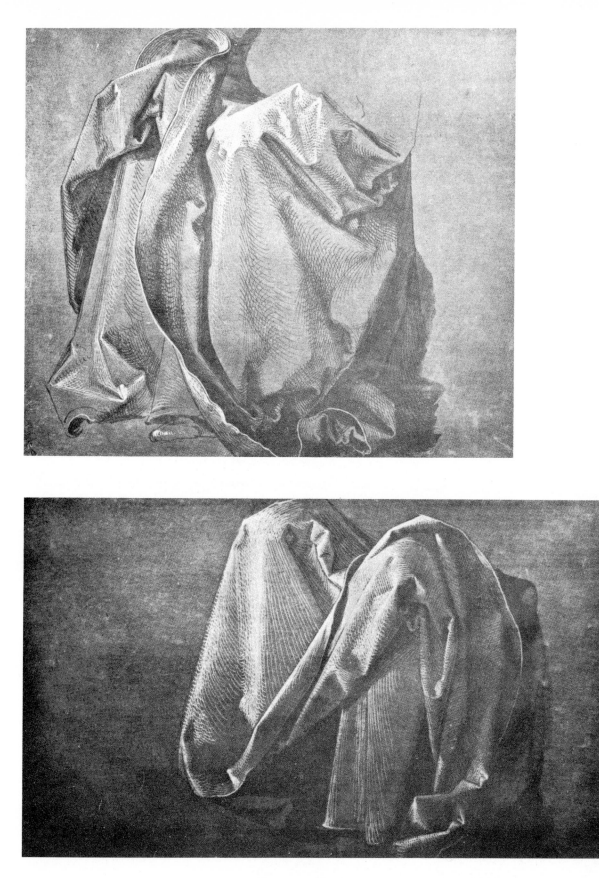

Figure 49: Albrecht Dürer, Drapery Studies, *Albertina, Vienna. Exact preparatory drawings.*

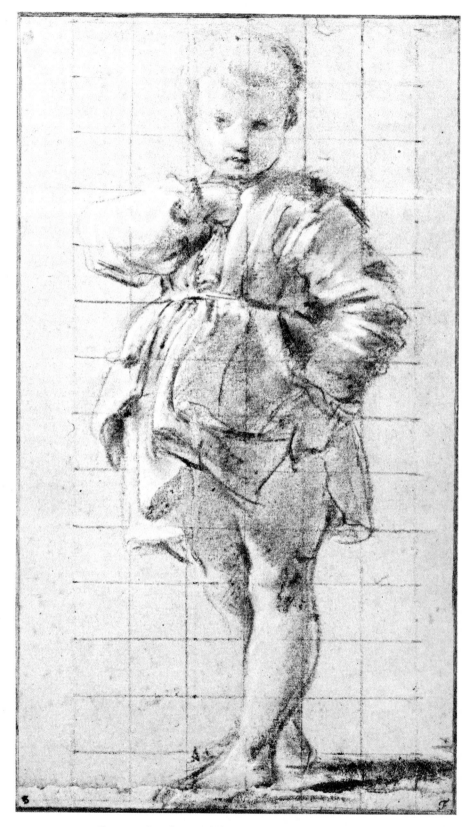

Figure 50: Bartolomeo Schidone, Study of a Boy, *Chatsworth Settlement, England.
A finished drawing, squared for transfer to canvas.*

Color Plates

Detail no. 1

Detail no. 2

FRANCO-FLEMISH SCHOOL, EARLY XV CENTURY

PROFILE PORTRAIT OF A LADY
Wood, 20⅜ x 14⅜ in.
Andrew Mellon Collection 1937

In contrast to the profile portrait by Henner (see next page), this painting seems to justify the accusation that profiles do not show the more interesting aspects of a person's face. However, five hundred years ago a court painter was not paid to reveal the character or mood of his royal patrons. He was expected to record precisely how they looked, try to make a pleasing picture, and stop there. Look carefully at this princess. She might have been sixteen, or twenty-six, or thirty-six. She may have been a sweet and demure housewife, or a foul tempered tyrant who smiled when the headsman fulfilled her orders. One thing we do know. From the left side she looked exactly like this.

Portraitists occasionally overlook the fact that the profile changes less with the years than other aspects of the head. Study detail no. 1. Here—unless an accident or disease changes them—the following features will remain constant: A, the shape of the forehead; B, the section between the bridge of the nose and the forehead; C, the bridge of the nose; D, the position and color of the eye; E, the position of the ear; F, the relation of the lips to each other. Features which will probably change are: G, the end of the nose; H, the corners of the mouth; J, the line under the chin; and K, the length of the ears.

Therefore, a profile view is apt to be more timeless than a full-face or three-quarter view, and in the long run a more faithful and lasting record. The artist, in this case, was more interested in abstract design than he was in psychology. Note how the curve and counter-curve of the collar and the turban, and the gold chain balance and emphasize the rounded forms of the face, and thus ennoble the aristocratic lady's somewhat homely features and pasty complexion.

Although the profile looks as sharp as a knife, you realize by studying detail no. 2 that the edge has been slightly modeled, thus giving a sense of form and skin texture.

As an exercise, make a profile outline of the head of someone you know well. With the minimum of shading along the edge, see if you can convey the same sense of form as you see in this portrait.

66

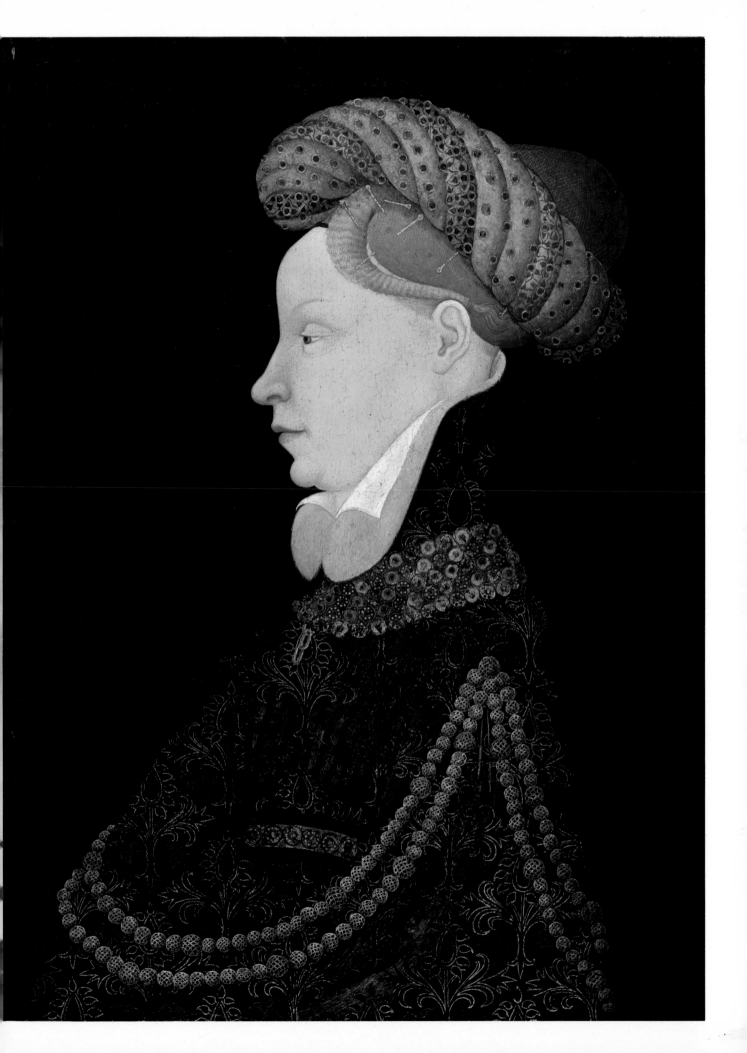

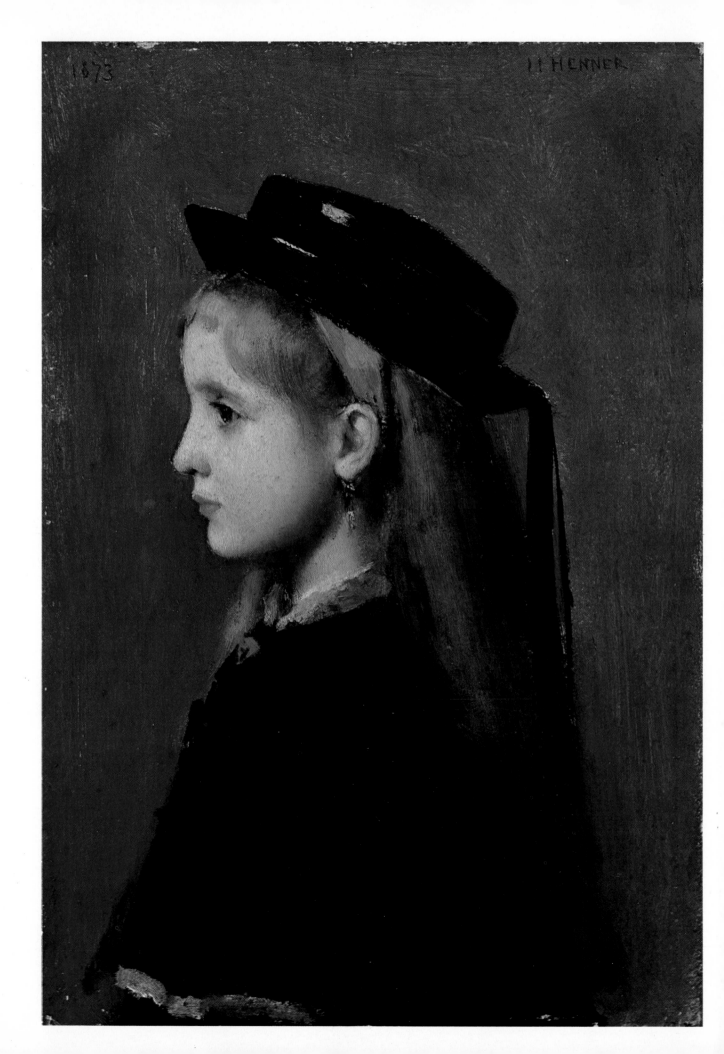

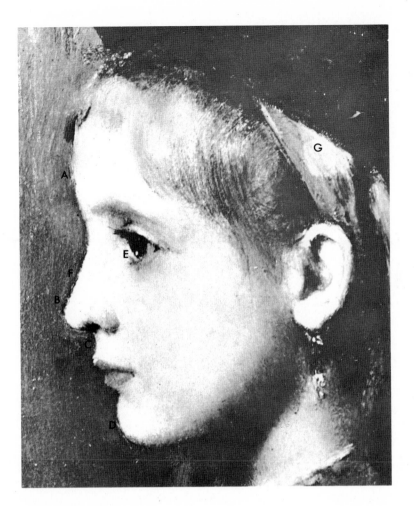

JEAN-JACQUES HENNER
French 1829-1905

ALSATIAN GIRL
Wood, 10¾ x 7⅜ in.
Chester Dale Collection 1962

It is often said that a profile portrait is undesirable because expression and mood cannot be shown. This portrait proves the contrary. Could a three-quarter or full-face view reveal more expression or produce a more telling portrait? Although the outline of the face seems consistently sharp in definition at all parts, there are slight variations which have an important effect on the total result. The forehead, for example, is slightly blurred at A; also the tip of the nose (B), upper lip (C), and chin (D). These irregularities give the effect of light being reflected, and also convey an illusion of slight movement. Second, the glistening highlights in the eyes (E) convey an impression of wide-eyed luminosity, and a wondering stare. Third, note the dark line outside the bridge of the nose which indicates a sharp edge (F). There is another unusual effect here. The head is placed further forward than one would expect in the picture format. In a subtle way, this gives the illusion that the Alsatian girl is walking slowly forward, lost in the world of her private thoughts.

Also notice that the flesh tones are nearly monochrome.

There are grays and blues along the edge of the jaw and over the eye, but the section in direct light is almost all golden yellow, with a few reddish brown halftones.

This was apparently painted very quickly, using an *alla prima* technique, (i.e., the colors are mixed on the palette and applied in their final hue directly to the canvas). The red hat band (G) is, of course, the key to the color scheme. Without this, the picture would still be good, but much less arresting.

Incidentally, Henner, who was the darling of the Victorians because of his alabaster-like nudes, probably had no idea that this quick sketch would be among his most famous works. The lesson to be learned is, don't throw anything away, and sign everything you do.

Make a profile outline of the head of someone you know well, either free hand or by tracing a shadow cast on a paper, or even by tracing a photo. Color the background a dark color. By modifying the outline in the way that Henner has done here, see how you can change the expression of the subject.

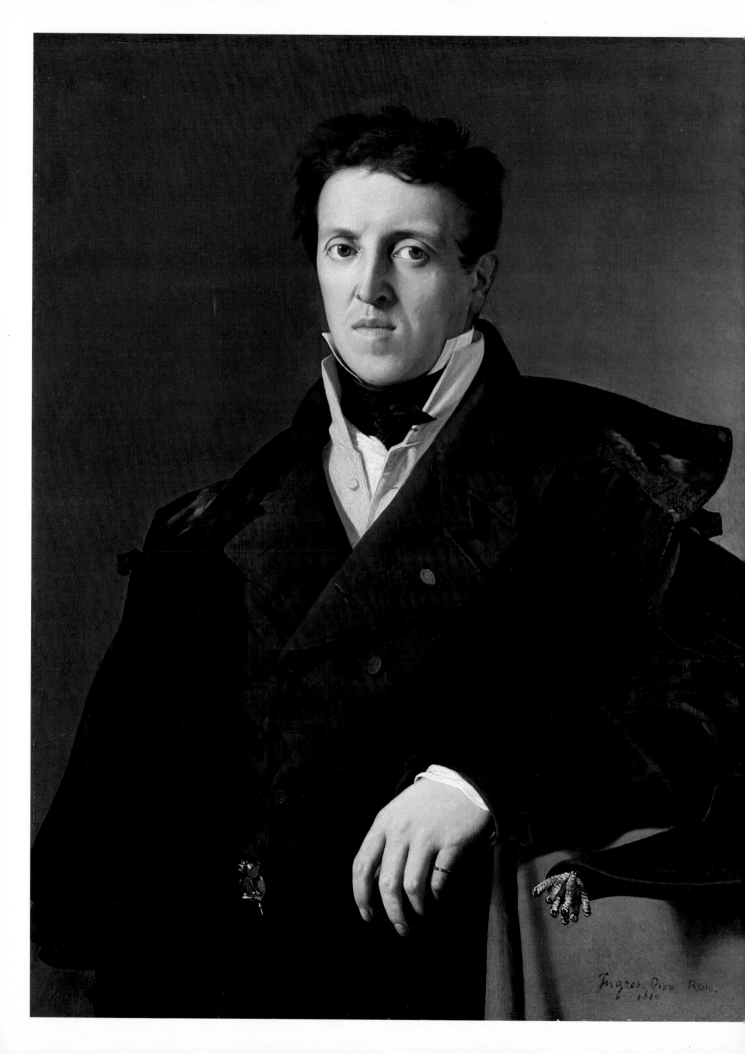

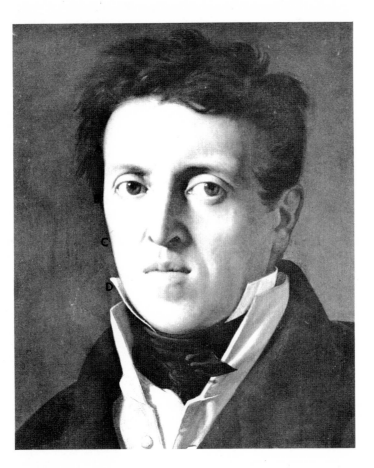

JEAN-AUGUSTE-DOMINIQUE INGRES
French 1780-1867

MONSIEUR MARCOTTE
Canvas, 36¾ x 27¼ in.
Samuel H. Kress Collection 1952

It is not easy to explain how Ingres was able to achieve such a startling illusion of three-dimensional forms by using only outline. And yet, both the theory and application of his method are simple. With a little practice and understanding, an artist can learn to apply this technique. To apply it with *success* may take longer. Stated very simply, Ingres varied the outlines according to the principle which is described in the Chapter on Line.

This is not what the camera, or any one-eyed creature sees, but it is a very subtle interpretation of stereo vision. Study the application of the theory in the detail. At A, notice the contour of the forehead. Seen at this angle the contour is quite indistinct and blurred. At B, the angle is sharper over the cheekbone; therefore, Ingres uses a harder line. At C the form is again rounded, as it was in A, and the line is correspondingly softened. At D, on the collar, the angle is very sharp, and therefore Ingres uses a knife-edged contour.

And so on. Study any part of this painting and you will see how consistently Ingres follows this principle. Add to this his mastery of light and shade, and the figure stands out with breathtaking realism.

As an exercise, get a Halloween mask made of rubber. Study the contours very carefully, and try to apply Ingres' principles to the face. If you are lucky, you will be able to convey a convincing impression of form by using outline only.

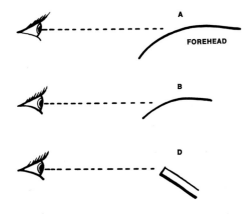

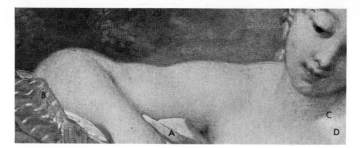

Detail no. 1

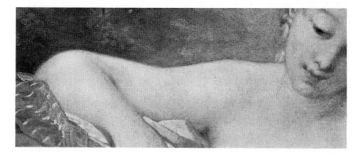

Detail no. 2

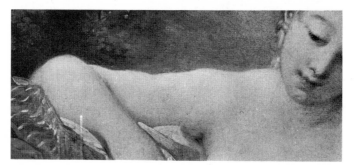

Detail no. 3

FRANÇOIS BOUCHER
French 1703-1770

VENUS CONSOLING LOVE (*slightly trimmed*)
Canvas, 42⅛ x 33⅜ in.
Gift of Chester Dale 1943

If you have an interest in portraying women, you would benefit by studying Boucher's work carefully, because in the long history of art he was the most successful in conveying the essential femininity of women. Obviously, the peaches-and-cream complexion and the rosy, dimpled flesh are part of the appeal of Boucher's painting, but there is much more to it than simply this. Study detail no. 1. First, note that the outlines of the flesh area are softened, so that the body almost appears to be covered with a downy fuzz. The fact that there are no shiny highlights strengthens this impression. To emphasize the softness, note how Boucher occasionally introduces a hard line (A and B) next to the skin. Third, note that all the contours of the body are gentle curves. Where one might expect a sharp fold in the skin (C), or a bone projecting near the surface (like the collarbone at D), Boucher simply paints over the area, cancelling out any shadow. The result may be a figure so plump and soft that it looks like a pillow, but this was what Boucher wanted, and this is what has appealed to so many people over the centuries.

The last and most subtle point is the rhythm of the outline. In detail no. 1 note that the line along the top of the arm has a gentle and essentially feminine quality. It is not too even, and the interval and height of the different curves are interesting and attractive.

Now, supposing this contour were simplified into the form shown in detail no. 2; this would have an appeal perhaps, but the contour would lose some of its grace. Now look at detail no. 3: this has become gross and faintly vulgar, although perhaps it is more accurate. This handling conveys the impression of a thin skin and bony body, which may be appropriate to a virile man, but is unattractive in a woman.

As an exercise, draw the outline of three identical figures. Alter one to make it seem virile, active, and strong. Alter the second one to make it resemble Boucher's figure, graceful, soft, and rather plump. Alter the third outline to make the figure appear coarse and gross.

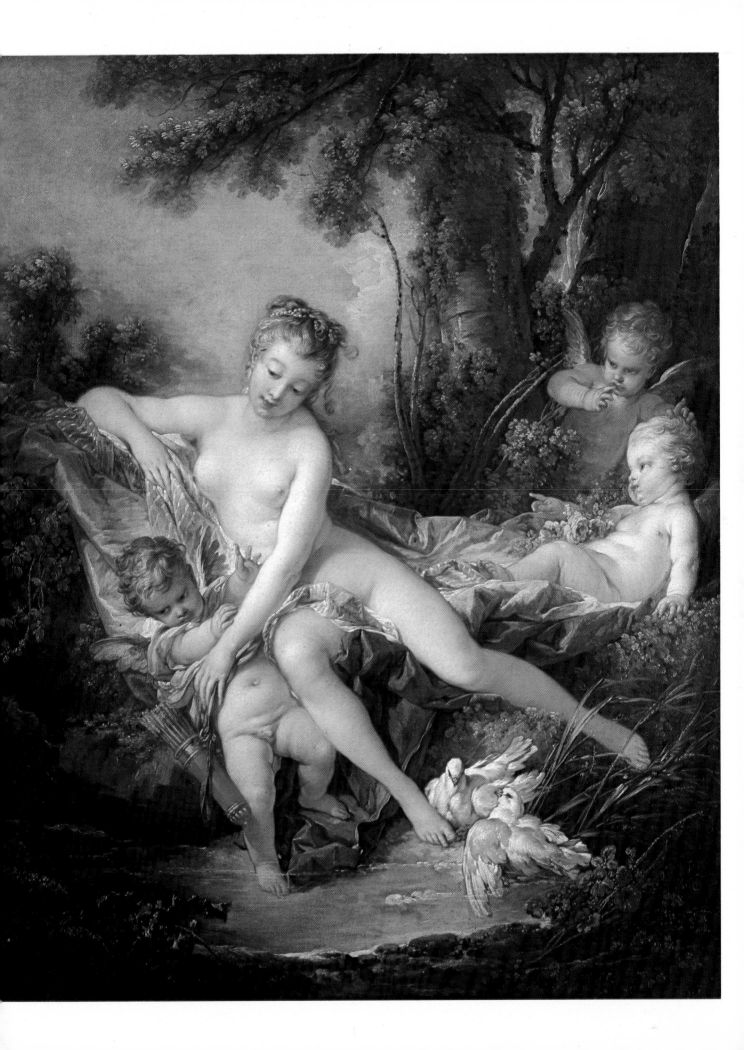

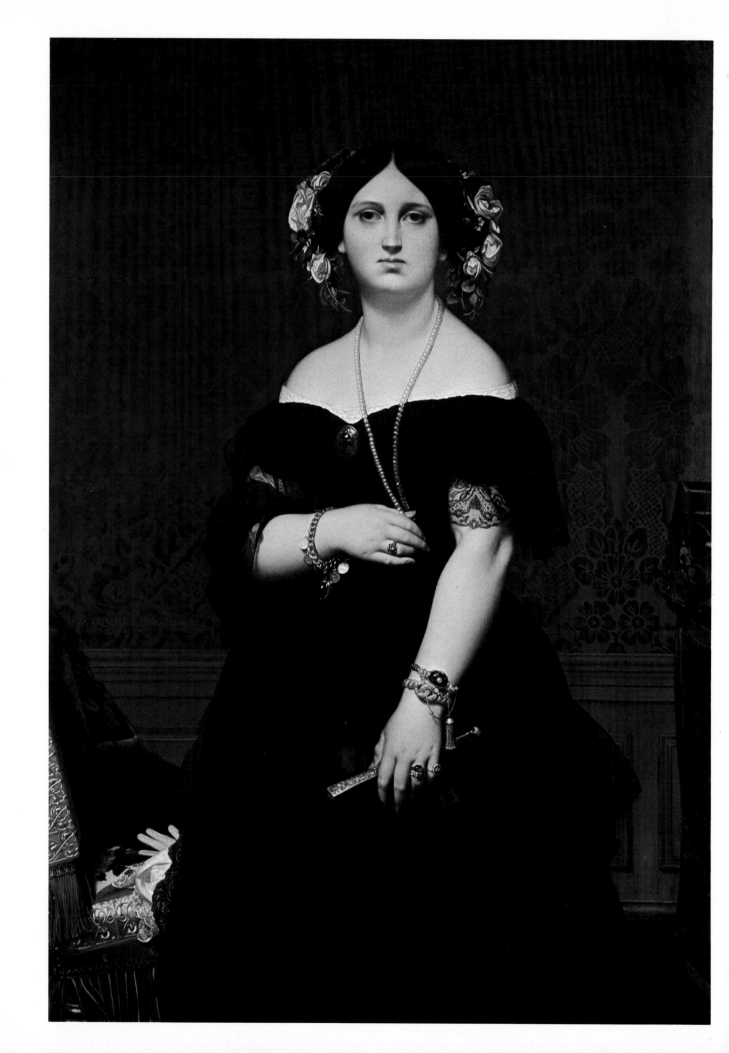

JEAN-AUGUSTE-DOMINIQUE INGRES
French 1780-1867

MADAME MOITESSIER
Canvas, 57¾ x 39½ in.
Samuel H. Kress Collection 1946

A contour outline, if used with absolute mastery, can record both the form and texture of any object so accurately that there is little need for any other modeling. Ingres believed this, and his paintings prove the point. First note that, since the source of light is behind you (the viewer), there is little shadow. This kind of light generally tends to flatten forms. Yet, in spite of this, the illusion of three-dimensional form is very convincing. For example, you have no doubt about the shape of the forearm (A) or back of the hand (B). This is because the contour is so subtly modeled that you instinctively know what happens in between. The different shapes of the edges of the arm are explicit. For example, at C the outline is almost lost and you know that this is a very well-rounded form. On the other side, at D, the line is sharper, and you know that the edge is slightly less rounded. Further down the arm, the line hardens at the wrist bone (E). At F the line is again soft, and at

G—on the thumbnail—very sharp. This is not all that Ingres can do with a line. Look at the jewelry. The highlights on the ruby are as sharp as a razor's edge (H). Next to this the gold mounting seems soft (J), and the filigree ring (K) seems even more fragile and delicate.

"Drawing is the touchstone (probity) of art," Ingres once said. And again: "An artist can learn all there is to know about color in an afternoon." From the historical point of view neither of these statements is wholly true; however, it is safe to say that if an artist can control a line the way Ingres did, he does not have to worry about anything else.

If you are interested in seeing how this system works, get a jeweler's exhibition hand and put a bracelet and a ring around it. Using this as a model, with the light behind you, see if you can vary the outlines in a way that conveys the texture and shape of your subjects.

75

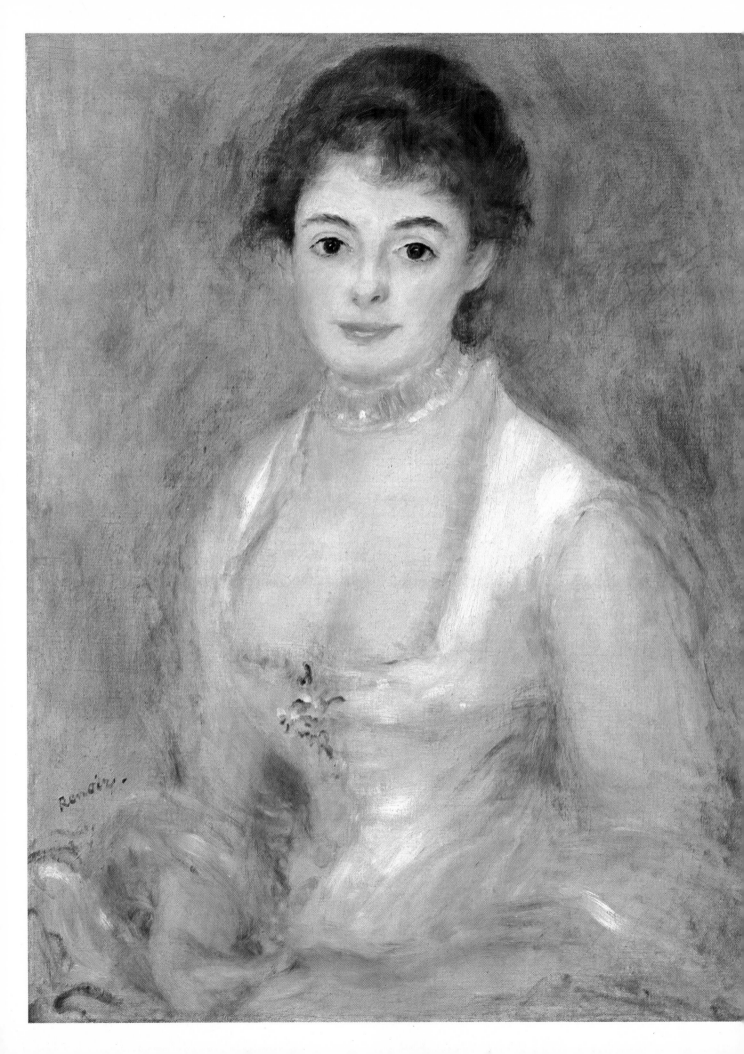

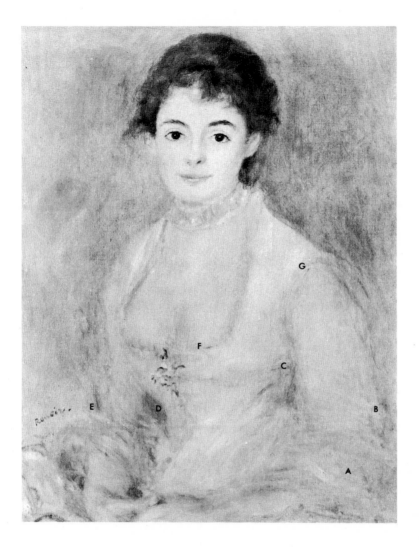

AUGUSTE RENOIR
French 1841-1919

MADAME HENRIOT
Canvas, 26 x 19⅝ in.
Gift of the Adele R. Levy Fund, Inc. 1961

The eyes are like a magnet. Everything else is subordinate to them and, no matter where else your attention wanders, you always come back to the eyes. This is natural. The human figure is the most interesting subject an artist can depict; the head is the most interesting part of the body; and the eyes are the most interesting feature of the head; so Renoir is only emphasizing the instinctive reactions of a spectator.

Note how vague the other forms become as they recede from the center of interest. At A there is no more than a slight indication of the elbow. Your imagination supplies what Renoir has left out. Note how he has pinpointed a few important points, so that the forms will not dissolve completely. The dark blue at B suggests the contour of the arm. The single stroke at C defines the junction of the arm. At D the torso is clearly indicated, and at E

the elbow. The edge of the dress is pinpointed by the slight accent at F, and at G the dress on the shoulder is similarly given an exact placement. Thus, in spite of the vagueness of loose, and apparently aimless, brush strokes, there are a series of inconspicuous checkpoints exactly placed to define the different sections of the body.

As an exercise in the use of this approach, go through your discarded paintings and select a few which have some passages you like. Then gradually build up the sections you like, and suppress those parts that are less successful, leaving only enough paint so that the forms still register. In other words, paint a diaphanous frame around the parts that you want to keep, leaving only a few pinpoints to hold together what is left. You may be surprised how a silk purse can emerge from a sow's ear.

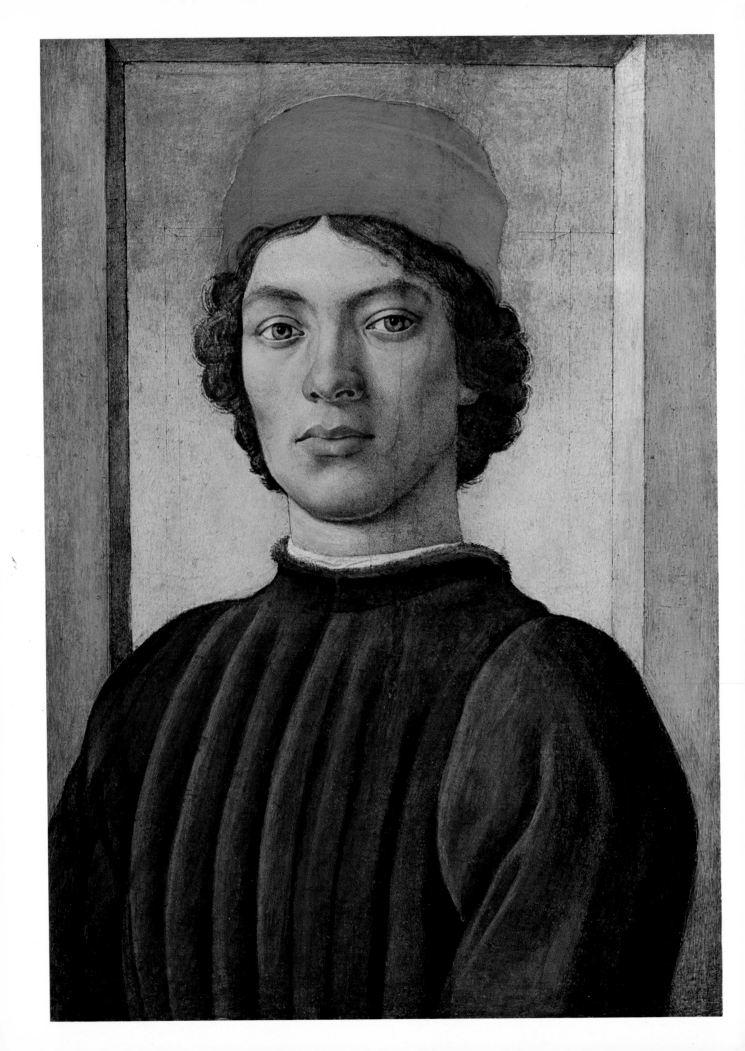

It is surprising how few painters are able to draw or paint an object so that the spectator has a convincing illusion of its solid, three-dimensional form. The technique of achieving this illusion (which, incidentally, is far removed from photographic realism) was one of the great achievements of Western art. Every painter should know how to convey three dimensionality, whether or not he ever uses the knowledge.

In this portrait the flesh areas are practically monochrome, and the artist has relied almost entirely on the use of light and shade to achieve his ends. Filippino Lippi has followed the principles of *five values* consistently and accurately, and has created a very convincing illusion of three-dimensional form. Note that the outlines do not help at all. They are as hard and sharp as a cut-out piece of tin. Note that each area has been treated more or less independently and the divisions between parts are as sharp as the outlines. It is surprising that the result is as har-monious as it is.

Highlights, which are slightly cool in color, are all about the same (A). The halftones have a slight warm reddish brown tinge (e.g. at B). The shadow edges are dark with a neutral grayish brown (C). Reflected lights are cool, possibly because the wall from which the light is reflected is a pale blue or green (D). Cast shadows are the darkest tone, and again tend to be neutral, with gray-brown (E). As a formula for painting flesh, this color scheme and scale of values can be used and will give a similar result. However, values must be exact, or else the illusion of form will break down.

As an exercise, take a simple subject, like a few eggs. Mix the five values beforehand on your palette. Using only these five values, try to represent the eggs with a convincing sense of form. After the paint has become completely dry, try to glaze a slight color over each egg, so that one will be green, another blue, and the third red.

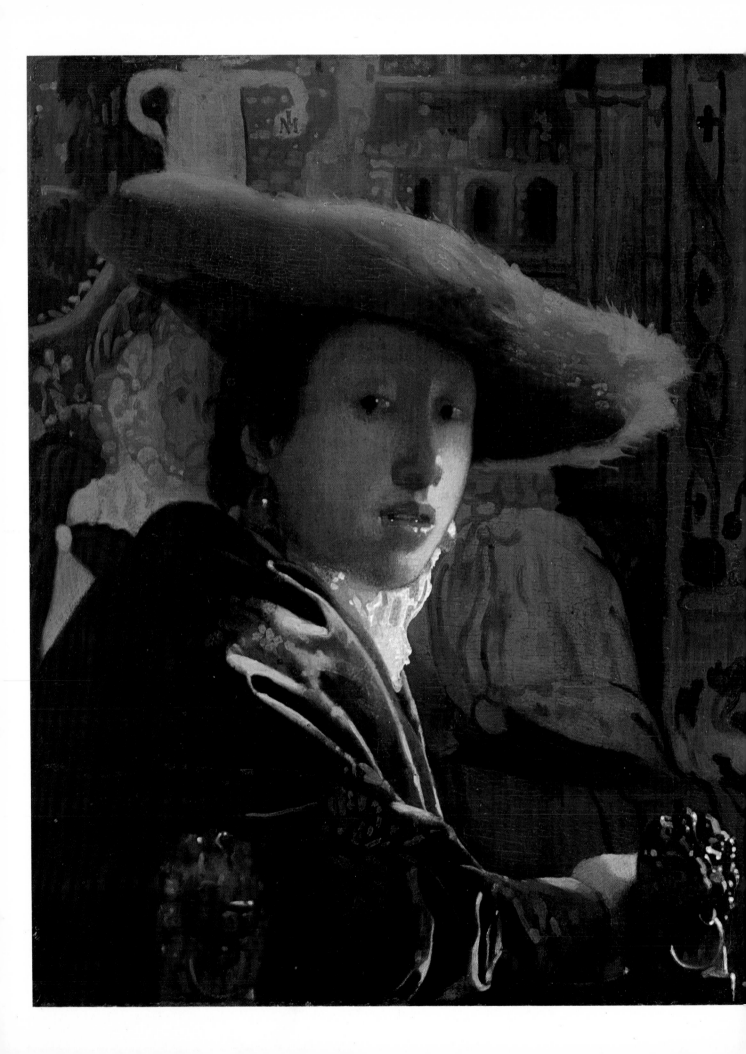

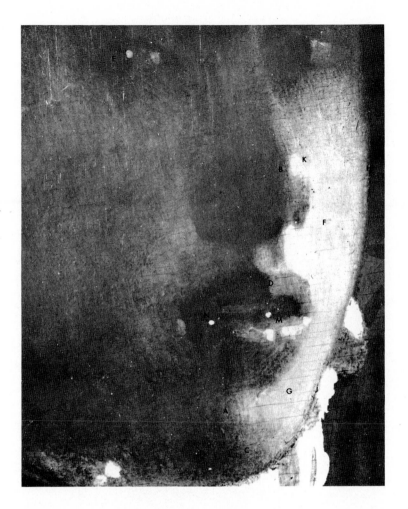

Often, when trying to learn from the works of a great painter, it is only after a very detailed analysis that you can begin to understand what a complicated and subtle process leads up to a particular result. Vermeer is a case in point. His handling of light has fascinated artists and scholars for generations, but to understand how he achieved his effects requires a technical analysis.

In the detail, first note that there is a decided difference between the areas of light and shade. Second, note that the boundary between light and shade—the "shadow edge"—has been handled with great care and finesse, varying from soft (A) to hard (B), at times lost (C) and then found again (D). Third, note that in the shadow area fine detail is lost in a suffusing mantle of darkness; for example, the eye (E) is no more than a dark blur. Fourth, on the light side, modeling is also cut to a minimum; there is no appreciable change in tone or color between the plane at F and the area at G.

Contours are also illusive. The line of the cheek (H) is softened, and at J it has been strengthened by a dark line. On the other hand, at K the contour of the nose is lost. The unique features of Vermeer's work, and the real key to understanding his treatment of light is in the way he handles highlights. Like jewels, the highlights are placed precisely and, like jewels, the settings are carefully prepared. Note that the contour at L is sharp as a knife. The lights at M are surrounded by a slightly less intense halo which makes the principal light glow with an almost incandescent quality. The dot of light at N registers perfectly as a drop of moisture at the corner of the mouth.

Having studied the detail, try an experiment. Take a piece of satin, place on it a peach and a piece of gold jewelry, light them from one side, and see if you can duplicate Vermeer's system of luminescent highlights.

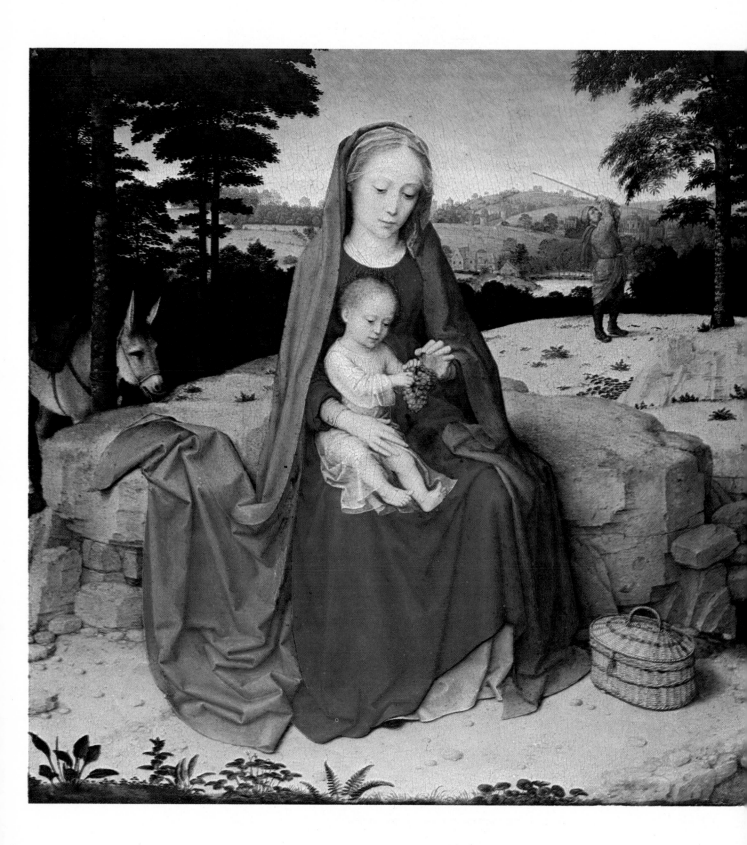

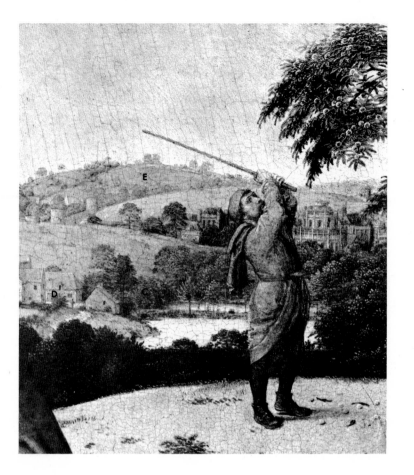

GERARD DAVID
Flemish c. 1460-1523

THE REST ON THE FLIGHT INTO EGYPT
Wood, 17¾ x 17½ in.
Andrew Mellon Collection 1937

A painter ought to know the principles of optical perspective, whether or not he ever uses them. Stated simply, optical perspective means that "the further away objects are, the bluer they become; and, secondly, the further away they are, the less distinct they are." These two factors may seem obvious, but it is surprising to note how many painters will put a red barn in the background of their landscapes, drawn in every detail, and then wonder why it won't stay in the distance.

Objects become bluer and less distinct because the intervening air is generally blue, and the particles of moisture in it tend to make distant objects become blurred.

You can see an exaggerated demonstration of optical perspective in the detail. At A, the leaves of the chestnut tree are a yellowish green. At B, the general tonality has changed noticeably; the trees are already blue-green. At C, the process has gone a step further; the bluish tinge is predominant. Note that the houses at D also become blue. The final stage of the process can be seen along the hori-

zon: trees, buildings, roads, fields are all a monochrome pale ultramarine (E). All local color has gone, and you see only the hazy outlines of objects. In nature the details probably would be even more blurred than in David's picture.

Of course, optical perspective can be modified greatly by both the atmosphere and the light. In Arizona, the bluish tendency is much reduced, because the air is so dry and dust-free. Over many cities the smog is so thick that the effect is much more marked. On the moon, optical perspective does not exist. Therefore there are no precise and infallible rules, except that objects in the distance tend to be bluer and hazier than objects in the foreground.

Paint a landscape with a series of bright red launching gantries—like those at Cape Kennedy—in the distance, a field of blue flowers in the foreground, and a green field in between. Try to modify these colors and contours so that the gantries will appear to be at their proper distance.

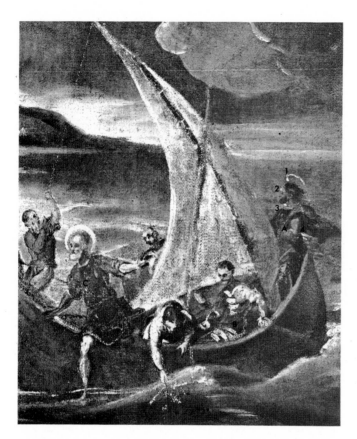

Detail no. 1

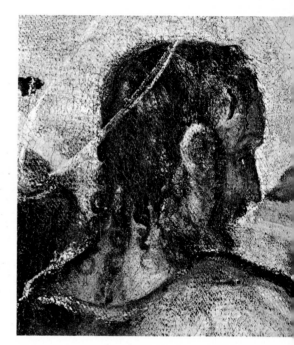

Detail no. 2

Jacopo Tintoretto
Venetian 1518-1594

Christ at the Sea of Galilee
Canvas, 46 x 66¼ in.
Samuel H. Kress Collection 1952

The eye instinctively is attracted to light, and a painter like Tintoretto paints mostly with highlights, leaving the rest to the imagination of the spectator. Look at detail no. 1. The base colors are mostly dull grays and browns. On to this Tintoretto draws with light, infusing the theme with a sort of dynamic energy. Part of the effectiveness derives from the fact that the brushwork has a vitality of its own, which seems to play like St. Elmo's fire around the group, giving a spiritual quality to it. Note the figure on the extreme right (A): the highlights on the halo, forehead, neck, and behind the arm (1, 2, 3, 4), make him appear like a sentinel touched by the first rays of some distant light. The next figure (B), in contrast, seems to be only a symbol of humanity—a skeletal and terrified figure, clad and chained by the eerie light. St. Peter (C), stepping into the sea, is bathed in an all-pervasive glow which seems to lift him from the surroundings of his companions. Below his foot, the sea flashes with a phosphorescent gleam.

Study the close-up of Christ's head in detail no. 2. Light again defines and etches what otherwise would be a dull and confusing mass.

Many painters in the history of art have found out that the most effective way of giving a sense of life and motion is by touching with light whatever they want to stress. The eye of the spectator will follow obediently and eagerly.

As an exercise, paint a picture of any subject with dull, neutral colors. After it is dry, take a stiff brush loaded with opaque white and see if, by placing accents, you also can infuse life and energy in the same way that Tintoretto has done.

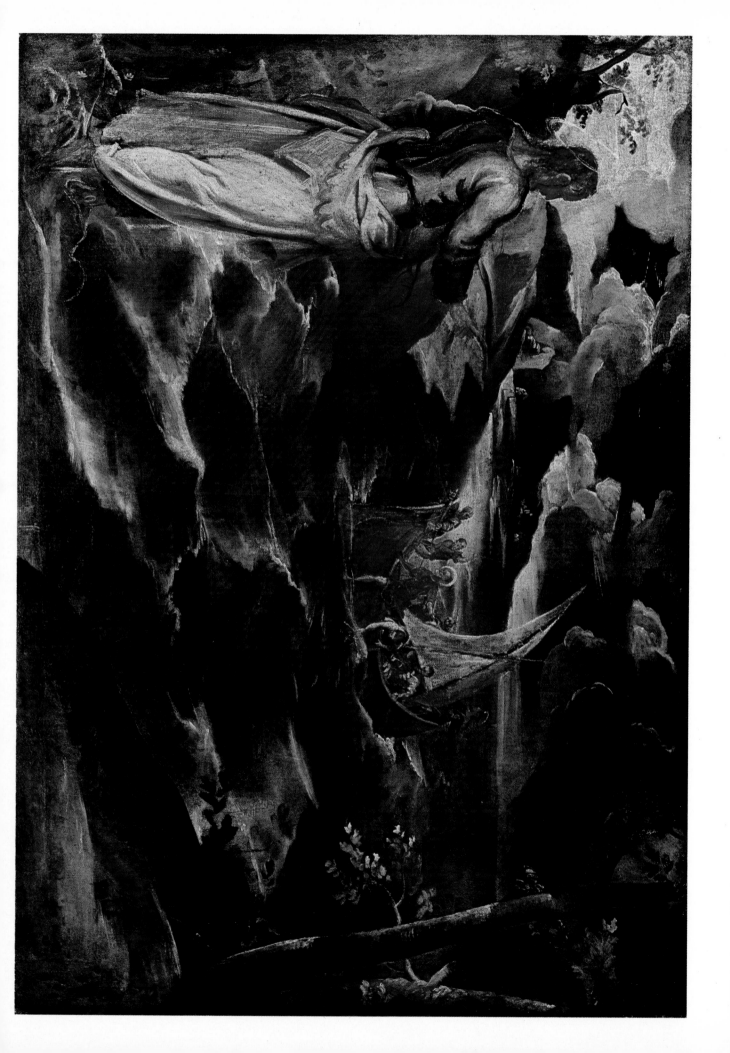

GIOVANNI ANTONIO BOLTRAFFIO
Milanese 1467-1516

PORTRAIT OF A YOUTH
Wood, 18⅜ x 13¾ in.
Ralph and Mary Booth Collection 1947

Students who have mastered the technique of using light and shade to give an illusion of three-dimensional form, often believe that they have mastered the Renaissance formula for portraiture. In fact, they have mastered only half of it.

Follow the steps which Boltraffio has used in making this portrait. First, observe that there is virtually no variation in color. The eyes are brown and the lips slightly red, but the rest is monochrome. Second, note that the planes of the face are modeled very precisely in five values of light and shade. Take a small area like the chin, for example, and analyze it. A is the highlight area; B the halftone area; C the shadow edge; D the reflected light; and E the cast shadow. If you look carefully at the other parts of the face, you will see that Boltraffio has used this system throughout. Some areas are blended so carefully that it is hard to distinguish the values, but they

are there, nevertheless, and underlie every part as a concise and skillful application of the principles described.

This is the first part of the Renaissance formula. The second is to alter slightly these values to give character and expression to the subject. For example, note that under the lip the shadow has been deepened very slightly (F). The shadows under the corners of the mouth have been deepened almost imperceptibly (G, H). The same is true of the shadow under the nose, making the nostrils seem to flare (J, K). Lastly, the downward lines at the corners of the eye have been stressed (L, M). All these accentuations create an expression of sorrow and resentment. You seem to read the thoughts of the one-armed boy.

Make two drawings of someone you know well. By emphasizing the same features as in Boltraffio's portrait, give one the expression of joy and the other of sadness.

86

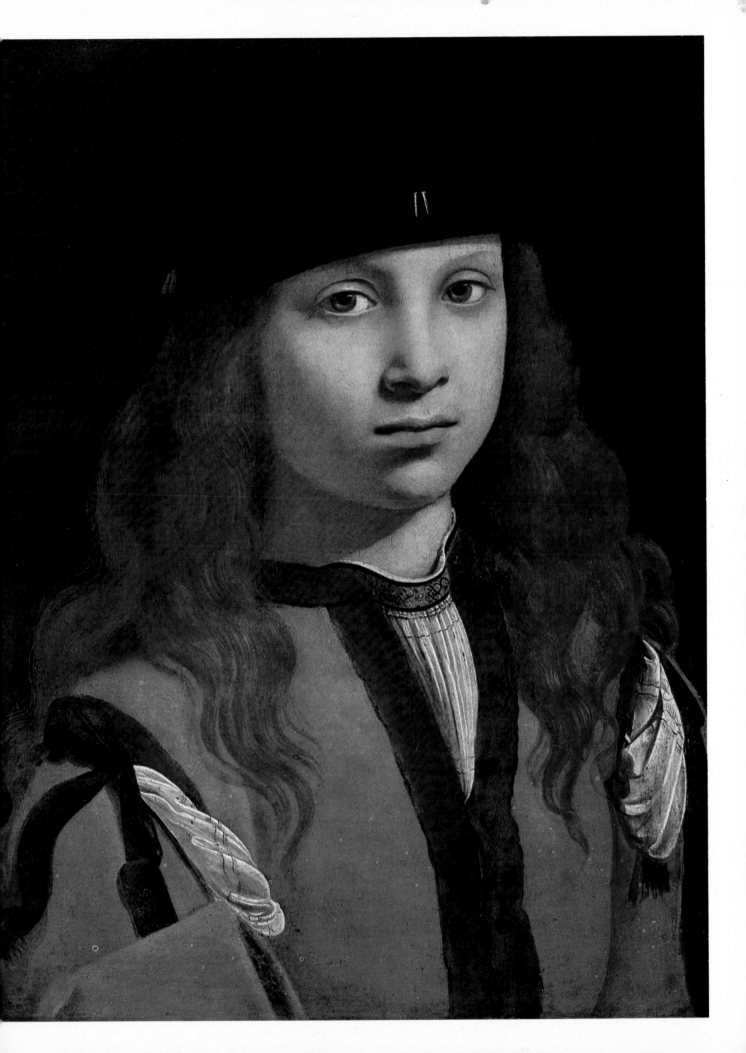

Detail no. 1

Detail no. 2

JEAN-BAPTISTE-JOSEPH PATER
French 1695-1736

FÊTE CHAMPÊTRE *(slightly trimmed)*
Canvas, 29⅜ x 36½ in.
Samuel H. Kress Collection 1946

There is a type of vision, used by artists, which might be called *psychological perspective*. Stated simply, it is based on the fact that you do not see everything with equal clarity, because everything does not attract your attention with equal force, and therefore everything should not be treated with equal finish. In painting, one way to subordinate features of secondary importance is to place them in a lower light, as though some cloud or object off stage had cast a shadow. This device was very frequently used in the Baroque period. In the two details you can see how this theory works in practice: detail no. 1 shows the center of interest, and detail no. 2 shows a group in the middle distance. Even allowing for the difference in scale, it is difficult to realize that they are both parts of the same picture. Detail no. 1 has a thoroughly worked out precise treatment even in accessory detail. Detail no. 2 is sketched in over the colored ground with quick, fluid brushwork, and colors are only indicated. It represents an early stage in the development of a painting of this type, and has been left in this condition intentionally. Note that the colors in this detailed section are less intense, the outlines vaguer, and there is a bluish cast according to the precepts of aerial perspective. The quick sketchy treatment adds yet another form of perspective.

Psychological perspective can be used in any part of a picture. I recommend it as a means of helping your spectator follow your mental processes, by making a selective emphasis of different parts of your painting.

Paint a still life of seven bottles on the top of a table. By the color of labels, the degree of finish, and the position, make it obvious that you want your spectator to look at the seven bottles in sequence and in a certain order.

REMBRANDT VAN RYN
Dutch 1606-1669

PORTRAIT OF A LADY WITH AN OSTRICH-FEATHER FAN
Canvas, 39¼ x 32⅝ in.
Widener Collection 1942

The good portrait painter must also have an understanding of human nature. Since ancient times, men have known that hands reveal character, experience, and mood more plainly than even the face. By force of habit, most of us unconsciously wear a mask in public, but the hands are usually naked in their truth. Almost without exception, portraitists who have been recognized as masters have made a special study of hands. No one has ever known more about this branch of art than Rembrandt. From looking at his subjects' hands you feel you know the sitters' age, mood, profession, domestic life, social status, and, it seems, their innermost thoughts. Study the detail. These hands belong to a person in her early forties, who feels at peace with the world. She is resolute, strong, and realistic, but not aggressive. She has worked hard (notice the thumb). She is married and confident of her

place in life. At the moment she holds an ostrich feather, a fabulous treasure from the mysterious East. She displays this not as an accessory frill, but as a symbol of her husband's success. It is her due and her reward.

Technically, these hands rank among the finest ever painted. The form of each finger and muscle is expressed simply and surely. The slightly rough skin texture is indicated, but not stressed (A). In contrast, the gold jewelry glitters and gleams with hard intensity (B). The feather has the feel of eiderdown (C) and seems to tremble.

As an exercise, make three rough copies of these hands by Rembrandt. By altering the outlines, texture, and proportions, make one look like the hands of a cardsharp, the second like the hands of a fashion model, and the third like those of a prizefighter.

90

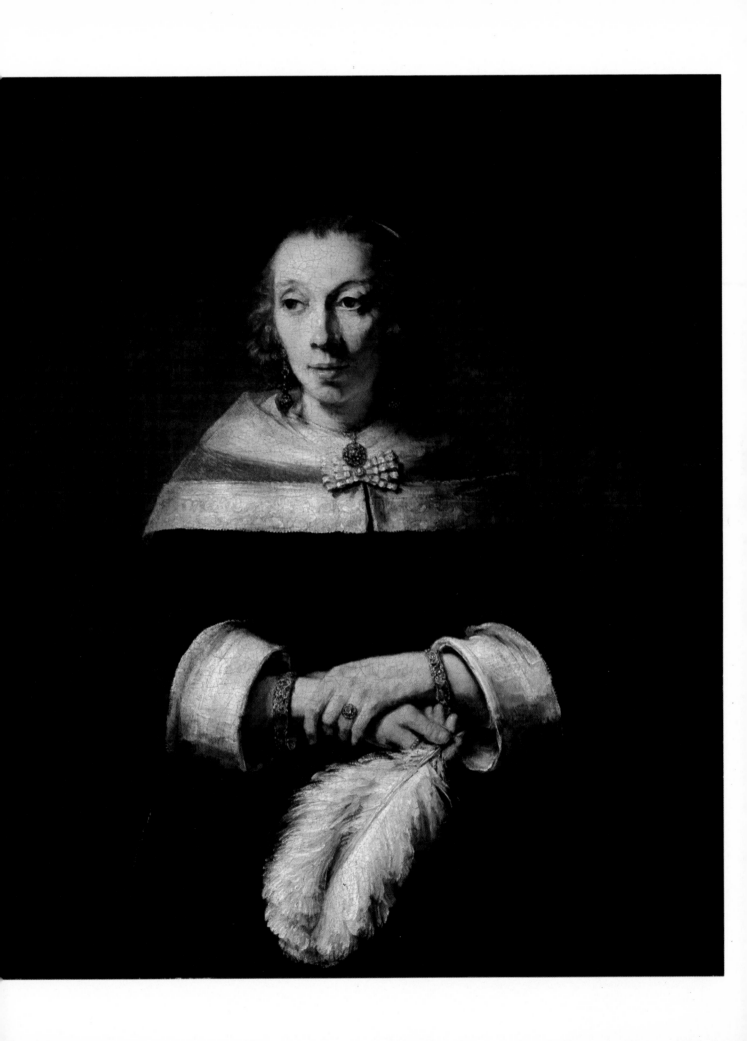

Detail no. 1

Detail no. 2

TITIAN
Venetian c. 1477-1576

DOGE ANDREA GRITTI
Canvas, 52½ x 40⅝ in.
Samuel H. Kress Collection 1961

Titian, like Rembrandt, knew very well what hands could express. Doge Andrea Gritti—the subject of this portrait —ruled Venice at a time when Venetian sea power was the only bulwark between the invading Mohammedan hordes and Christian Europe. He literally held the future of European civilization in his hands. His adamant character, like that of Churchill in our own time, stiffened the resistance of the Western world until the tide turned. How does a painter convey this kind of iron will in his subject? The face and pose obviously are important, but the hands are also essential elements which can reinforce or negate the total effect. In detail no. 1, note how the three dark bars (A, B, C) between the fingers are like the teeth of an iron wheel, as strong and tireless as the man. Note that the hand is not resting, but is clutching the red robe, conveying—even in this minor act—an impression of

resolute action. Note also that the size of the hand has been considerably exaggerated. It is about half again as large as it should be. This also conveys an idea of power and strength. Lastly, look at the brushwork. Strokes like those at D, E, and F are like the blows of a sledge hammer. This kind of brushwork would be unthinkable for a portrait of a young girl, or for a recluse and scholar. Contrast the hand with that in detail no. 2, also by a first rate portraitist; this was the hand of an aristocrat and author, not a strong political leader. Obviously, if the Doge's hand had been painted this way, Titian would have created a split in the personality of the painting.

As an exercise in the use of brush strokes, paint the outlines of two dogs' heads. Then, using whatever brushes and colors you wish, make one dog into a fierce and dangerous hound dog, and the other into an amiable lapdog.

92

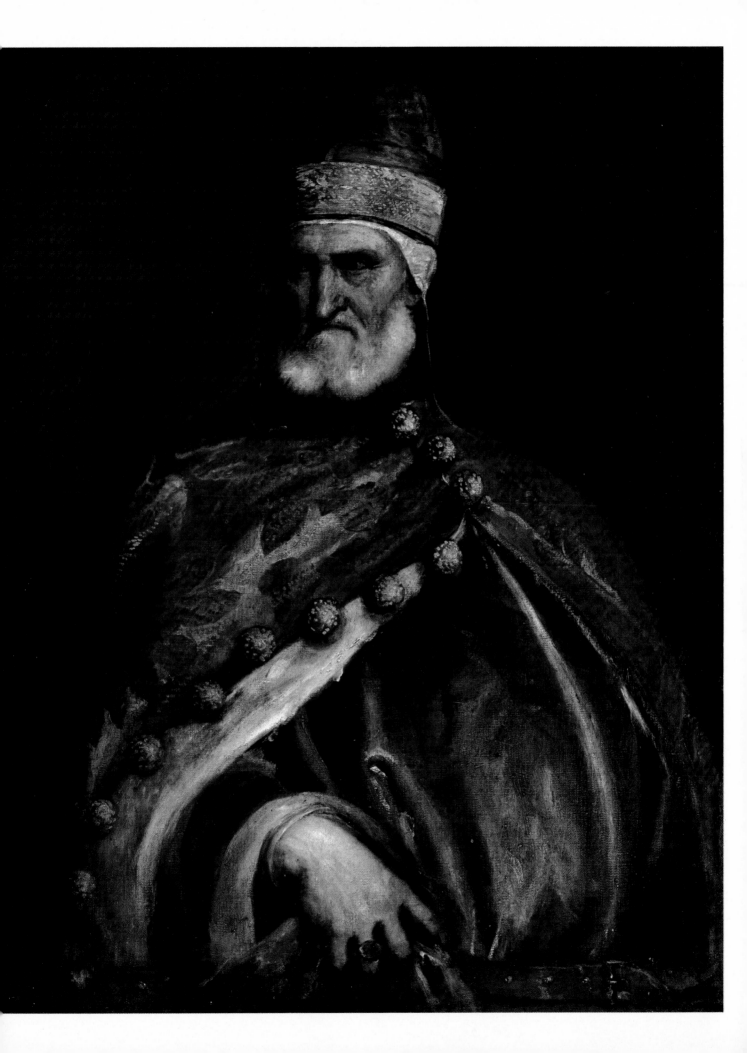

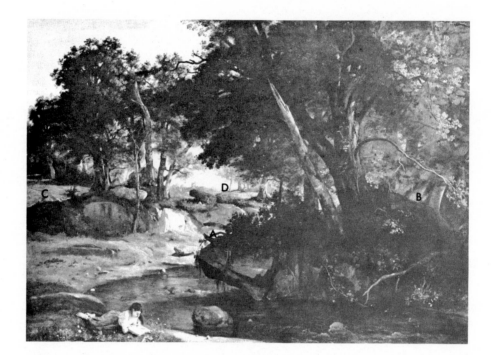

JEAN-BAPTISTE-CAMILLE COROT
French 1796-1875

FOREST OF FONTAINEBLEAU
Canvas, 69⅛ x 95½ in.
Chester Dale Collection 1962

An aspect of Corot's art you can clearly see in this painting is his use of hidden space. There is nothing more interesting than the suggestion that there is a fascinating and exciting prospect which the spectator can almost, but not quite, see. Here you are curious to know about the continuation of the sunlit riverside, and what is going on along the other side of the bank in shadow (A and B). Furthermore, your curiosity is aroused by the path off into the woods on the left (C), and by the stag at D, moving towards an invisible landscape in the dis-

tance. All of these hidden spaces challenge your immagination. This technique of using hidden space can be exploited in non-objective art as effectively as with a realistic approach.

As an exercise, arrange a series of bottles on the top of a table in such a way that you create areas of hidden space, which will lure and frustrate a spectator. Make a drawing of this arrangement, emphasizing optical pathways through your still life.

Detail no. 1

Detail no. 2

EDOUARD MANET
French 1832-1883

GARE SAINT-LAZARE
Canvas, 36¾ x 45⅛ in.
Gift of Horace Havemeyer in memory of his mother
Louisine W. Havemeyer 1956

This is one of the very few pictures reproduced in this book which was painted out of doors, without any preparatory work. According to our best information Manet did not arrange his subjects—a friend and the daughter of a fellow artist—but set up his canvas, and painted them exactly as he came upon them sitting at the end of a small garden near the railroad station. You have to look carefully before you understand the spatial relationships. Behind the iron grille is a drop of perhaps fifty feet to the railroad tracks, where an engine has just passed leaving behind a cloud of steam and smoke. The small figures standing on the viaduct in the upper right section and by the shed below give the scale and key, but you have to find and analyze them before the floor plan of the picture emerges. Nor is there unity in the design, or any feeling for form in the figures; the little girl is a flat silhouette, and the objects in the older girl's lap are flat shapes (see detail no. 1). You can tell what they are easily enough, but there is no real depth or mass to any individual part.

Manet was not interested in the illusion of three-di-

mensional space or form. He took a theme just as it was presented in nature, and by the wizardry of his brushwork and color sense converted it into a unified and exciting optical experience. Look at the deep blue of the bow in the girl's dress in detail no. 2. The paint is dragged, scumbled, slashed, daubed, and caressed on, in a marvelous display of brilliant brushwork. Every part of the picture is equally exciting. Manet, like many other painters of genius, could take any theme, and by the virtuosity of his technique transform it into a supreme work of art. After studying a canvas like this for a little time, the theme becomes increasingly unimportant, and you become hypnotized by watching the verve and daring of a masterhand at work.

Look at your own painting, and ask yourself what would be revealed if details were made of your work like the ones on this page. Is your brushwork deft and assured? Do you know exactly what tone and color you want in each square inch of the canvas? Is there a pervading harmony? Other people will ask these questions, so it is better that you ask them first.

97

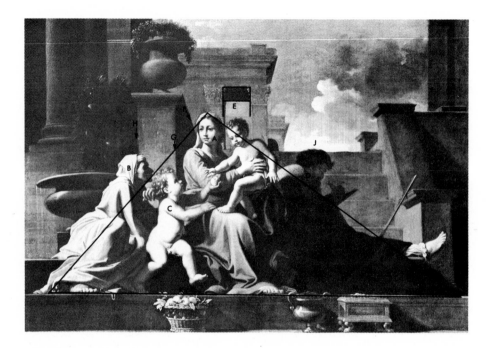

Nicolas Poussin
French 1594-1665

Holy Family on the Steps
Canvas, 27 x 38½ in.
Samuel H. Kress Collection 1952

According to the principles of design, the pyramid is the most stable form. So, if you want to convey an impression of permanence, peace, and security, use the pyramid as a design basis in your painting. Furthermore, a spectator looks instinctively at the top of a pyramid; so, if there is a feature which you want to emphasize, place it at the summit of your pyramid, unless there is a good reason for doing otherwise. Poussin is one of the great masters of design. His shapes, colors, and lines interlock with almost mathematical precision, and a student can learn much by carefully analyzing a painting like this one.

Here the heads of the Virgin and Christ Child (A) are obviously the focal points. Therefore they are at the apex of the pyramid and receive the most direct light. St. Elizabeth (B) and the infant St. John (C) to the left, being secondary, are further down the pyramid and partly in shadow. St. Joseph (D), on the right, is the least important member of the group and, therefore, is almost lost in shadow.

Apparently accidental motifs further emphasize each of these figures. Christ has two eye-catching rectangles of blue and brown (E) directly over his head. The Virgin has a sharp diagonal line pointing at her throat (F).

Both St. John and St. Elizabeth have sharp edges plummeting onto their heads (G and H). Even St. Joseph receives discreet recognition by having the top of his head project over the parapet (J).

Another principle of design is that a straight line is usually a barrier to the eye, and if you want your spectator to pass this barrier you must break the line by some means. For example, the step along the bottom of the triangle would have been a forbidding optical hurdle if Poussin had not opened it up in three places (K, L, M) with very minor highlights.

The features I have pointed out are not obvious at first sight, and this is the art in designing: your spectator is not supposed to know that he is captive, otherwise he will get bored and resentful. Subtle designing is a fine art and force must never be used.

As an assignment, design a landscape in three sharply divided horizontal layers. For example, place a river in the foreground, a waterfront in the middle distance, and sky in the third section. Now try to break the boundaries between the layers by making subtle openings, such as Poussin has used.

Detail no. 1

Detail no. 2

BOTTICELLI
Florentine 1444/45-1510

THE ADORATION OF THE MAGI
Wood, 27⅝ x 41 in.
Andrew Mellon Collection 1937

There is something very satisfying about a picture with an obvious design. Look at detail no 1. The aisle (A) leads up to the central group. The architecture (B) acts as a frame within a frame, and all the principal figures bow towards the center. Nothing is left unexplained; every square foot of floor space is accounted for; each actor occupies his allotted place. In the hands of a lesser artist these Renaissance formulas can be monotonous. In the hands of a painter of genius they never are, chiefly because no matter what the broad overall design, Botticelli is always the great master of line, and even in the smallest detail his mastery of design asserts itself. Take, for example, a small section on the right-hand side, and study any part of it as an exercise in non-objective designing.

The basic outline of each horse's leg is the same, but in Botticelli's handling each leg is a separate interpretation most beautifully harmonized with its surrounding elements. As a test, alter any part of the design, however small. For example, note the stirrup swinging from the gray horse (C) in detail no. 2. Imagine this hanging straight down: the rhythm and harmony of the surrounding verticals would be altered and this section would lose one of the essential elements which bind the composition into an interlocking unity.

As an exercise, try using the Renaissance design formulas for a view looking down a familiar street. Make the principal lines of the composition converge onto a single figure in the middle distance.

This picture of an estate near London at first sight looks photographically realistic. Actually it is not. The house and park pictured here still exist, and photographs of the estate show that Constable rearranged nature considerably to suit his purposes. First, notice that Constable has taken liberties with the laws of optics. Technically, the reflections of the trees in the water should fall approximately along the line A-B. Constable, however, has not adhered to the laws of reflection; he brought down the dark area, probably to avoid making a light horizontal band across the picture, an effect which would have been a barrier to the viewer's eye. Instead, he has contrived a pathway of light leading up to the house, the focal point (C-D). The most prominent cloud (E) is directly over this spot, and the silhouetted fence along the bottom (F) catches your eye directly below. Violating most of the accepted rules of design, Constable has placed the house almost exactly in the center.

This painting is a masterpiece, and yet it lacks unity. Try masking out the areas indicated along the left- and right-hand sides and see how much more satisfactory the composition is. There is a good reason for this. Originally the picture was not so wide, but the man who commissioned it—a retired army general—objected because the painter had not shown enough of his estate. Constable, therefore, sewed pieces of canvas on either side and painted in the grove of trees at the left and the deer park at the right. In order to help hide the seams, and also to lock in these added sections to the composition, he had to put in the black cow at G and fishing boat at H. It is very rare for a painter to add to his work in this way without losing the essential unity. As a postscript, it is also a bad idea to place a cow—or any other living thing—so that it looks out of the picture, as Constable has done at G. The viewer instinctively does the same thing, and you can never be sure that he will look back again.

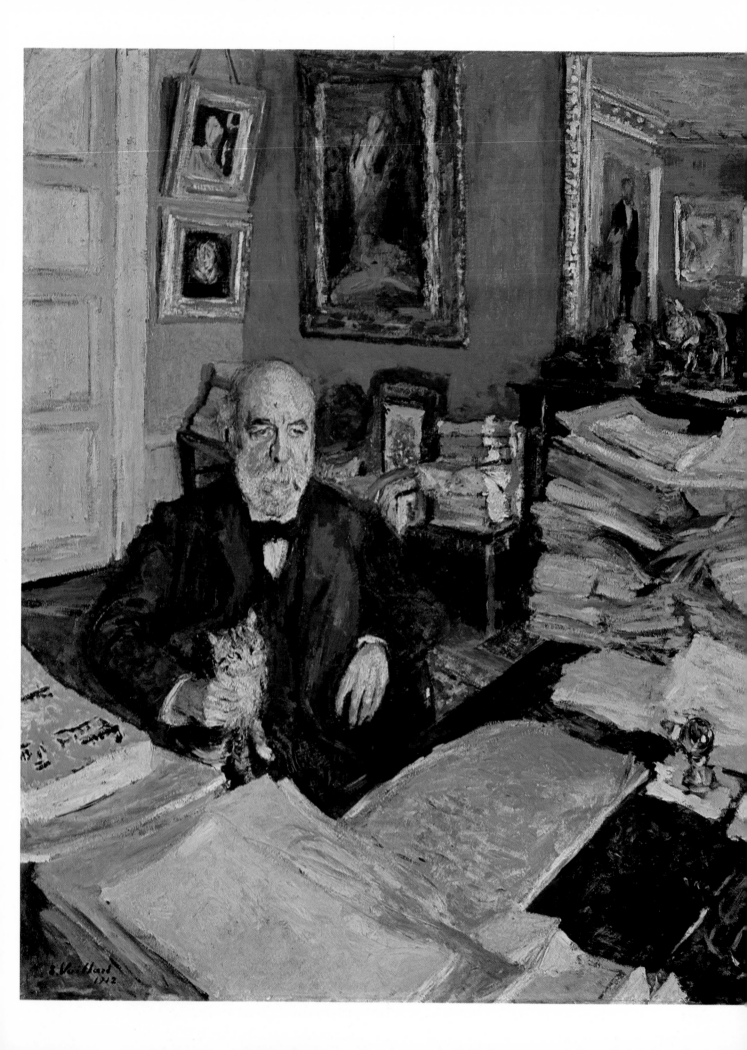

ÉDOUARD VUILLARD
French 1868-1940

THÉODORE DURET
Cardboard mounted on wood, 37½ x 29½ in.
Chester Dale Collection 1962

The ability to create order and unity out of apparent chaos is one of the secrets of Vuillard's technique. Here he has deliberately posed optical problems, and the viewer feels the sense of accomplishment when all pieces are fitted together. First, the desk covered with books (A) makes a sort of treacherous plateau, across which you must pick your way. Then there is the well-like space in which the man and his watchful cat sit (B). After some study, these elements begin to emerge. Next, at C, there is a wall of piled books. But at the summit there is a deliberate trap. The top blends into the mantle over the fireplace at D. Over this again there is a problem space: suddenly you realize you have gone through the looking glass and are seeing the opposite corner of the room (E).

The main subject is clearly defined by the fact that the man sits at the intersection of two main axes (F and G); but here again there are puzzles and challenges. For example, at H the shoulder seems to blend with the edge of the room, and at J dark shadows under the door seem to penetrate into the figure.

Vuillard probably did not intend to mystify his viewer; but, like Manet, he unifies his picture with color and brushwork, and you fall into his spatial pitfalls with a certain pleasure only when you start to prowl around his private den. As a general rule, it is not wise to play tricks on your spectator. If you do it too often, the viewer gets annoyed and passes on to the next picture.

As an exercise, make a color sketch of the room in which you are working now, trying to create the same kinds of spatial and optical puzzles.

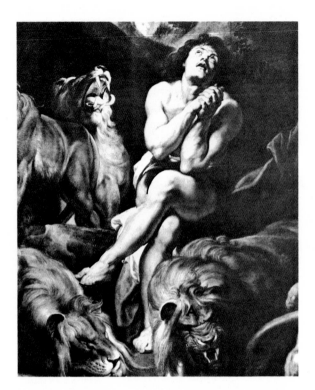

Detail no. 1

Detail no. 2

PETER PAUL RUBENS
Flemish 1577-1640

DANIEL IN THE LIONS' DEN
Canvas, 88¼ x 130⅛ in.
Ailsa Mellon Bruce Fund 1965

More than any other painter, Rubens had the ability to endow any living form he depicted with exuberant energy and life. One reason for this is the way in which he consistently avoided rigid geometric forms, such as straight lines, circles, and right angles. Instead, Rubens used curvilinear rhythms, a feature which gives a sense of swirling motion to his figures. A curve in itself will not give this effect. It has to be an S-curve of irregular proportions. Thus the form A in detail no. 1 is not particularly exciting or alive, but the mane surrounding it surges and rolls like a breaking wave or like flames in a wind, as theorists in Rubens' day described this kind of motion. Other theorists compared it to the movement of a serpent, or of a river winding across a plain. They argued that if a form

lacked this rhythm in nature, the painter should place accents on one side of the form and then on the other, in order to superimpose a serpentine design. Note here how Rubens has done this in Daniel's leg. Lights and darks constantly interplay with each other, an effect that makes the limb come alive. Thus, if you want to convey a sense of life and motion to an element in your picture, follow the precepts of Rubens and use the S-curve. As an exercise in the use of this S-curve, find a photograph of a cat or other animal, and superimpose on it accents along the outside of the contours in alternate rhythm as Rubens has done, and see whether you too can give the creature a sense of exuberant energy and feline life.

106

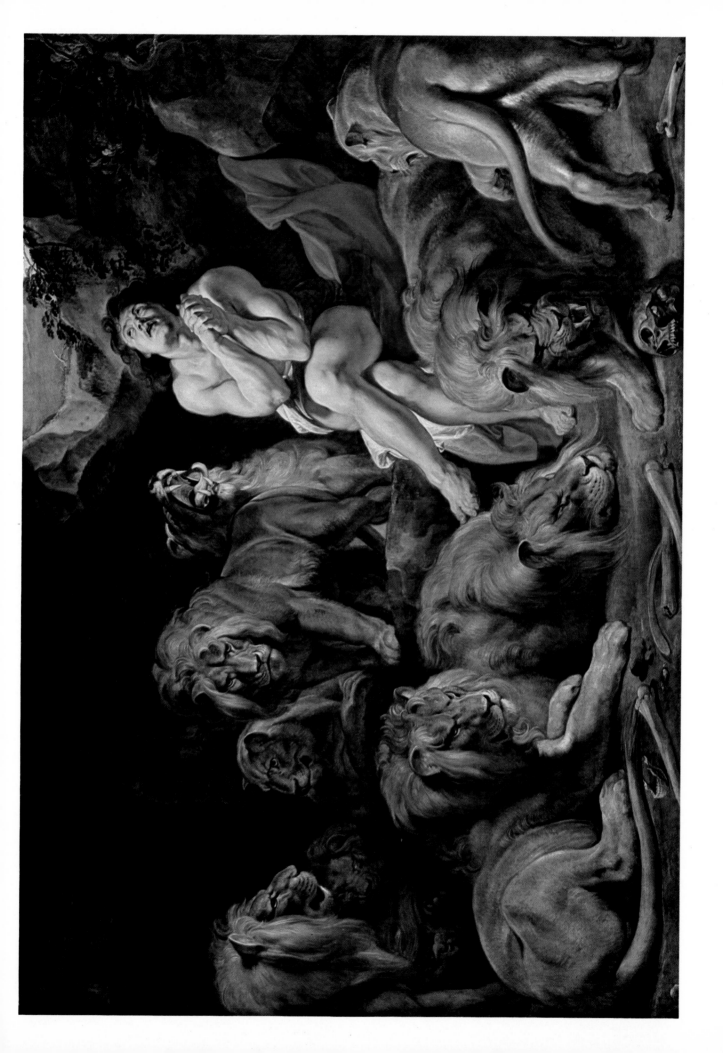

JACOPO TINTORETTO
Venetian 1518-1594

THE CONVERSION OF SAINT PAUL
Canvas, 60 x 92⅞ in.
Samuel H. Kress Collection 1961

Tintoretto was one of the great innovators of design, and this painting—done when he was about twenty-seven—shows the full measure of his genius. He ignored every rule of his day, and invented a new manner which revolutionized Western painting. The central core of his new system was that light is the key element in design, and that any emotion, any action, or any thought can be expressed by using light to its full effect.

In this painting the theme is one of intense drama. The Roman commander Saul—later St. Paul—was sent to persecute with death and fire the newly founded Christian sects. He was marching with a contingent of soldiers towards Damascus when he was struck from his horse by a thunderbolt and a terrifying voice from heaven asked him why he was taking this cruel course.

Note that the general design is based on an X, which in itself implies instability and motion (A-B and C-D). Note that the V-design is repeated in the figure of the Saint and in the figure of Christ in the upper left corner (E, F). Note further how design elements are arranged along the diagonal connecting the two principal figures —the steps (G), the edge of the green flag (H), even the pale horse (J) strangely appearing directly over the Saint act as totally unexpected, but important links in the design.

Notice how many unpredictable elements appear in this picture. Tintoretto may have originally planned the roadway starting at the lower left and going across the bridge on the right as a basic structure, but in the finished design notice that the road is not even incidental, nor is the horizon important. By some alchemy Tintoretto has combined disconnected groups in strange attitudes, all apparently rushing out of the picture plane, and yet he has preserved both unity and coherence.

We know that Tintoretto made extensive use of models. He had doll-like figures made of clay and either he propped them up, or he suspended them in miniature theatrical settings. Presumably, he also arranged lights around this mock-up to study accidental effects of light and shade. It is difficult to imagine how Tintoretto could conceive a composition so intricate and so unexpected without using a model to prompt his imagination.

If you are interested in figure painting, it is a good investment to buy a number of articulated manikins, either children's toys or artists' manikins. These can be arranged, with light shining on them so that compositions can be created which otherwise would not occur to you. As an exercise, take a dramatic theme, such as an automobile accident, arrange the figures and lights for the most dramatic effects, and make a black-and-white sketch of the result.

108

Paul Cézanne
French 1839-1906

Still Life
Canvas, 26 x 32⅜ in.
Chester Dale Collection 1962

Cézanne is often called the father of modern painting, and yet it is difficult to explain just why he was so important and what can be learned from a study of his painting.

First of all, try to imagine what this painting would be like if it had been painted by a Dutch seventeenth-century master (see de Heem's still life). The glass would have glittered and the table cloth would seem soft to the touch. Or try to imagine what a colored photo of this arrangement would be. And yet Cézanne's picture in many ways is more realistic than either because Cézanne painted not only what his eye saw, but what his mind told him must be true. In this case the picture is most carefully composed, designed like a Gothic cathedral, with the stresses and supports placed exactly where needed. First note that the composition is based on a cross and pyramid, the most stable design imaginable. Next, note that the objects, even the apples, seem to have the specific gravity of lead. Cézanne was not interested in textures or in incidental color. He wanted to construct the composition so that it was as solid as a granite pylon. Now follow his thinking as he works out each part. The line of the wall at A competes with the jug, and therefore Cézanne fades it out. At B, however, the line of the wall is important, since it links two parts of the composition; therefore, it is strengthened here by a darker tone along the edge. The edge of the napkin at C is also important to the structure of the whole, and therefore Cézanne reinforces the contour here with a shadow behind the cloth. Now follow

the line along the contour of the jug. The oval opening (D) is not drawn in correct perspective. If he had drawn it in perspective, the shape would have been too delicate and thin for the rest of the forms; therefore, Cézanne deliberately reforms it into a shape which fits the composition. The contour down the right side of the jug (E) is strengthened, since this is one of the important elements of the design. At F—since the horizontal line is also one of the skeletal elements—the line is also reinforced. The contour around the jug is again strengthened to stress this continuity. Further down, at H, the line is almost lost because here it is less important for the structure. At J the line is again stressed, and at K there is an anchor of dark mass. Now follow the other lines of the composition and you will see that Cézanne has treated every part of the painting with the same intensive—and almost engineering—attention to weight and stress.

By making these considerations more important than exact realism, texture, etc., and by stressing the basic laws of forms in space and composition, Cézanne opened the door to a new era in art.

As an exercise, make an arrangement of objects on the top of a table, and paint a still life, using the principles which I have tried to describe in Cézanne's painting. In this you will not be concerned with local color or with texture, but only with the basic structure of the composition in three dimensions, and the relationship of parts to one another to form a perfect harmony.

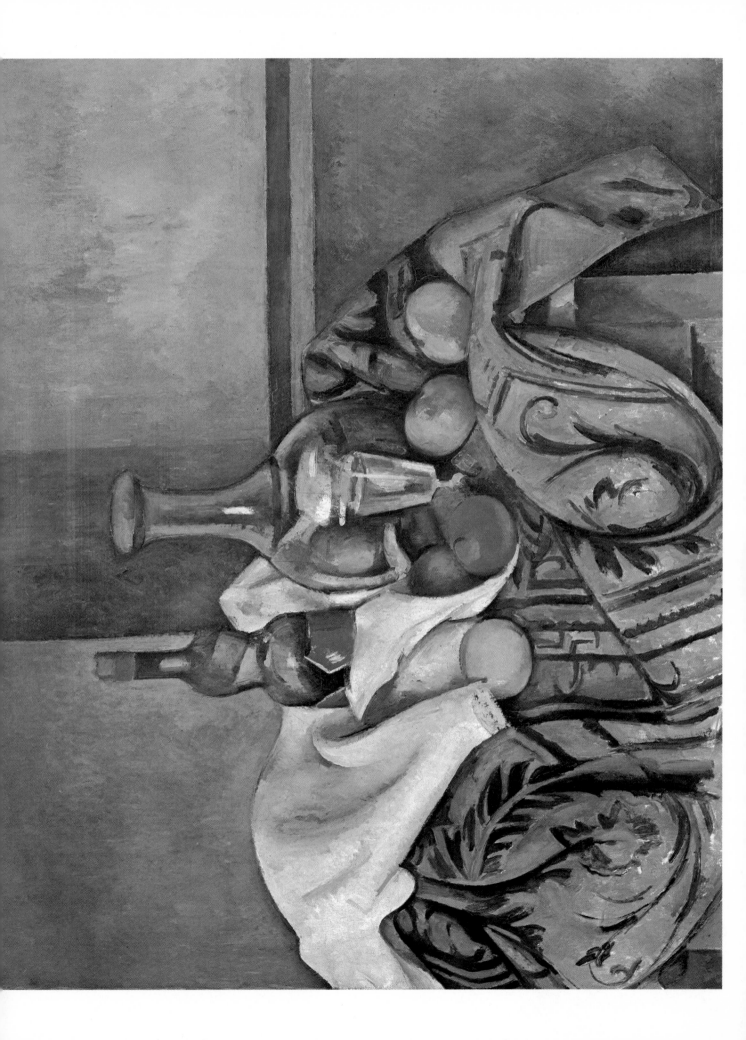

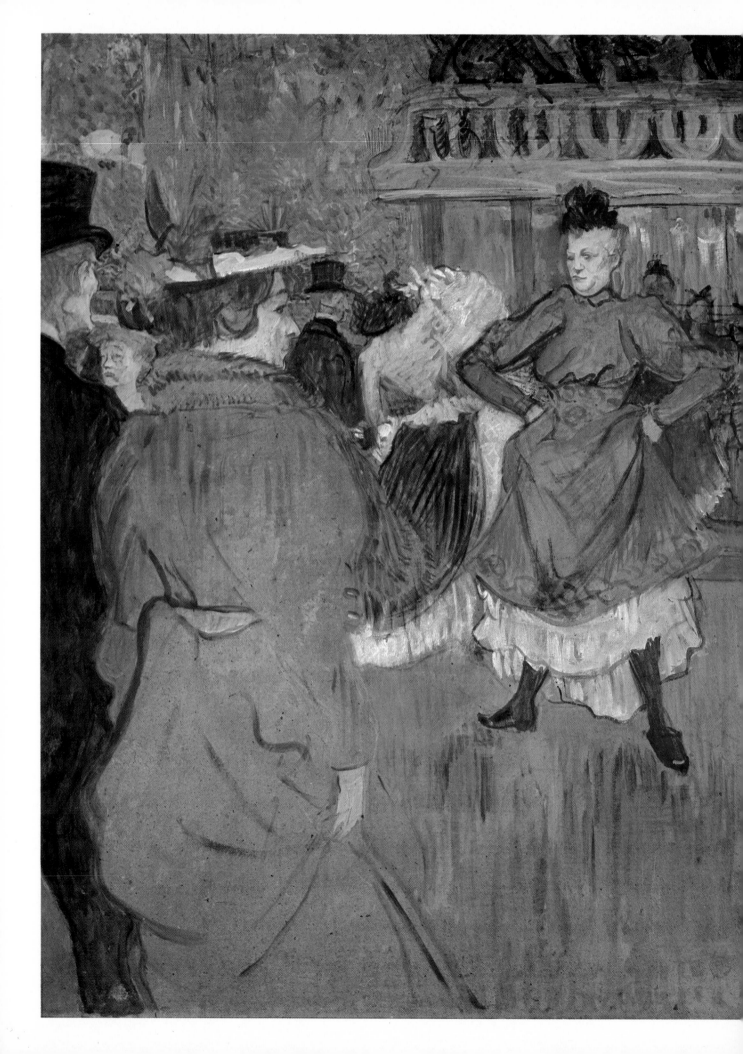

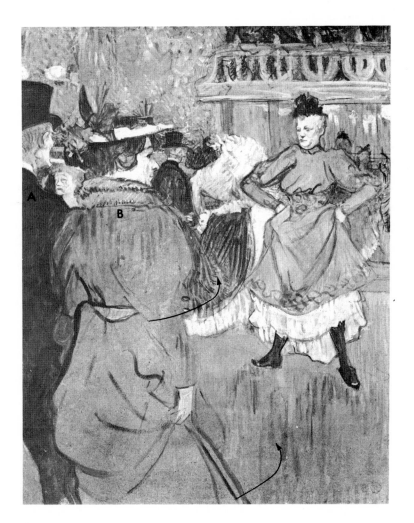

HENRI DE TOULOUSE-LAUTREC
French 1864-1901

QUADRILLE AT THE MOULIN ROUGE
Gouache on cardboard, 31½ x 23¾ in.
Chester Dale Collection 1962

Painters have always tried to solve the problem of breaking down the barrier between the picture and the spectator. In order to lure the spectator into the picture plane, the painter can use trickery sometimes, or an open invitation, or an appeal to curiosity. Toulouse-Lautrec learned some of this technique from the study of Japanese wood blocks. Note here that the male figure on the left (A) is only half shown and is also a spectator like you. The figure of his companion (B) is hastily sketched in, and it is obvious that she is about to move off towards the left. By insinuation we follow the arrow and step into the gap to her right, and thus get a place in the front row, as it were. The fact that you cannot see the lower part of the

woman, but only as much as your eye would take in at a quick glance, again draws you into the picture. Your impulse would be different if the whole figure were shown or more carefully studied. By using this sketchy technique Toulouse-Lautrec conveys a sense of constant movement and ever-changing spatial arrangement.

As an exercise, make a composition showing a group of people on a beach. By using fragmentary views of some of the people, changing the degree of detailed work for other members of the group, and leaving pathways open through your composition, see if you can induce your spectator to enter the picture and mentally become a member of the group.

Detail no. 1

Detail no. 2

RAPHAEL
Umbrian 1483-1520

SAINT GEORGE AND THE DRAGON
Wood, 11⅛ x 8⅜ in.
Andrew Mellon Collection 1937

More painters have been influenced by Raphael than by any other artist in history. The reason for this perennial admiration is that Raphael could endow anything he represented with an indefinable appeal and beauty. Most people unconsciously want this quality in their art. Raphael achieved this effect principally by rhythm of line and design. To appreciate his genius in this field, analyze the design of this famous painting (detail no. 1).

First, note how effectively the knight is linked to the dragon. The horse's hoof almost, but not quite, touches the monster's head (A); this gap sets up a tension. Your eye is unconsciously drawn to this point. Second, notice how the idea of strife and violence is accentuated by the sharp angles at B, C, D, and E. The shapes in this area give the impression of sharp teeth. Third, note how the long diagonal beginning at F creates a line of force thrusting into the lower left section. Raphael ties the elements together with inconspicuous knots of design: for example, at G, H, J, and K, where lines cross and unite. The elements described above are the obvious features, but even the smallest details are made to contribute to the total effect. Follow any of the major lines of composition, and you will see that the rhythm and harmonious effect is

never lost. A unique feature of Raphael's compositions is that you can also follow his design backwards into space and never be disappointed. For example, start at L and follow the ground plan backwards to the horizon. There is never a dull or discordant transition.

Turn to detail no. 2. We have a very revealing insight into Raphael's working methods when we compare this preparatory drawing (which was pricked with a pin so that the design could be transferred exactly onto the panel) with the finished painting. Evidently Raphael did not plan to have the ties at G and J, in his original design. The gap at A, however, was a key element in the drawing, as were the jagged edges in the area at B. This evidently was planned as the heart of the composition from its earliest inception.

As an exercise, make a composition of figures, or a still life, or even a landscape, and try to introduce a point of tension where important elements almost meet, as Raphael has done at A. In addition, try to link at least two other elements by crossing extremities, such as Raphael has done at G and J. You will soon find out how simple and effective the system is for controlling your spectator's eye and unifying a composition.

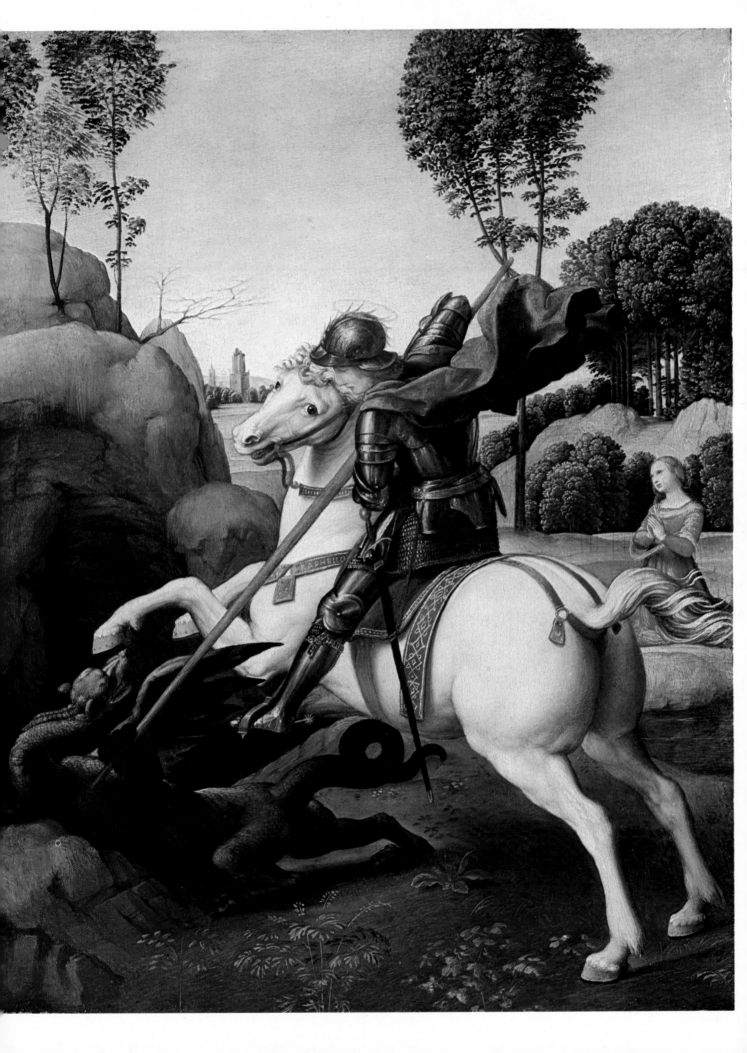

MIGUEL SITHIUM (Michel Sittow)
Flemish c. 1465/70-1525

THE ASSUMPTION OF THE VIRGIN
Wood, 8⅜ x 6½ in.
Ailsa Mellon Bruce Fund 1965

In a painting, size has very little to do with merit. *Mary, Queen of Heaven,* of the Master of the Saint Lucy Legend, measures about 7 x 6 ft. This one, with a similar design and theme—painted about the same time—is reproduced actual size; yet, who would say which is the greater work of art?

In contrast with the blaze of glory and resplendent colors in the larger painting, here the mood is quiet and of the utmost refinement. Certainly one of the main factors which produces this impression is the color. The predominant blues, pale yellows, warm grays, and subdued greens are all colors inducing a reflective mood of peace and quiet. The stability and symmetry of the design, which neither challenges nor surprises the spectator, enhances the tone of devotional calm. This tiny picture was commissioned by a queen, to be uncovered and seen only when she was at prayer in her private apartments. Obviously, an intimate and delicate treatment was required for such a purpose. The design, although time-honored in its general outlines, is a fascinating interplay of radiating and semi-circular forms, designed to focus attention on the head of the Virgin. Follow the lines made by the wings and arms of the angels. Almost without exception they lead towards the Madonna's face. As a counterfoil to this are the semi-circular shapes which also form a kind of frame for the central figure. In the hands of a minor artist, design elements like this can be obvious, repetitious, and tiresome. Handled by a master like Sithium the subtle continuity of rhythm makes the smallest ripple in the drapery an integral and important element. Follow, for example, the line on the left, starting at A and falling downwards in a gentle curve through B, C, D, and E. On the right, the counterpart of this line is even more elusive, since it skips and follows along inconspicuous ridges (F, G, H, J) in the drapery. The technique of controlling your spectator's attention is an art that every painter should learn, and to do this without making it obvious is to make it more effective.

As an exercise, design a landscape with a single dominant focal point. Make all the lines of the composition either converge on this point, or act as fragments of a frame for it. The difficult part of this assignment is to do this without making the design so obvious that your viewer becomes bored.

116

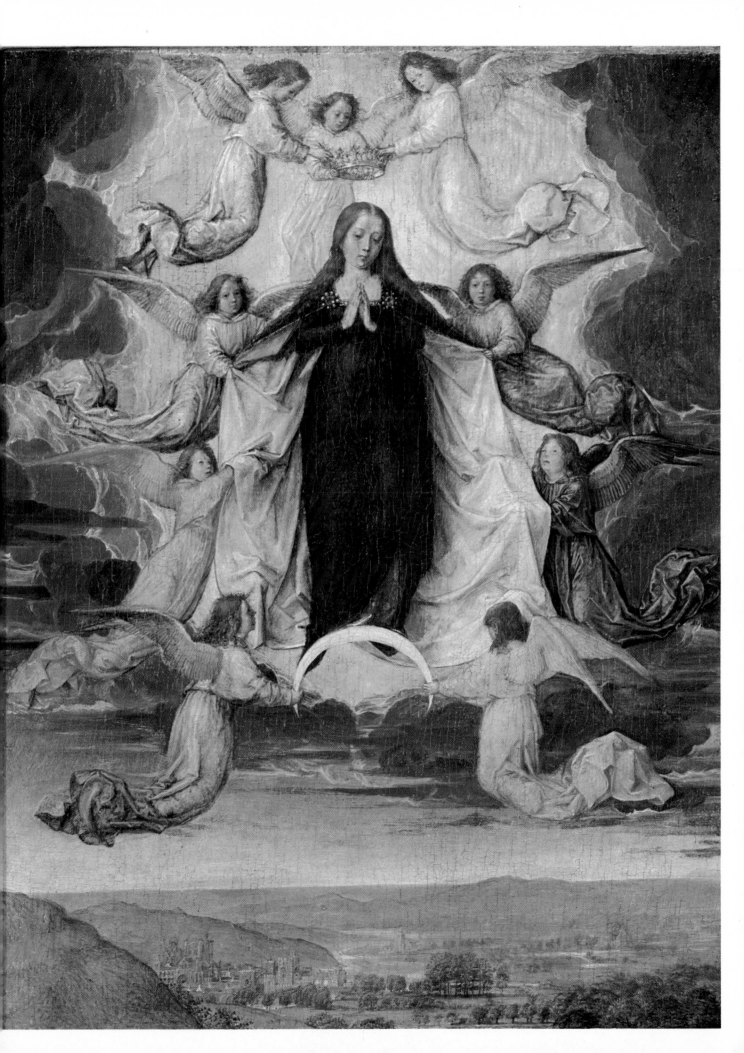

WINSLOW HOMER
American 1836-1910

RIGHT AND LEFT
Canvas, 28¼ x 48⅜ in.
Gift of the Avalon Foundation 1951

"When I have selected the subject," Homer was quoted as saying, "I paint it exactly at it appears." Using this famous quotation as a justification, critics have usually claimed Homer as a great champion of realism, and they have sometimes forgotten how complicated the business of "selecting" a subject was. Neither Homer nor anyone else ever saw a scene like this (and lived to tell the tale). The convincing realism of the ducks, and the shock that you are looking down the barrels of a shotgun, serve to camouflage an involved and subtle design. Basically, there are four horizontal bands (A, B, C, D), which are linked by series of repeats and keys. The most obvious link is the wave crest between A and B. Note the shapes of the wave. At E it has a jagged series of points; at F it is a single, more rounded, form; and at G it is a slightly curved hook. Now look at the links between bands B and C. The webbed feet of the ducks (H) have been carefully emphasized to repeat the jagged motif of the wave. The beak of the falling duck repeats the wave below (J), and

the bow of the boat and lip of the wing repeat the curved hook (K). Observe that two of the three keys are used again to link the last two bands (C and D): the webbed foot at L and the wing tip at M.

Homer, like several other masters (notably Pierre Bonnard), liked to leave problems for the spectator to solve. For example, the hunters, half hidden behind the swell, are placed in an optically challenging and slightly confusing position. Similarly, there is doubt about the line N. Is it a bank of fog, or the horizon of the sea? The rim of the sun (O)—barely visible in this area—emerges only after careful study. Note the pin feather at P. This serves as an exclamation point for the whole composition. Cover it with your hand and you will see at once how much depends on this bit of fluff.

As an exercise, paint a row of houses which are separated by sharp vertical lines. Try to bridge these vertical barriers by using design repeats and interlocking elements.

Eugène Boudin
French 1824-1898

The Beach at Villerville
Canvas, 18 x 30 in.
Chester Dale Collection 1962

A frieze composition—figures grouped in a long horizontal band—poses a special problem to the artist. In a case like this, it is generally not advisable to have a single focal point, since the eye cannot encompass all parts at the same time. The artist is more or less obliged to have a series of focal points which lead into one another and encourage the spectator's eye to pass over the band like a relay race baton, with the hope that the baton will not get dropped.

Boudin—like many artists who paint waterfronts—became a specialist in solving the problem of frieze composition. Although the figures in this painting look as though they were grouped in a solid herd along the water's edge, there is a rather complicated ground plan which emerges as you study the picture. The way leading into the composition is guarded by the dog (A). Having gotten by him, you stroll over to the group B. The yellow ochre, the high tone of the white dress (C), the fleck of white lining (D), and the parasol (E) make it obvious that this is the principal group. From here your eye strolls along to the left. The cloud at F and the red coat at G

both urge you to turn in this direction. There is another charming pair of ladies at H. The interesting silhouette at J urges you to go further. The child playing in the sand at K gets a passing glance, as do her parents at L. And so your promenade by the seashore ends, and it has been very pleasant thanks to Boudin's skillful guiding.

The details of a composition like this were probably not worked out in advance. Boudin evidently first brushed in the sky and beach, then blocked in the general groupings of figures, and—with this as a base—he started to improvise with accents and colors to take you on your evening's outing.

As an exercise in frieze composition, paint a long, narrow picture, using any subject which pleases you: figures, trees, houses, automobiles, or even abstract shapes. Now try to arrange these figures, placing accents and colors to lead your eye through the groupings without getting lost on the way. Improvise with the same devices which Boudin has used, and try to make your design so subtle that your spectator will not realize he is being led.

Detail no. 1

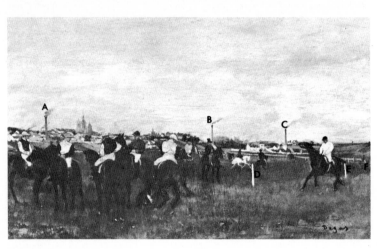

Detail no. 2

EDGAR DEGAS
French 1834-1917

THE RACES
Canvas, 10½ x 13¾ in.
Widener Collection 1942

You can learn at least one lesson from this sketch: no matter how many rules there are for a design, a man of genius can always come up with an entirely new solution to a problem.

Study this composition carefully. The sky—two thirds of the picture—is a blank. The foreground is a muddy field. Practically the entire action and interest is concentrated along a narrow band near the horizon. An extraordinary feature is that foreground objects and the distant town are mixed together (see detail no. 1). Both color and shapes are repetitive and, at first sight, confusing. In spite of this, each figure and each element on the horizon emerges clear and distinct. A lesser artist would have emphasized the legs of the horses to help separate the apparent confusion. Not Degas. He deliberately concentrates all your attention along a narrow frieze, and thus creates an entirely original plan and design. In detail no. 2, note how he has placed a few vertical accents to act as anchors: the distant chimneys and the white posts (A, B, C, D, E, F). These act like periods in a dramatic narrative and help keep order in an otherwise chaotic mixup.

As an exercise, try a similar composition with a still life arranged on a window ledge, placing your objects so that they are in front of the horizon line. In the background paint trees, houses, and automobiles. See if you can keep a sense of order and space between the conflicting elements.

Detail no. 1

Detail no. 2

AELBERT CUYP
Dutch 1620-1691

THE MAAS AT DORDRECHT *(slightly trimmed)*
Canvas, 45¼ x 67 in.
Andrew Mellon Collection 1940

At first sight the design in this painting seems simple and straightforward. In fact, neither the problem nor the solution are as easy as they look. First of all, all the action is concentrated in a small space, a narrow band along the water's edge. Dutch artists, like Cuyp, living in a completely flat country interlaced with water—without mountains or cliffs to break the horizontal monotony—were the first to realize that light and shade, properly handled, can compensate for any deficiencies in the structure of a landscape. Moreover, the Dutch artists realized that the sky and clouds provided endless variations, which could often complement and accentuate the long, low landscape beneath.

In this picture there is no doubt about where your eyes are supposed to look first. In detail no. 1 the shroud (A) on the big boat points like a spear at the intersection with the horizon, where a black figure stands in a small row boat (B). Just in case you do not look here, Cuyp has also made a sharp contrast between the dark silhouetted figure and the pale, silvery background, and has placed the figure next to the bright patch of red (C). If you are in any further doubt, Cuyp has placed the Dutch national flag waving conspicuously directly over this point (D).

After your eye and attention have been drawn like a magnet to this figure—who, incidentally, is the King of

England returning from exile to his country—Cuyp offers two alternative routes. Either you can let your attention wander onto the boat (E), where there are various amusing by-plays among the sailors and from there your eye can join the group in the small boat off the bow (F). In detail no. 2 note that Cuyp has placed two design accents here: the oar—almost touching the anchor line—(G) and the bow of the boat beyond, the tip of which almost touches the side of the ship (H). This device of making two different objects almost touch invariably draws the eye of your spectator and makes an otherwise commonplace design into an exciting optical experience.

Return to detail no. 1. Cuyp has provided a second route for your eye to follow. You are free to explore the many channels between the moored craft on the left (J). Note how the painter seems to bar your way, arousing your curiosity at L, and making you more anxious to see beyond.

A close study of this picture provides valuable information about the technique of design. As an exercise, try to solve a similar problem. Take, for example, ten automobiles parked along a road, or ten apples on top of a table, and make a composition which will hold the spectator's eye and attention and which, in purely abstract terms, will also be rewarding and interesting.

124

REMBRANDT VAN RYN
Dutch 1606-1669

THE MILL *(slightly trimmed)*
Canvas, 34½ x 41½ in.
Widener Collection 1942

For almost two hundred years, this painting has served as a painting lesson to landscape painters. Constable, Turner, and countless others have acknowledged their debt to Rembrandt in general, and to *The Mill* in particular. It is not easy to state in words the reason why this painting has had such a mesmeric effect for so long on so many people. For Rembrandt, the son of a miller, the picture may have been a summation of the golden memories of his childhood. For the Dutch people, who fought the most desperate battles for their freedom near this site, the picture may have been a patriotic document; but for the rest of us who fall under the picture's spell there are other reasons.

One reason—and this is something a young artist would do well to note—is that the picture appears to be straightforward and easy to grasp: a twilight view of a windmill overlooking a river. There is a certain majestic simplicity which is arresting and impressive. But this is only the beginning. The rest of the picture emerges only after careful study. Almost lost in the gathering shadows there are other worlds, each as complex as the overall picture. In the foreground groups of people emerge (A), and over the bridge (B) a herd of sheep comes down to the water. On the distant shore (C) houses and animals are suggested, making a picture within a picture. The mill itself is part of a complex structure, with houses and stone barns (D) perched or built on the curved ramparts and filled with unexpected recesses.

This hide-and-seek-and-find challenge is, of course, not the main reason for the picture's greatness, but it is a factor. Rembrandt never reveals everything at once; there is always a great deal left to the spectator's imagination. Therefore, the viewer is invited to take part in the process of creating the painting, and there is nothing which gives a viewer more pleasure than being asked to contribute in this way. Conversely, there is nothing more tiresome than being told all the details. A hint is always more effective than a cataloguing statement.

126

Jean-Baptiste-Camille Corot
French, 1796-1875

A View near Volterra
Canvas, 27⅜ x 37½ in.
Chester Dale Collection 1962

At first this scene looks informal and unplanned. In fact it is neither. Your eye ambles along the road as easily as the rider's horse. Every instinct focuses first on the rider (A). The main reason for this is that a human figure is always interesting. Second, the white horse and dark shadow cast by the rock (B) make a sharp contrast, and the eye is always attracted by violent changes either in color or tone. Third, the pattern of shadows at C arrests your attention. Nowhere else in the picture is there such sharpness or such striking light-and-shade pattern; you are *forced* to look here. Afterwards, in your imagination, you may continue along the road until you round the corner at D, or you may take flight towards the blue horizon over on the left. As usual, Corot rewards an attentive viewer by paying a small dividend for careful looking: half-hidden among the trees is the figure of a monk at prayer (E).

The student is often convinced that the master landscapists worked out of doors, painting directly from their subjects. In fact, very few great landscape artists worked this way. (Monet was an outstanding exception). Practi-cally all those painters made notes or sketches, which were combined later with memories and edited in the studio to produce pictures which may, or may not, be of recognizable scenes.

This view was not only painted in the studio, but was painted in a different country and years after Corot had seen the subject. This is a golden memory of his student years in Italy, painted in France. In spite of this long separation and the fact that the scene is probably largely imaginary, the details and the quality of light are precise. His memory, aided probably by pencil and oil sketches, has caught the mood with more force than if he had been painting there on the spot. Memory tends to sift out unimportant detail, leaving a truer image than the eye actually can see on the spot.

Practically everyone has some favorite view which they will never forget. As an exercise, paint from memory a landscape which you remember with particular clarity. It may not be exact, but it probably will have an emotional appeal which a more impersonal approach would never give.

128

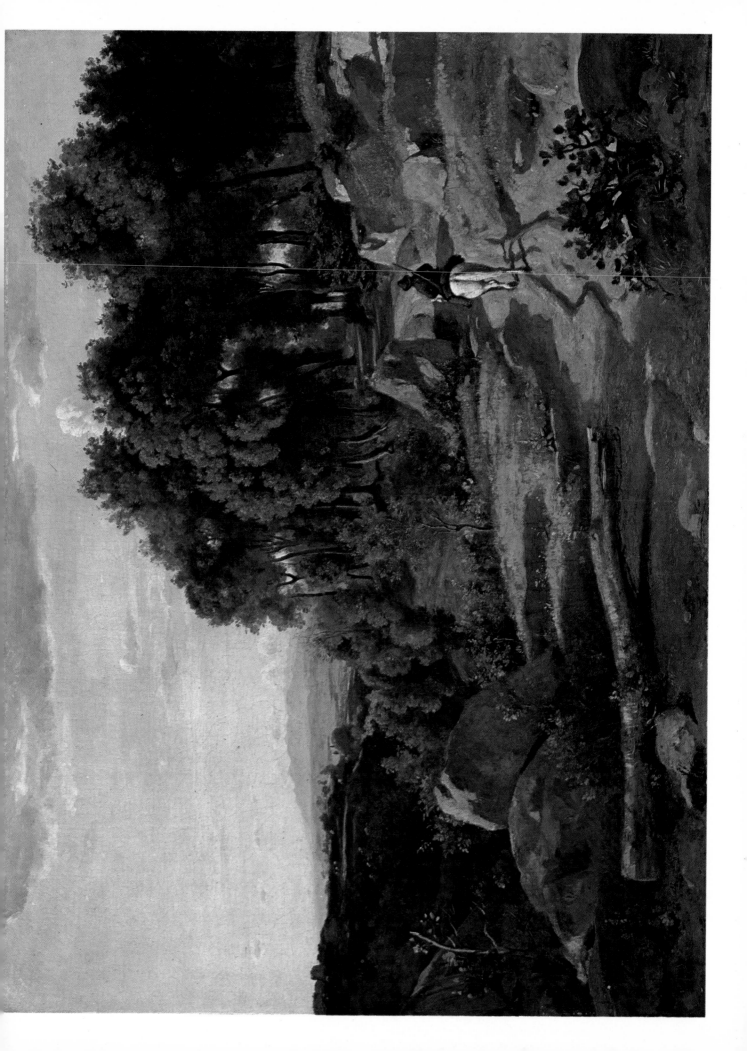

Overlay no. 1

Detail no. 2

EL GRECO (Domenikos Theotokopoulos)
Spanish 1541-1614

SAINT MARTIN AND THE BEGGAR (*slightly trimmed*)
Canvas, 76⅛ x 40½ in.
Widener Collection 1942

There was a theory that El Greco had an eye defect which made him see figures with abnormal elongated proportions. This theory underestimates his talent as an artist. Like all great painters, El Greco sensed the effect of his pictures on the spectator's eye, and the elongated proportions are the result not of any physical abnormality but of his intuition and possibly carefully calculated planning. Whatever the motive, the results are obvious. His attenuated figures seem to be suffused with a kind of ecstasy. It is very difficult to imagine the same effect produced by fat or squat figures. Besides the attenuated figures, there are other considerations which contribute to the effect of emotional tension. For example, note the design. The picture is split down the middle—as though cut with a sword—by a line that culminates in the Saint's head (A, B in overlay no. 1). This channels your eye to the Saint's face; even the clouds part to make way for the head. Interlaced with this central axial line is the strong

diagonal E-F, and the S-curve C-D, which—like a flowing current of energy—unites the two figures.

These links are emphasized by a series of secondary accents, some of which can be studied in detail no. 2. El Greco intended to stress the intense emotion of the shivering wretch as he looks towards the Saint. The area of light at G helps to emphasize the direction of the Beggar's look. The light area under the chin (H) stresses the angle of the head. The very bright light in the eye (J) gives an expression of burning intensity. Even the direction of the brush strokes at K, L, and M, emphasize the directional flow towards the upper right. Note that there is no accent at N, behind the head, which would have counteracted the effect of the others.

As an exercise, paint—in monochrome—a picture of a hand pointing to the left. Using brush strokes and value accents, make all the lines of emphasis follow in the direction of the pointing index finger.

130

PIETRO PERUGINO
Umbrian, probably 1445-1523

THE CRUCIFIXION WITH THE VIRGIN, SAINT JOHN,
SAINT JEROME, AND SAINT MARY MAGDALEN
*Transferred from wood to canvas, middle panel,
39⅞ x 22¼ in.; side panels, each, 37½ x 12 in.
Andrew Mellon Collection 1937*

A painting is no finer than its smallest detail; if the secondary motifs have a painterly quality, then the painting as a whole is probably a first rate work.

Note the precision of the flowers here. Each species could be an illustration in a wild-flower manual, and are composed as carefully as the design of the whole altarpiece. Note also the pile of rocks. The dominant motif is the boulder (A); this motif is accentuated by the dark wood and concentric arrangement of stakes (B, C and D) and by the higher intensity of light falling on it. The chiseled facets on the right (E) have been modeled with painstaking accuracy. Note also the frame of shadows (F) separating this stone from the others. The miniature mountain range and several mainlines of the composition lead to this boulder (L and N). In order to avoid confusing and competitive detail, plant forms on the same plane have been deliberately subdued (P). On the other hand, those which lead the eye towards the boulder have been strengthened (Q). On a small scale, this whole section has been treated as a major composition, worthy of every finesse and technical mastery which Perugino had at his control.

Microcosms like this very often contain the seeds of greatness, and many an expert will base his judgment of a painting on a study of such apparently minor details.

FRANCISCO DE GOYA
Spanish 1746-1828

VICTOR GUYE
Canvas, 42 x 33½ in.
Gift of William Nelson Cromwell 1956

The effectiveness of this portrait derives from three elements which are contrasted with one another and held in equilibrium. First is the solid dark mass of the background and floor. Except for a shadow, there is nothing in this area to show light, materials, or distances. The boy might be in outer space. Second, notice the gold and frill of the page-boy costume. This is in complete contrast with the background: busy, specific, high-toned, and glittering. Like a series of outstretched hands, the repeated Vs in the costume (A) seem to lead up to and hold the head. The third element is of course the boy's head, for which the rest of the picture is, in a sense, only a frame. Again, the brush handling, color, and tonality of this area are in complete contrast with the other two areas. The outlines in the face are soft and the brush strokes are caressing, as opposed to the brittle blobs on the jacket (B).

The use of contrast should be studied by painters with great care. Try to imagine what this picture would be like if the background had been filled with distracting detail,

or had been less extensive, or in a higher color key. Or, again, what the effect would have been if the jacket had been in simple flat colors.

Goya, the father of many children, knew his subject well, and has treated the boy with understanding and sympathy. He treated the clothes, on the other hand, as a caricature of officialdom. The boy was the son of a French general who had been sent to Spain as part of the occupation forces of Napoleon. Goya probably detested the father, but he was too much of a student of human beings to let his hatred spill over onto the boy.

As an exercise, paint a landscape divided into three sections: sky, foreground field, and a house in the field. Use three different types of brushwork: flat, even color for the sky; heavy impasto, brilliant colors, and bold brushwork for the field; and smooth, carefully modulated tones for the house. The problem will be to achieve unity and not detract from the focal point, i.e., the house.

134

Detail no. 1

Detail no. 3

Detail no. 2

Detail no. 4

CANALETTO
Venetian 1697-1768

THE SQUARE OF SAINT MARK'S
Canvas, 45 x 60½ in.
Gift of Mrs. Barbara Hutton 1945

A *piazza* is a place where people go to spend their leisure time meeting friends, shopping, and watching spectacles. Canaletto provides the same kind of entertainment in his picture. Within the framework of famous buildings he paints a series of smaller pictures representing pleasurable aspects of Venetian life. The fascination of his approach is that each is a separate and complete entity, like a series of short stories or one-act plays. These pictures within a picture can be isolated as in the details here, and each is a well composed and interesting work of art in its own right. The group conversing (detail no. 1); the tradesman waiting for a customer (detail no. 2); the outdoor sermon

(detail no. 3); and the men-of-war at anchor (detail no. 4). There are at least ten other miniature scenes in this painting.

To incorporate so many independent elements into a single composition requires, first, a very skillful design and, secondly, cross-links of color and repeat motifs. Most important is the unifying effect of the short, blunt brush strokes.

As an exercise, draw a bird's-eye view of the neighborhood in which you live, showing at least ten different activities of your neighbors, and try to combine the ten scenes into a unified whole.

136

THOMAS GAINSBOROUGH
British 1727-1788

LANDSCAPE WITH A BRIDGE
Canvas, 44½ x 52½ in.
Andrew Mellon Collection 1937

This painting appears to be a factual record of golden sunlight, summer haze, country folk, and leisurely living. Look again. You cannot be sure whether the landscape is English, American, or Italian. You cannot tell whether the trees (A) are evergreens, oaks, or beeches. You cannot even be certain that the round objects on the roadway (B) are sheep or boulders of rock. There is good reason for this vagueness. The landscape never existed except in Gainsborough's imagination. We know from his correspondence that occasionally—as a break from his round of portrait painting—he used to go into the kitchen, clear away the table, and arrange lumps of coal, sticks of wood, piles of sand, pieces of glass, heads of broccoli, and anything else he could find, forming an interesting pattern on the table. Then he would construct in his imagination landscapes based on these assorted objects. Actually, what he finally painted was not a landscape, but a mood. In this case, it is a mood of

peace and quiet. Gainsborough ranks as one of the founding fathers of the great landscape tradition, and it is amusing to think that such great art was begun on a kitchen table.

You can learn a lesson from this. Most people collect things for no reason except that they like to feel and look at them. Many painters have made their favorite knick-knacks and bric-à-brac into themes for a life-time work (see Harnett). There is no reason why a painter should not use miscellaneous stage props as a spur to his imagination. Try it sometime. Children's building blocks make a good basis. Mix them with plasticine, plastic bottles, and anything else you have around: electric light bulbs, mops, tissue towels, or, like Gainsborough, heads of broccoli. You don't have to paint a landscape. Paint a moonscape or, if you prefer, just an exercise in non-objective space and form.

138

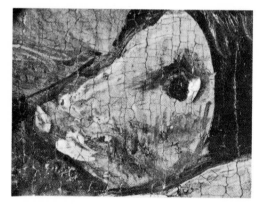

Detail no. 1

Detail no. 2

HIERONYMUS BOSCH
Flemish c. 1450-1516

DEATH AND THE MISER
Wood, 36⅝ x 12⅛ in.
Samuel H. Kress Collection 1952

The approach of death is a theme worthy of a great artist. Here Bosch marshals all the forces of his genius to express a mood of grim inevitability. The colors are autumnal and dry. Even the paint is thin and desiccated. The shapes are stiff and old. Study detail no. 1. It would be difficult to imagine this figure in a scene expressing any other emotion than fear. And yet it is not easy to pinpoint the reasons why this is so. The cruel smile and the sword-shaped wings are obviously sinister, but there are other, more subtle and more telling reasons. Look at the shape of the black hood. The sharp right angle at A conjures up the image of a war machine. Similarly, the pointed wing at B—with the round dot on top—is an unnatural configuration. If the dot had been larger, or smaller, we might have accepted it, but this size leaves a disturbing impression of evil. The ring of spikes at C is also disquieting; some foul insect or poisonous tropical plant might possess such a fringe. Again, the creases at the

elbow (D): the material is harsh and stiff, and the folds are like a healing flesh wound. The light falling on the head is directly from above, as though the man were standing trial in a prisoner's dock. These are all minor points—and the figure is only a small part of the painting —and yet, cumulatively, these elements build up an impression of fear, evil, and pain. Notice detail no. 2. Again, this is only a small section of the painting, but the impression of this detail is very similar to that of detail no. 1. When all the various elements in a painting express the same emotion or concept, the final effect will be conclusive and overwhelming. The painting will carry conviction and purpose—although most people who look at your painting will not be able to analyze the reasons for its success, or realize why the effect is so strong.

As an exercise, try to paint a scene of horror, using these same devices. Perhaps you too have the same quality of imagination as Bosch had.

140

PIETER BRUEGEL THE ELDER
Flemish c. 1525-1569

THE TEMPTATION OF SAINT ANTHONY
Wood, 23 x 33¾ in.
Samuel H. Kress Collection 1952

One of the oldest tests of an artist's imagination is the story of Saint Anthony. According to medieval legend, the devil, having unsuccessfully tried to weaken the Saint's resolve by tempting him with the delights of the flesh, decided to drive him out of his mind. The devil therefore opened the gates of hell, and called forth all the demons, monsters, horrors, hybrids, and changelings which are supposed to torture the souls of the damned. These creatures were ordered to break the Saint's spirit. Saint Anthony survived the onslaught, becoming the saintly symbol of triumph over fear, evil, and the devil.

From an artist's point of view the ancient legend was a challenge. Just how horrible can the world become? Bruegel populated his sinister forest with slimy fish-toads and winged beetle-men and, in the skies, monsters in weird machines swoop and hover.

There is an important point to note in this design. The principal figure is hidden and this, in a way, introduces an added note of horror. You are forced to travel through a nightmare landscape before you find the center of interest. Your eye goes from A to B in the sky, to C,

D, and E, and finally comes across the hermit Saint in his lean-to, at F. There is a psychological reason for this, which is worth introducing into your own work if you wish to convey an impression of terror.

All of us have subconscious fears of certain things and situations—spiders and snakes, hands in the dark, drowning, to name a few. Try to combine all these horrors in one picture and, like Bruegel, paint the most terrible world you can imagine. Use your own experiences and a familiar setting—the street or house where you live, for example. People it with every repulsive thing or creature that you can conjure up. Your picture does not have to be realistic; some purely abstract shapes can be terrifying. You too, like Bruegel, may produce a picture both terrible and beautiful. Some outstanding modern painters have made fame and fortune by exploiting the sense of horror (Max Ernst, for example). You too may have that particular quirk of imagination which can imagine the horrible, and you too may produce a fine painting: there is no way of telling until you try.

142

Detail no. 1

Detail no. 2

MATHIS GRÜNEWALD
German c. 1465-1528

THE SMALL CRUCIFIXION
Wood, 24¼ x 18⅛ in.
Samuel H. Kress Collection 1961

This is a very powerful expression of grief, and a painter can learn a great deal by analyzing the way in which Grünewald achieved such a shattering effect. The first means is obviously the color. The yellow of Christ's body is the color of a corpse; the red in the clothes is that of blood; the contrast of the yellowish green with the red produces a discordant and repelling impact. The indigo of the sky—unrelieved except for the moon—is a terrifying cloak of darkness. The livid ash gray of the faces add a chilling note. The color scheme itself—quite apart from the subject—gives the effect of death, decay, and pain.

The real impact of this picture, however, is derived mostly from the rhythms of design. Study the body. The ragged edge of the cloth reinforces the hideous marks of lacerations on the flesh. The spikes in the body are painted with a rough and savage brush stroke which seems to duplicate the blow of an executioner.

Now look at the hand in detail no. 1. Like any living thing which has been pinioned and allowed to die, the fingers are cramped in the last agony of death. The rhythm of this design is, by its nature, agonizing. Lastly, look at the head in detail no. 2. Even the brush strokes used to draw the eyes are like the lashes of a whip. The thorns of the crown, ready to gouge into the eyes, are reminiscent of the claws of some savage animal.

This is an overwhelming expression of pain and sorrow because everything in the painting contributes to the same effect: color, design, brushwork, and, of course, subject. If any of these elements had been out of key with the rest, the total effect would have been softened.

As an exercise, find some bird or other creature that has died. Lay it on the table, and try to paint it using the principles described in this picture. The result may not be pleasing, but if you have followed the above description you should be able to convey an idea of death.

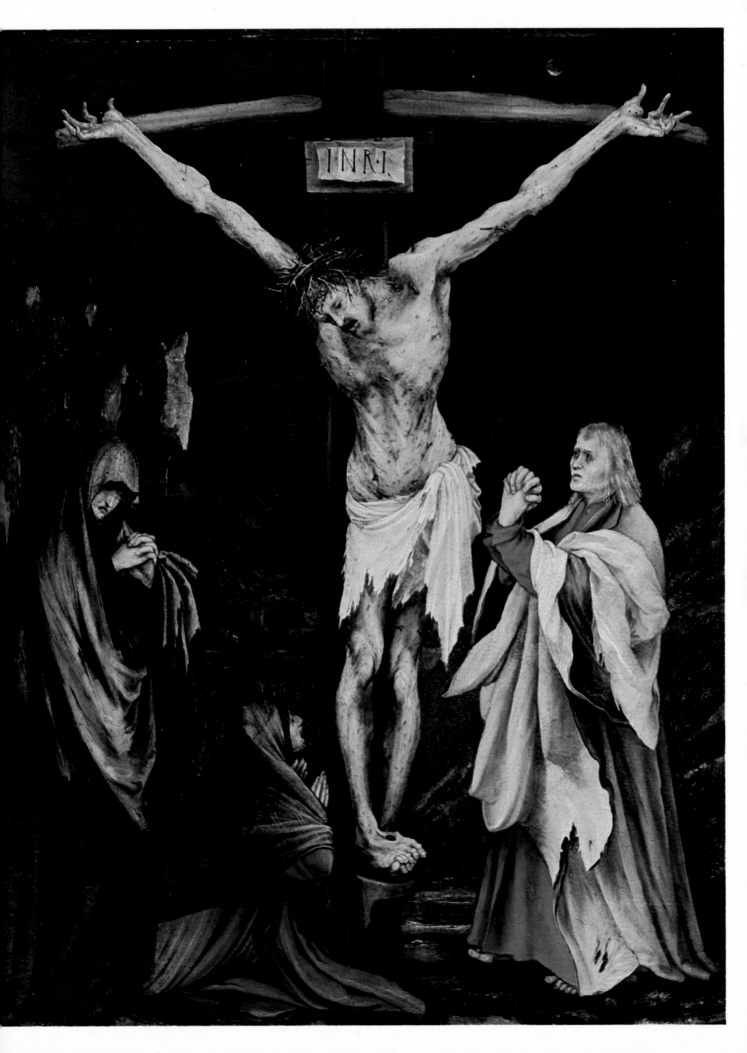

Detail no. 1 Detail no. 2

CANALETTO
Venetian 1697-1768

VIEW IN VENICE
Canvas, 28 x 44 in.
Widener Collection 1942

The painter who paints exactly what he sees and makes no
efforts to edit the details—changing some, passing over
others, and emphasizing others—is apt to produce a dull
painting. Unedited nature usually is untidy and monoto-
nous. The artist must take what is given to him, and
recreate the scene in such a way that the viewer is unaware
of being tricked by the painter's sleight of hand. The *View
in Venice* is a marvelous example of this kind of finesse.
First, the Piazza really looks like this; all the buildings are
situated exactly as Canaletto has shown them. After he
had drawn them correctly (probably with a sort of me-
chanical copying device), he was faced with the duty and
task of transforming three pictorial elements from the
everyday into a fascinating interplay of light and design:
the people were the first element, a few moveable props
the second, and the light was the third.

Now let us see how he transformed these three ele-
ments. Study detail no. 1. In the lower left, the doorway
is black and dull and very similar to the other entrances
along the canal. Therefore, Canaletto places a bright prow
decoration on a gondola (A) in front of this entrance.
The windows above the doorway are also too similar.
Canaletto therefore places a figure looking out of one of
them (B). A lesser painter might have placed another
figure higher up—an effect that would have been repeti-
tious and obvious.

Reflections on the canal tended to be monotonous.
Canaletto therefore breaks the expanse of water with red

trousered gondoliers, and a line of moored gondolas (C
and D). The bridge is too severe and too even. So Cana-
letto places three figures on top of it, silhouetted as if by
accident against the dark trees (E). Below, a brightly lit
gondola breaks the dark area, and upright mooring poles
(F) even further interrupt the line of the span.

The way Canaletto breaks through the optical barrier
of the long shadows (G to H) beginning at the base of
the monument is most interesting and instructive. No less
than five figure elements help your eye over this hurdle
(J, K, L, M, N). The shadows cast by the church have
another set of guides carefully placed. And so on and so
on. The longer you look, the more subtle little aids you
find.

As a matter of interest, notice what happens when
Canaletto cannot introduce a device to accentuate an ap-
parently accidental element. At O the statue is lost and
confused with the background. Since this area is so far
from the ground, Canaletto could not introduce people or
accidental shadows, and he was too proud, or too clever,
to introduce a flock of pigeons.

Detail no. 2 (which is from another painting by Cana-
letto) illustrates the artist's techniques very clearly. The
architectural background is blocked in, as at P. The figures
are then applied in shorthand calligraphic brush strokes,
sometimes with several colors and tones (Q), and some-
times with no more than a few dots and dashes (R).

146

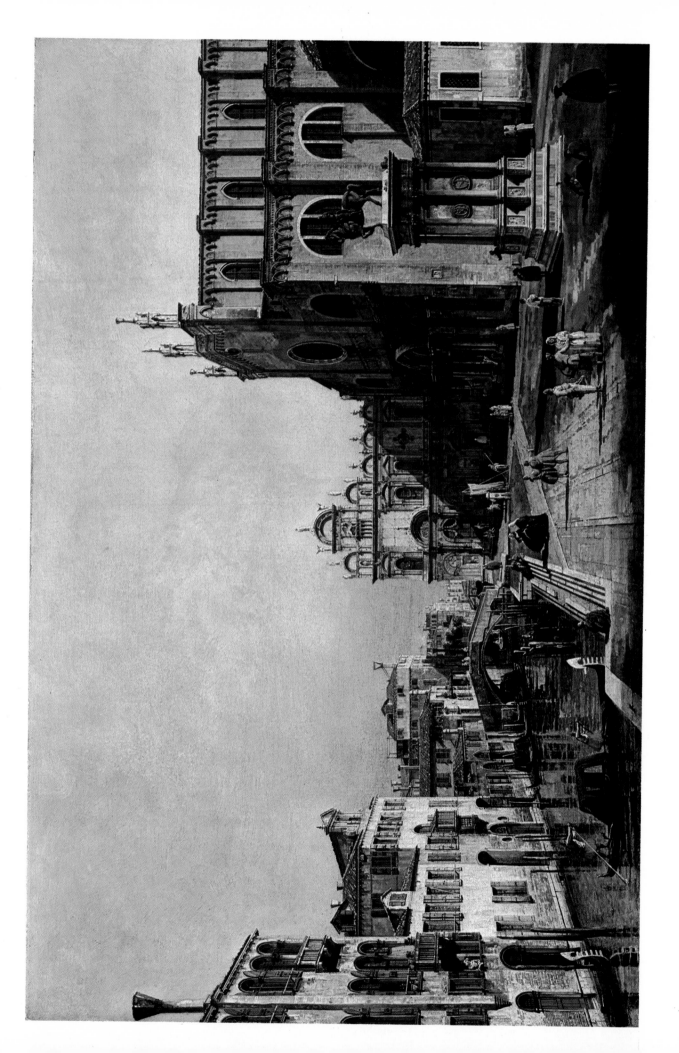

SIR ANTHONY VAN DYCK
Flemish 1599-1641

MARCHESA BALBI
Canvas, 72 x 48 in.
Andrew Mellon Collection 1937

Artists, since prehistoric cavemen, have exaggerated and altered what they saw in order to achieve a desired effect. Van Dyck, a brilliant draftsman and portraitist, wanted to give the impression of a gracious and aristocratic presence in this portrait, and for that reason he practically eliminated the body of the attractive marchesa. He placed her head so near the top of the frame, and made her appear so tall as a result, that instinctively you feel inferior, and look up to her as though she were seated on a royal dais. If you try to analyze the forms under the silk brocade you realize that her proportions are impossible. Her head-to-body ratio is about 8:1, and therefore abnormal to the point of deformity. It is doubtful whether van Dyck's patrons in the seventeenth century, or anyone except a painter, would notice this; nor is it important. To achieve a desired effect any distortion is justified, as long as it does not at the same time destroy or negate the overall impression. Distortion becomes tiresome or irritating when it is pointless, when it is introduced as a diversion or as a cloak for ignorance. A good painter will never deliberately falsify unless he has a good reason for it.

As an incidental note of design, look at the lower right corner. The curl in the rug stops and anchors the strong diagonal sweeping down from the upper left corner, and thus your eye is returned from this section of the outfield back into the main picture area.

148

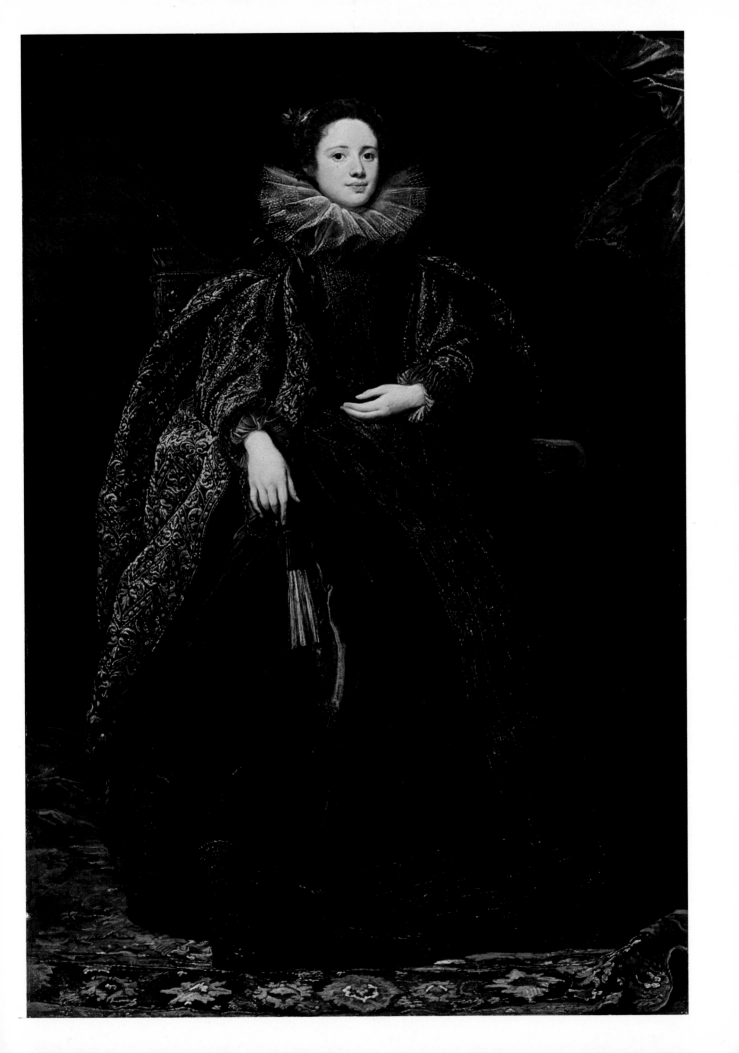

Pieter de Hooch
Dutch 1629-c. 1683

A Dutch Courtyard
Canvas, 26¾ x 23 in.
Andrew Mellon Collection 1937

For more than three hundred years, paintings like this have been treasured as great works of art and sold for fortunes, and a painter would do well to ask himself the reasons for this continuing admiration, and to question whether his own work could be measured by the same standards.

The first reason for esteem is probably de Hooch's craft of painting. The transparency and luminosity of the oil medium have been exploited to the fullest. The glass of wine, for example, glows like a stained-glass window. Notice the subtle blending of colors in areas such as A, a process requiring great skill and patience. The second reason is the respect for the facts of vision. Light does not fall in the same way on surfaces of different texture. The light on the whitewashed wall at B is not the same as that on the worn brick steps at C, or the splintered doorpost at D. Third, there is a searching inquiry into the nature of things. A prime purpose of art has always been to reveal some aspects of truth, either physical or spiritual, seen or unseen. In the detail you see that de Hooch painted a section of wall with as much understanding and sympathy as if he had painted the portrait of a person. The steps are worn slightly more on the right (E) because people instinctively cross a threshold on the side opposite the hinges. There are dirty handmarks of a child at F. The backs of chairs have stained the wall at G. Each brick in the wall (H) has been treated as an individual. Each blade of grass seen through the doorway (J) seems to have been studied with a botanist's eye.

When details such as these are emphasized, they can turn a painting into story-telling sentiment; when painted by a de Hooch, however, they become parts of life, molded by the human beings who make and use them.

Test your power of observation by making a detailed drawing of a chair in your studio. Try to show what kind of materials it is made out of, its age, what kind of care it has had, and what kind of people have used it.

150

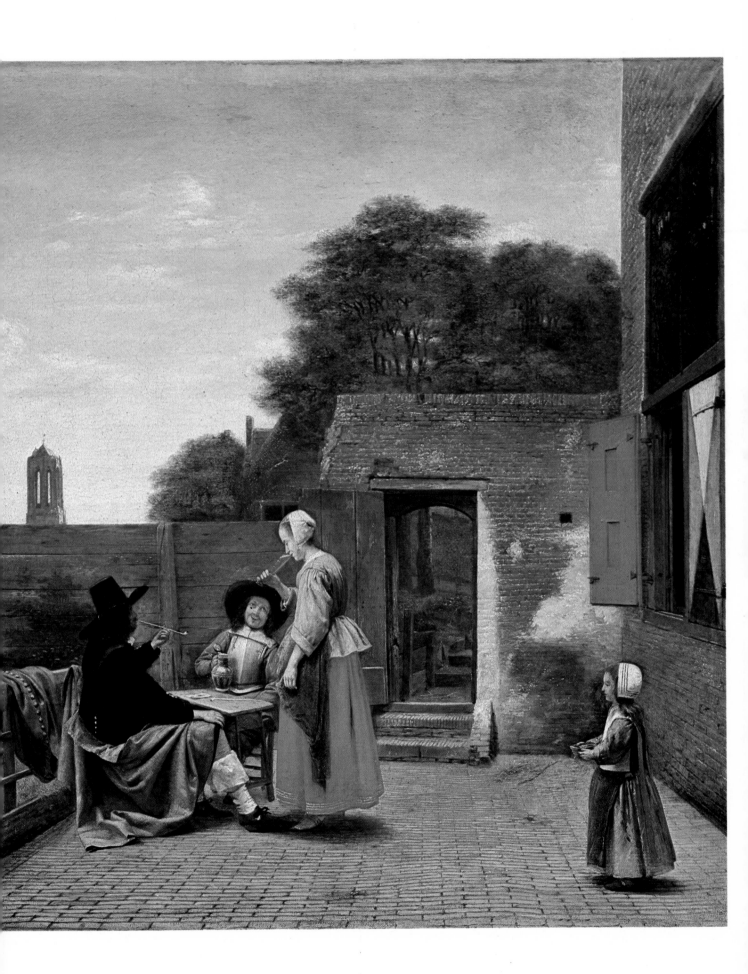

Composition no. 2

Composition no. 3

Composition no. 1

Composition no. 4

LUCAS CRANACH THE ELDER
German 1472-1553

A PRINCE OF SAXONY
Wood, 17¼ x 13½ in.
Ralph and Mary Booth Collection 1947

Students learning the art of portraiture generally do not realize how important the space surrounding a head can be. To illustrate this point, I have made four cut-outs. Composition no. 1 makes the child seem taller, older, and more authoritative. Such a proportion would be effective for a portrait of a soldier or a socially influential person; but for a child, this handling of space is wrong. In composition no. 2, by emphasizing the curls of the hair and roundness of the eyes the child is made more appealing, and the whole painting acquires an air of informality and charm. This format is very common for miniatures, and therefore is especially appropriate for children. In composition no. 3, although the area surrounding the head is about the same as no. 2, the straight sides produce an entirely different effect on the portrait. The sides are too

close and the child is confined; the straight lines emphasize the line across the eyes and mouth, making the child look rather severe and bad tempered. A child should be allowed room to move. If he, or she, does not have space, the child seems to be imprisoned and unhappy. Composition no. 4, again, is an unsatisfactory composition for a child. The surrounding black space is too wide and makes the child look frightened. His hands seem to clutch the robe nervously. The assymmetry suggests that the child is trying to hide in the corner and would gladly leave the picture if he could.

Studying these five different treatments of the same head learn to be very careful about the surrounding space in a portrait. By misusing the space, your best intentions may be cancelled out or altered.

152

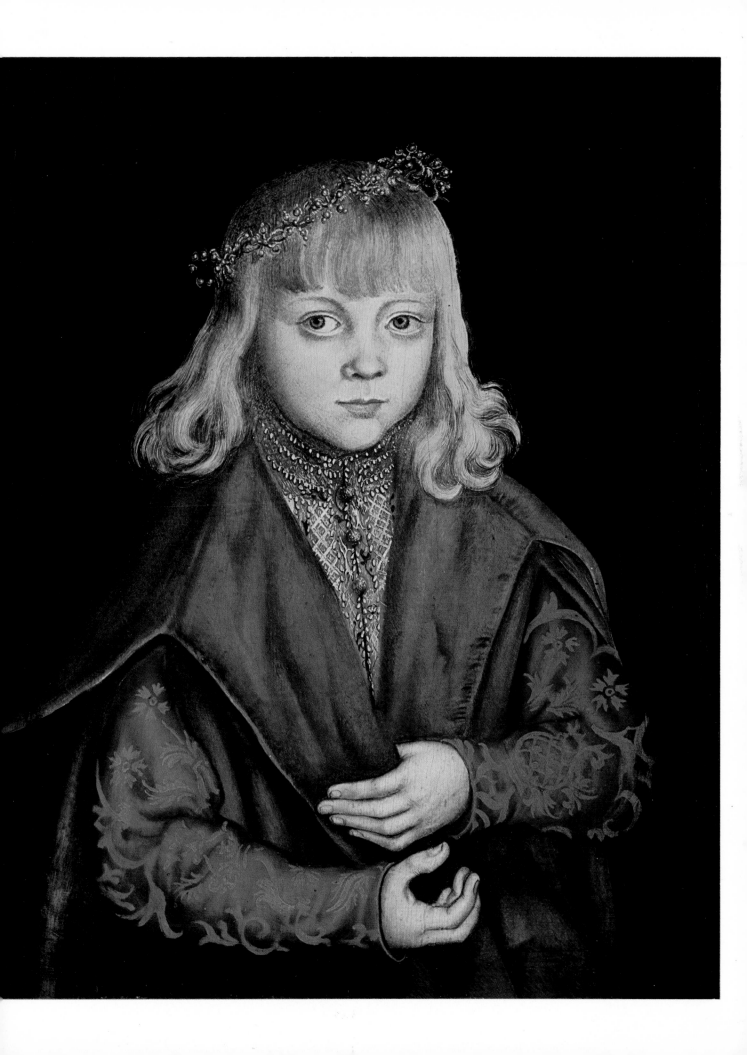

MASTER OF THE SAINT LUCY LEGEND
Flemish, active 1480-1489

MARY, QUEEN OF HEAVEN
Wood, 85 x 73 in.
Samuel H. Kress Collection 1952

The unknown painter of this magnificent panel illustrated a fundamental principle of color harmonies. Stated simply, the only sure test of color is your eye and judgment; there are no hard and fast rules. If, for example, a fabric designer should propose a combination of pinks, oranges, vermilions, and saffron yellows blended with mottled sap greens—all colors used on this panel—he would be called color blind. And yet here the total effect is superb. These color combinations of red, used by themselves, would be offensive, but the painter has modified them by using intermediary colors as catalysts and insulators. Take, for example, the vermilion of the central figure (A) and the cadmium orange of the angel on the right (B). To unite these colors there are six intermediaries. First is the dark green robe (C), which acts as optical

barrier and keeps the vermilion separate; next in sequence is the yellow tinged with red (D); next is the wing, an intermediate color between orange and vermilion (E). From there to the angel the transition is easy: pale blue (F), pale green (G), and accents of dark green (H). On the left, the transition A to J, uniting vermilion with saffron yellow, is handled with equal finesse.

As an assignment and to test your color sense, take any combination of colors, however clashing and unlikely they may seem in juxtaposition. Brush them in at full strength on different parts of the paint surface, and then build the transitions of colors between them so that the final effect is easy and harmonious. Of course, there are times when you may want a jarring, discordant effect to create shock; in that case, these bridges are unnecessary.

154

PAUL GAUGUIN
French 1848-1903

FATATA TE MITI
Canvas, 26¾ x 36 in.
Chester Dale Collection 1962

This picture represents a scene in the South Pacific where Gauguin had fled from civilization in search of an earthly paradise. It illustrates a current nineteenth-century theory that colors, quite apart from the objects associated with them, can produce an emotional reaction.

In this painting Gauguin has chosen a color harmony completely alien to what we ordinarily see in nature. The two shades of purple (A and B) livened by orange (C) and contrasted with the black tree trunk (D) and turquoise water (E) make an exotic combination intended to evoke ideas of strange and primaeval beauty. Note that the colors are strong, relatively pure, in broad areas and not diluted with minor variations. In order to judge the importance color plays in the general effect, compare the black-and-white reproduction with the color version. Without the colors the picture is dull and confusing; with the colors it becomes a window opening onto a world of forbidden pleasures and sensuous warmth.

As an exercise, follow Gauguin's theory by painting a landscape with the most unlikely colors imaginable. For example, try a view with blue trees, red grass, and a brown sky. Such combinations are possible in nature, but not likely, and the effect of such a color scheme would be certainly bizarre. In your painting you will find that you can arouse very strange and confused emotions by playing on the color sense of your spectator and by combining unfamiliar colors with familiar objects.

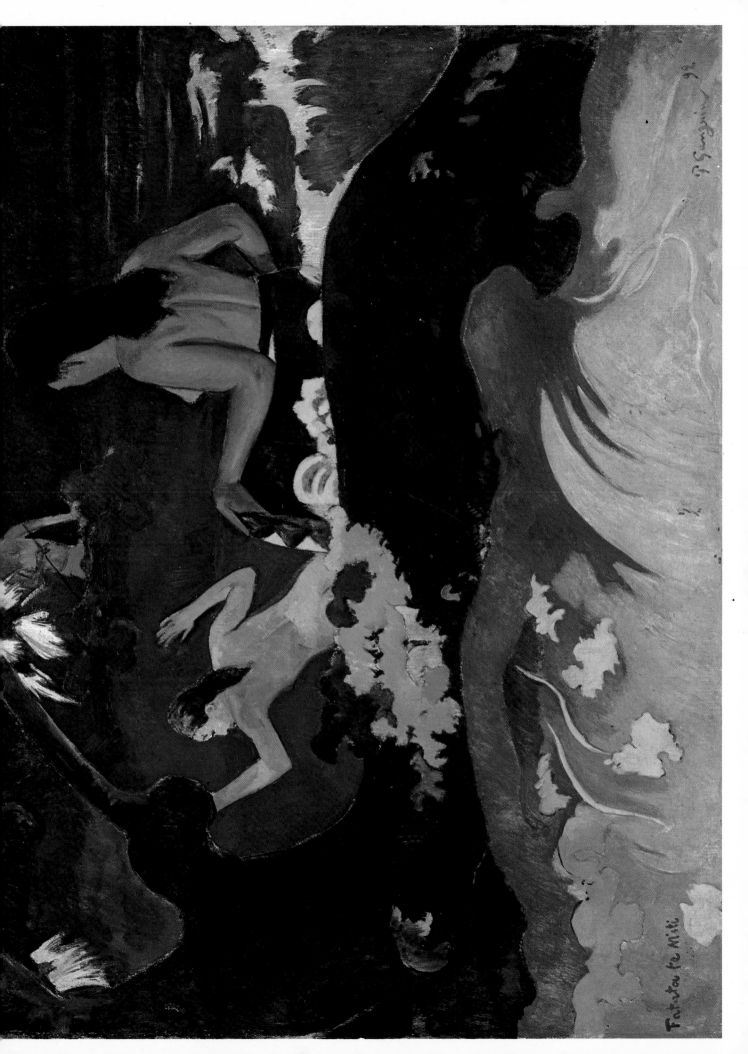

ODILON REDON
French 1840-1916

EVOCATION OF ROUSSEL
Canvas, 28⅞ x 21⅜ in.
Chester Dale Collection 1962

Roussel, the subject of this picture, was a composer of music, and the picture was probably conceived while Redon was listening to the composer's symphonic work. The strange face may be a self-portrait.

Color harmonies that are usually not seen in nature, or have been deliberately changed from what one would expect to find in nature, have the power to evoke a trance-like mood. For example, in this painting you are at first confused by the strange juxtapositions of objects and colors. This confusion passes and, in time, you accept the artist's decisions and become soothed and almost hypnotized by the painting. Color plays an important part in this. The baby blue background (A); the russet complexion of the figure (B), the stemless green flowers floating (C) in the void; the black coat with incised scribbling (D); and the dark gray blob on the beard (E) produce a color combination one might expect to find in a landscape, but hardly in figure composition.

As an exercise, paint a dream still life using sky-blue oranges with silver leaves, a black banana, a white apple, a red melon with green inside; the background can be gold. Make the objects float in space, and see if you can evoke the same kind of mood as in this picture. A picture like this primarily exercises the outer fringes of your imagination; perhaps you will find that you, too, have the kind of imagination that can produce a good painting by combining improbables.

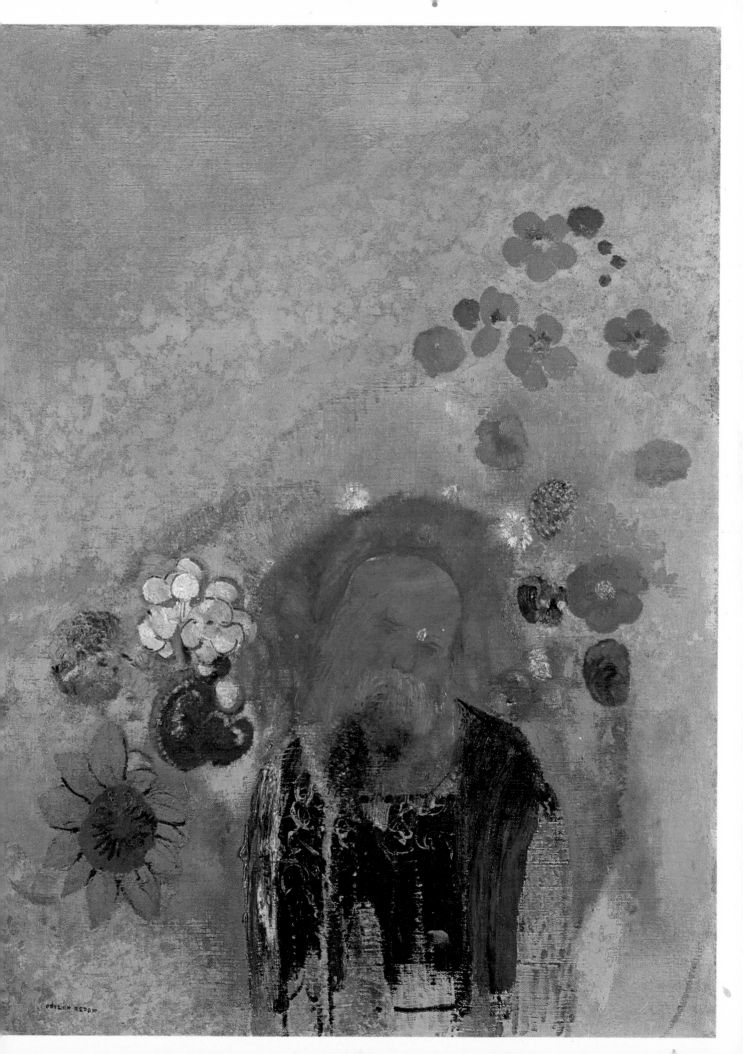

JEAN-HONORÉ FRAGONARD
French 1732-1806

A YOUNG GIRL READING
Canvas, 32 x 25½ in.
Gift of Mrs. Mellon Bruce in memory of
her father Andrew Mellon 1961

Practically everyone who looks at this picture gets a sense of pleasure from it. Children yearn to be older and older people long to be young again; the picture is almost a poster advertising that the happiest years of life are those of the teen-ager. This irresistible impression of quiet enjoyment is partly the result of color. Yellow is the color of sunshine, springtime, and hope. The burnt sienna underpainting gives a warm glow to the whole. Even the greens are the color of spring plants. It is impossible to imagine a cold draught in the room where the young girl is seated. Another reason for the impression of enjoyment is the pattern of quick brush strokes. They seem to create delicate frills and ribbons and soft taffetas even in the down filled pillow, where there are no ornaments. The brush strokes seem to gambol and have a life of their own.

Study the detail. A is an area of transparent burnt sienna underpainting. Over this, pale colors mixed with lead white and probably an oil-resin medium are brushed in freely to give an impression of a two-toned silk (B and C). The frills of the bow at D are rendered with what looks like a piece of wood—possibly the handle of a paint brush—which is used to "write" in the thick paint with an incised line (E). The light catches the irregularities of the paint surface and conveys an impression of delicate material.

As an exercise, try to follow a similar course. Choose any emotion, and make the subject, color, and brush strokes all express the same feeling.

160

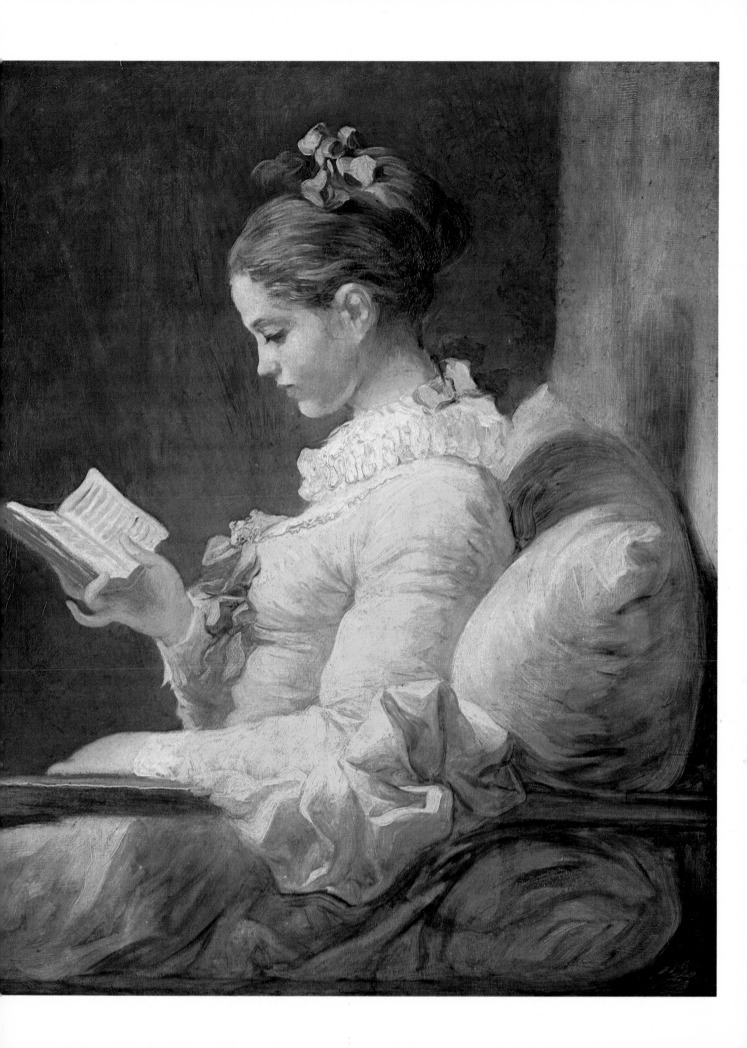

PABLO PICASSO
Spanish 1881-

LE GOURMET
Canvas, 36½ x 26⅞ in.
Chester Dale Collection 1962

There are many different ways to unify a painting. Picasso here uses two methods with supreme mastery. The first is color. The overall blue could have been depressingly icy; however, it is infinitely varied within its own hue. A is a cold blue; B is a green-blue; C is a black-blue; D is a yellow-blue; E is a warm blue, etc. Also, the blue tonality is broken by two areas of warm color, F and G, which form a link with the pink of the child's cheek. Without these warm accents, the effect of the picture would have been entirely different.

The second unifying element is rhythm of design. The child is scooping food out of a bowl, and Picasso has used a curved spoon-shaped design as a recurring motif. You find the same rhythm in the tablecloth (H), the curtain (J), the dress (K), and the hair (L). The whole picture, in fact, is knitted together like a hooked rug by these consonant designs. Many painters, from the painters of Greek vases in 450 B.C. to the present time, have used this device of recurring design. It is simple and effective. If your painting lacks unity, try this simple method of restoring harmony.

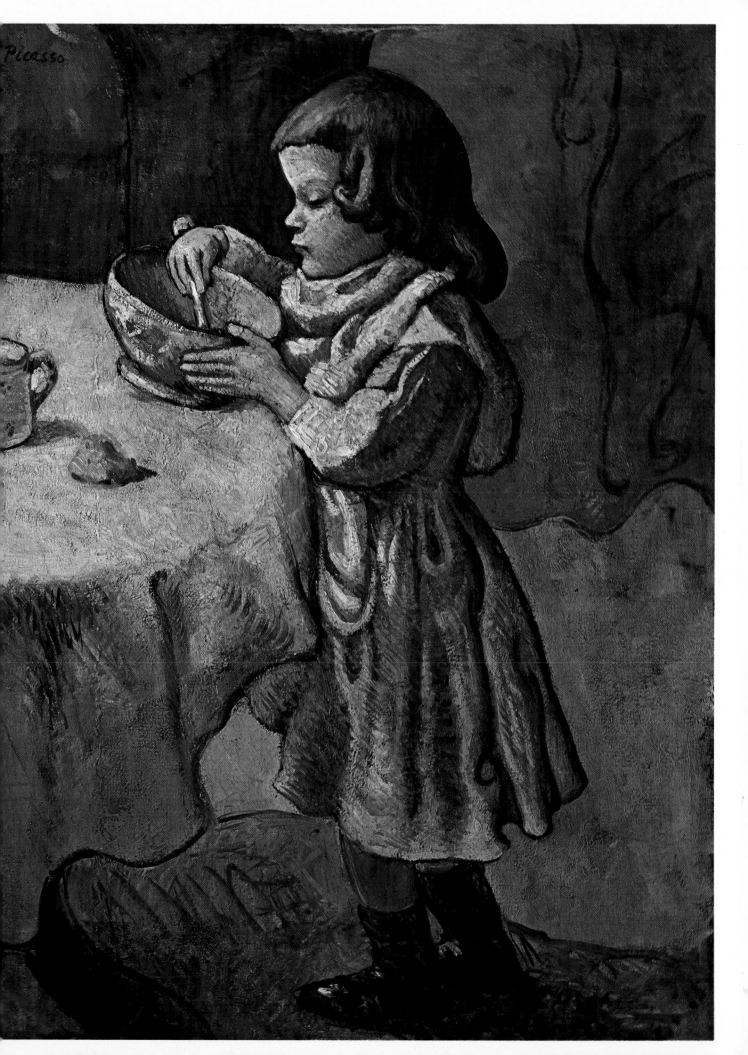

REMBRANDT VAN RYN
Dutch 1606-1669

SELF-PORTRAIT
Canvas, 36¼ x 29¾ in.
Widener Collection 1942

If you analyze a Rembrandt painting, you will find that there are always surprises. One surprise is apt to be the very limited range of the colors he used. According to best information, Rembrandt used black, lead white, red (probably a transparent dye called madder), orange, yellow (probably an earth yellow like ochre) and brown (perhaps burnt sienna). In many paintings, like this one for example, he did not use any blue or green at all. Against such a warm combination, a mixture of black and white will register as relatively blue; red and a neutral will count as violet. It seems strange that the greatest painter in history could suggest the full range of the spectrum, and yet not use one third of it. Color is relative and subjective. Your imagination supplies blue and green in Rembrandt's paintings; he does not.

Another surprise you will find is the use of light. Instinctively your eye is attracted to the brightest areas (A), and yet the brightest area is only a shirt. Second, your eye is attracted to the sharpest highlight (B), and here there is a pearl earring (which Rembrandt probably never wore). Third, you study the face, and realize that the greatest detail and concentration of light is on the forehead (C). The eyes and mouth—which in most portraits are the most revealing parts of the face—here are lost in shadow, and again your imagination supplies the missing detail. The overall effect is so forceful that you seem to read Rembrandt's thoughts.

As an exercise, make a portrait of a person turned away from you so that you see mostly the back of the head and line of the cheek. See how much of this person's appearance and personality you can suggest by emphasizing only incidental and secondary details.

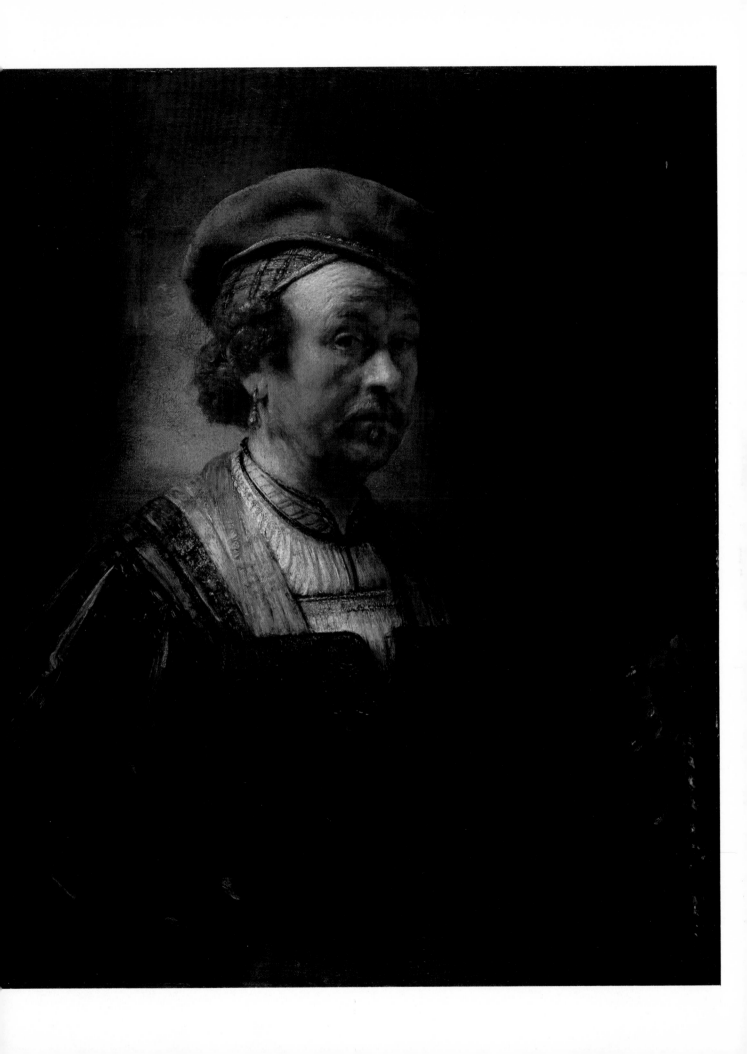

EDGAR DEGAS
French 1834-1917

MADEMOISELLE MALO
Canvas, 31 7/8 x 25 5/8 in.
Chester Dale Collection 1962

Very few painters in history would have dared combine the elements which Degas has brought together in this portrait, and even fewer would have succeeded in producing a masterpiece as the result. Consider the difficulties. The sour-yellow and white chrysanthemums are the antithesis of the skin tones in the flesh. Degas not only includes these colors, but places them directly alongside the most delicate parts of the face. Yet, there is no conflict. The face clearly predominates. The catalyst, of course, is the flowered chintz chair cover (A), which acts as the transitional element between figure and background. This is razor-edge control of values and color. A false move, and the painting would have been a disaster. Brinkmanship like this calls for a genius.

Next, observe the effect of the four lighter areas in the dark mass of the black dress (B, C, D, E). The very small white color at B acts as a key opening up the black area of the dress. The hand at C is fine in scale and relatively high-keyed, another focal point which relieves the other-wise somber lower left part of the painting. D, by comparison, is larger and has a bright accent recalling the higher-keyed colors in other sections of the painting. E, on the other hand, is big and flat, serving as a base to the painting.

To understand how carefully the lighter areas have been placed, take a piece of black paper and cover any one of them, and observe how the lower sections become dense and heavy. The balance in a picture like this is so precise that the slightest alteration is like changing a wheel in the workings of a watch. It may look about the same, but it does not tick any more.

As an exercise, cover a canvas with a coating of ivory black mixed with turpentine. Then, by rubbing out parts of this priming coat and placing the minimum number of small accents of lighter colored paint, try to evoke forms suggesting a still life, so that the imagination of your viewer is prompted to fill in the gaps.

166

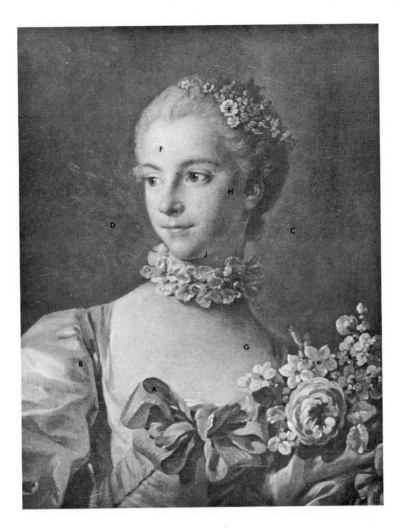

FRANÇOIS BOUCHER
French 1703-1770

MADAME BERGERET
Canvas, 56¼ x 41⅜ in.
Samuel H. Kress Collection 1946

Color is always relative. As a demonstration of this truism, often repeated but seldom tested, take a piece of red paper and place it near the head in this portrait. You will discover that the life-blood will drain out of the lips and cheeks, and the lovely Madame Bergeret will become a corpse. Boucher gets away with these icy-cold flesh tones by surrounding the figure with even colder colors—the blue bow (A), the silvery dress (B), the chill-green sky (C), and foliage behind (D). Practically the only warm accents near the face are the pink roses (E).

If this picture had been painted according to the so-called standard rules for painting flesh tones, the highlights (F) would have been painted in a cool color reflecting the northern light of the sky; the halftones (G) would have been local colors suffused with warm yellows and reds; the shadow edge (H) would have been a dark neutral; and the reflected lights (J), warm reds and browns. Boucher has altered this scheme. The face is practically a monochrome painting in bluish gray, and only the cheeks and lips have a tinge of warm color.

As an exercise, paint a portrait using Boucher's color scheme, and see if you can capture the same impression of ethereal delicacy. Incidentally, we know that Boucher sometimes arrived at his color schemes by arranging sea-shells on the top of a table. You may also find such a practice useful.

EDOUARD MANET
French 1832-1883

OYSTERS
Canvas, 15⅜ x 18⅜ in.
Gift of the Adele R. Levy Fund, Inc. 1962

This painting clearly shows one of the reasons why Manet was a key figure in the development of modern painting. It is difficult to imagine yourself picking up the fork, squeezing the lemon, or eating the oysters. The fork, the plate, the lemons, and the oysters, all have the texture of coarse oyster shells. Turn the reproduction upside down, and you will see that there is very little sense of three-dimensional form, or space. All the objects are equally flat.

Manet was not interested in any of these aspects of painting. He was interested in the quality of paint, the expressive power of brushwork, and the subtlest harmonies of color. These facets of painting have become increasingly important in modern art, and Manet, therefore, was a pioneer of the modern art movement. Look carefully at the lemon rinds. The most intense yellow is at A, where the rather rough impasto makes an arresting pattern. Note the very slight variations of this color at B, again at C and D. Inside the pith is another variant (E). They are

all different. Note also the faint recalls of these yellows at F on the cup, at G in the oyster, and even on the fork at H. These yellows probably did not exist in the actual still life—except on the lemon—but were invented by Manet to form a cross-linkage in his total composition. Other colors, for example the blue-greens and browns, are handled in the same way, regardless of their actual appearance. This cross-linkage of color and texture is as important today as it was in Manet's time, and you would do well to study a painting such as this with great care. There are pearls of painterly wisdom in those oysters.

Test your ability to use this principle of color by arranging a simple still life of an orange, a book, and a white handkerchief on a wooden table. Make the orange of the fruit the dominant color, and unobtrusively introduce recalls of orange in the other three elements of the composition.

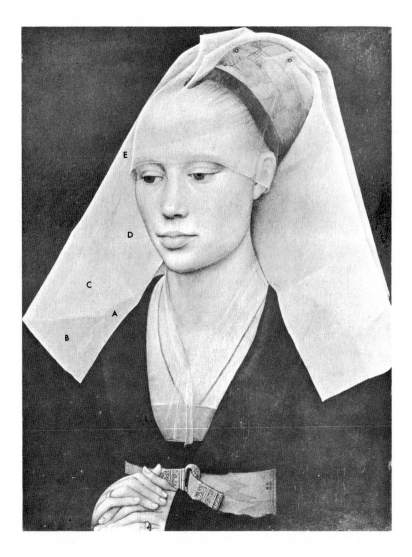

ROGIER VAN DER WEYDEN
Flemish 1399/1400-1464

PORTRAIT OF A LADY
Wood, 14½ x 10¾ in.
Andrew Mellon Collection 1937

This is one of the most popular portraits in America. The reasons for this popularity depend on a number of factors which are far from obvious. At first glance you are aware of the strong design and sharp outlines. Next, you are attracted by the brilliant red in the belt, which suffuses a glow in the otherwise pallid color scheme. (Hold your hand over this red area and see how the life blood drains from the face.)

Another factor, more important than those already mentioned, is the extreme refinement and subtlety of tone within the broad areas of light color. Look carefully at the starched headdress. At A there is a brown tone from the dark dress beneath. At B the tone is warmer, reflecting perhaps color from some hidden source. At C there is a undefinable effect combining the grayish white of the material with the warm tones from the same source. Next to

the face (D) the color is cool. Up on the forehead (E) a yellowish tone is introduced. And so on. Analyze any part of the light areas, and you will see the constant and fascinating interplay of closely related warm and cool color tones, each blending and shading into the next with infinite subtlety and refinement. How long will you look at this picture before you are aware of the green tone next to the red belt? You don't see such delicate nuances at once, yet these are what gives this picture its almost universal appeal. You would do well to study these refined points because, regardless of style, finesse of this kind can be a valuable asset to any painting.

As an exercise, paint a picture divided into two sharply separated areas of light and dark. Into both sections try to introduce subtle nuances of color representing a full range of color hues.

172

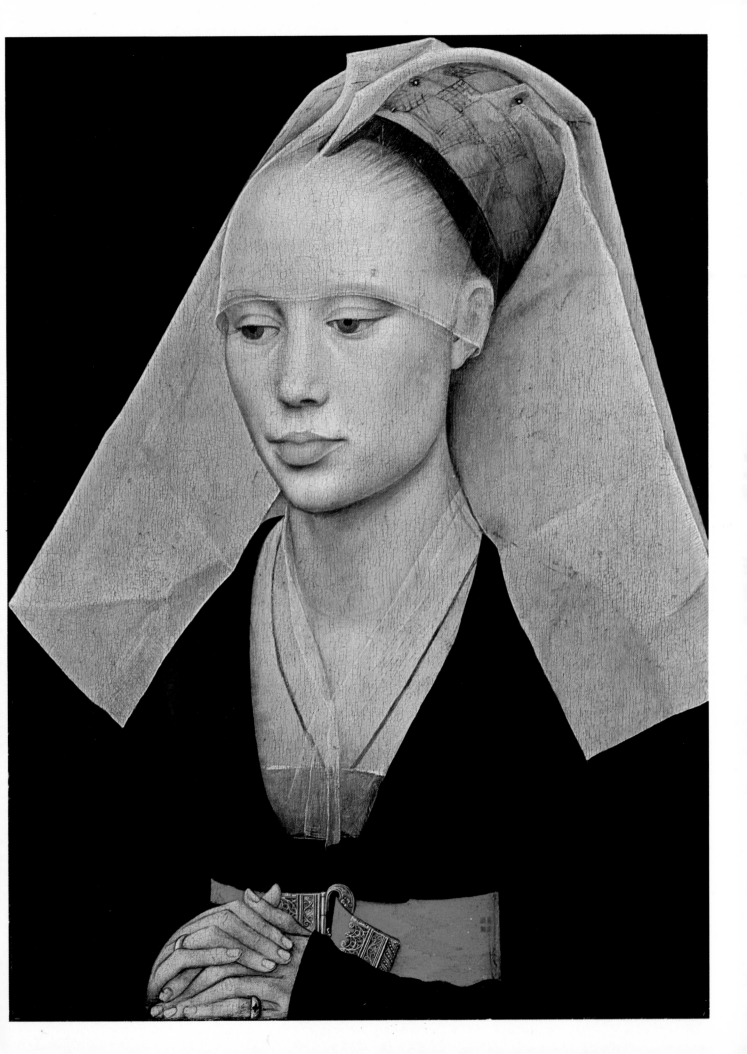

PABLO PICASSO
Spanish 1881-

FAMILY OF SALTIMBANQUES
Canvas, 83¾ x 90⅜ in.
Chester Dale Collection 1962

A student, if he could understand half of the subtleties in this painting, would be well on the way to learning what the ingredients are of a masterpiece.

Start with the color: study a small section, for example in the area near the seated figure. The vase (A) is painted with a quiet variation of pinks, reds, and browns; the drawing of the handle and spout is both refined and sensitive. The same color harmonies and delicacy of drawing are transferred into the dress (B) and into the mysteriously indefinite landscape (C). The black accents of the boy's shoe and the harsh shadow on the ground (D) are in complete contrast to the lyrical quality of these areas. The severe black outlines on the woman's clothing (E) pick up the same dissonant hardness. Both areas contrast with each other so diametrically in terms of treatment, color, and mood, that they serve as supports for each other. Most good artists realize that the easiest way to make a color or type of line effective is to place the line or color next to its opposite. For the same reason a woman stands out among a group of men, and a rainy day is beautifully satisfying in a parched desert.

Notice also the color subtlety in the harlequin figure to the extreme left. A lesser painter perhaps would have settled for three shades of blue on the diamond-patterned types. Picasso uses at least *ten,* and again transfuses the same hue into surrounding areas; the hand and the cheek, and the sack which the old man carries, and even the girl's arm. By creating such sympathetic chords Picasso leads your eye on a fascinating tour, and never lets you get tired.

A great painting obviously means different things to different people. The German poet Rilke, who lived in a house where this painting hung during the 1920's, wrote the following ode about the painting:

But tell me, who *are* they, these acrobats, even a little
more fleeting than we ourselves,
 —so urgently, ever since childhood,
wrung by an (oh, for the sake of whom?)
never-contented will? That keeps on wringing them,
bending them, slinging them, swinging them,
throwing them and catching them back;
 as though from an oily
smoother air, they come down on the threadbare
carpet, thinned by their everlasting
upspringing, this carpet forlornly
lost in the cosmos.

Rainer Maria Rilke, Duino Elegies, *trans. by Stephen Spender (Norton and Co., New York, 1939)*

174

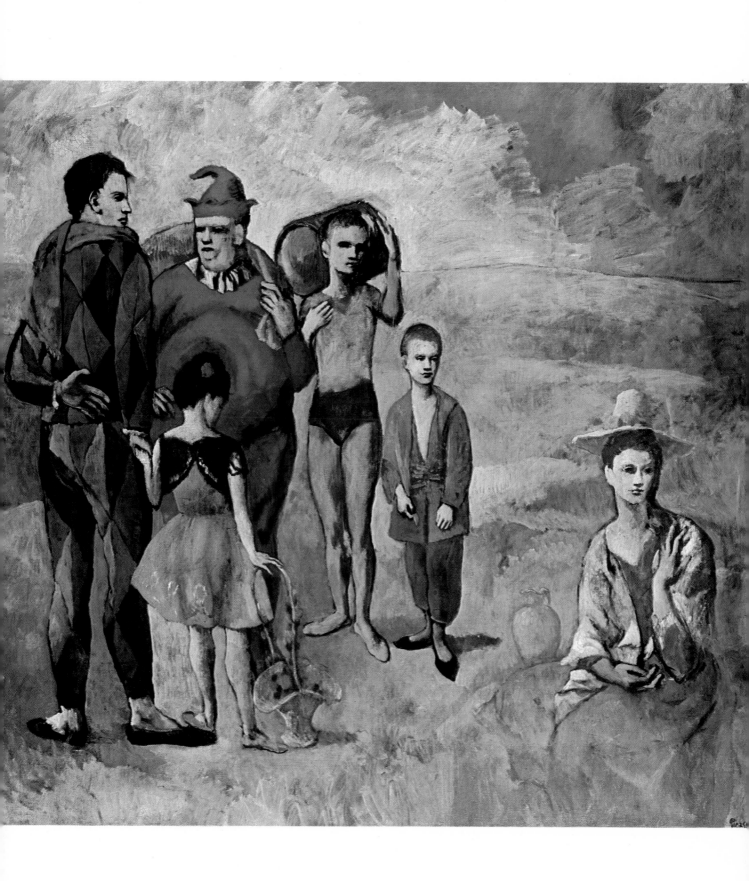

HENRI MATISSE
French 1869-1954

POT OF GERANIUMS
Canvas, 16¼ x 13⅛ in.
Chester Dale Collection 1962

At first sight this painting looks like a simple theme in a simple setting, but in fact it is a masterful example of the use of point and counterpoint in design and color.

The dominant theme is the color combination of orange and green. The pot itself shows the two colors in clashing juxtaposition (A and B). The picture as a whole is a series of variations on this theme.

In theory, sap green is nearly opposite reddish orange on the color wheel, and an interior decorator would lose his clients if he proposed using such apparent dissonance in a room. However, here these non-sympathetic colors are modified and blended so skillfully that it is possible Matisse chose these two as a challenge to his incredibly well-tuned sense of color. One of the catalysts binding the two dissonant colors is the pink of the flower (C); another is the purple of the ledge (D).

Also observe carefully the dark accents which bind the composition together. The most important accents are the horizontal bars at E, F, and G. Counterpoised to these are the three triangular holes at H, I, and J. Last are the two ellipses which hover like flying saucers, and provide curiously mobile elements in the design (K, L). All of this looks rather simple and elementary, and yet none of these colors can be changed by the slightest degree, nor can any of the elements of design be altered without introducing a sour note, changing the whole harmony of balance.

As an exercise, design a still life in which two of the principal elements are painted one brilliant orange and the other ultramarine blue. Now try to paint the rest of the picture, using only variations of these two opposite colors, without losing the harmony of design and color.

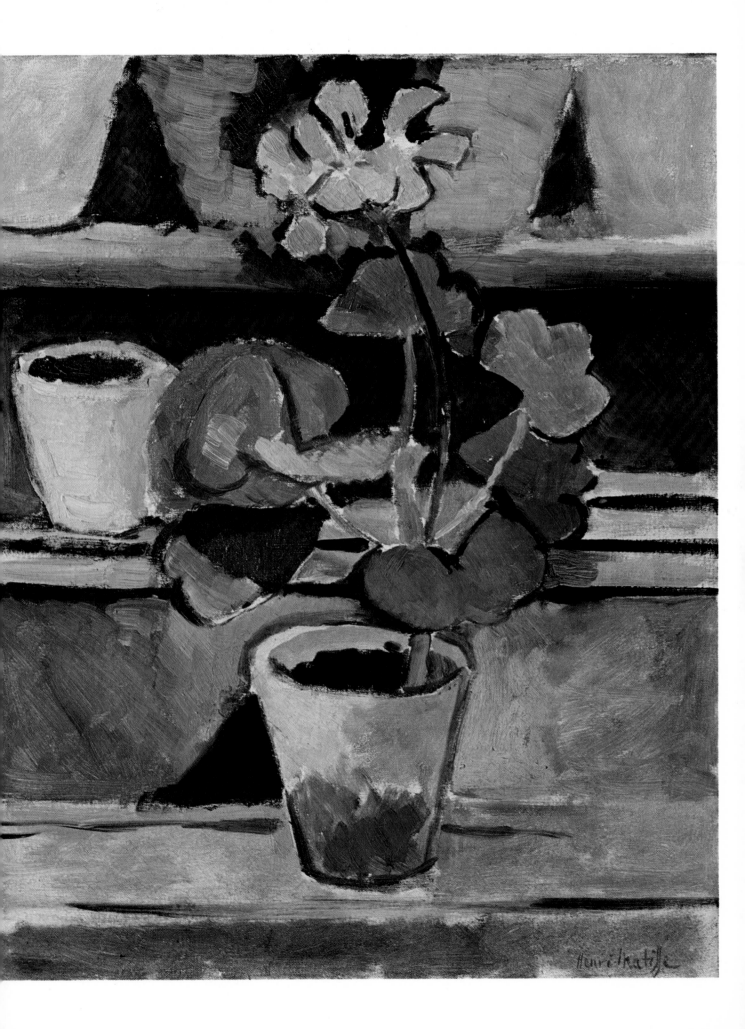

John Constable
British 1776-1837

A View of Salisbury Cathedral
Canvas, 28¾ x 36 in.
Andrew Mellon Collection 1937

We know from Constable's writings that he was very con-
scious that paintings tend to change drastically under dif-
ferent degrees of light. To understand this, first look at
the color reproduction under a bright light, and then
gradually diminish the amount of light until the forms
become indistinct.

A fact which painters of all ages often fail to consider
is that their work probably will not be seen under the
same lighting conditions at all times. Most painters prefer
a northern light when they are working, because it re-
mains relatively constant. However, the north light is also
a cold light. A picture painted under a north light, seen
by a western light or by an artificial light may change
considerably. For this reason many artists working today
paint under artificial light, since their picture probably
will be exhibited and seen under the same conditions. The
manufacturers of light bulbs have not yet been able to
duplicate exactly the color of natural light, but a com-
bination of warm and cool fluorescent tubes can come
fairly close. I advise you to paint, if possible, by natural
light, with the studio window facing towards the north
and to the sky—not towards a red brick wall or a mass
of green foliage. I would also strongly recommend that
you check your painting by tungsten light at frequent
intervals, to avoid unpleasant surprises when you see it
exhibited in a gallery or collector's home.

Another factor which most painters tend to ignore, but
which can be of prime importance, is that the *degree* of
light can also alter a picture completely. We know from

the correspondence of John Constable that he worried
about this point: he would check his finished work in the
late evening light to make sure that the values and colors
were sound.

Study this picture under a strong light, then gradually
lessen the light. As the degree of light fades you will
understand why Constable emphasized certain features.
For example, note the strong accent down the side of the
steeple of the Cathedral. Without this the spire, in a dim
light, might be lost against the cloudy sky (A).

Note also the flecks of sunlight in the shadow cast by
the mass of trees (B). In a dim light these disappear;
however, the strip of sunlight in the foreground (C), and
very slight differences in value between the shadow in the
foreground (D) and darker portions under the trees (E)
are sufficient to convey a very convincing sense of a flat
plane of grassy meadow.

Lastly, note a typical Constable flash of genius; a lesser
painter could never have resisted the temptation of putting
highlights among the foliage in the great mass of trees to
the left. Constable knew that this might destroy the im-
pression of a dense mass of dark leaves and, instead, put
only a single accent of sunlight at the base (F). No one
could ever make a rule for a decision like this, and yet
such subtle points are what make a masterpiece.

As an exercise, paint a landscape which is divided into
two sharply contrasted areas of tone. Try to make the
picture as interesting and appealing seen in bright sunlight
as it is when seen by the light of a single candle.

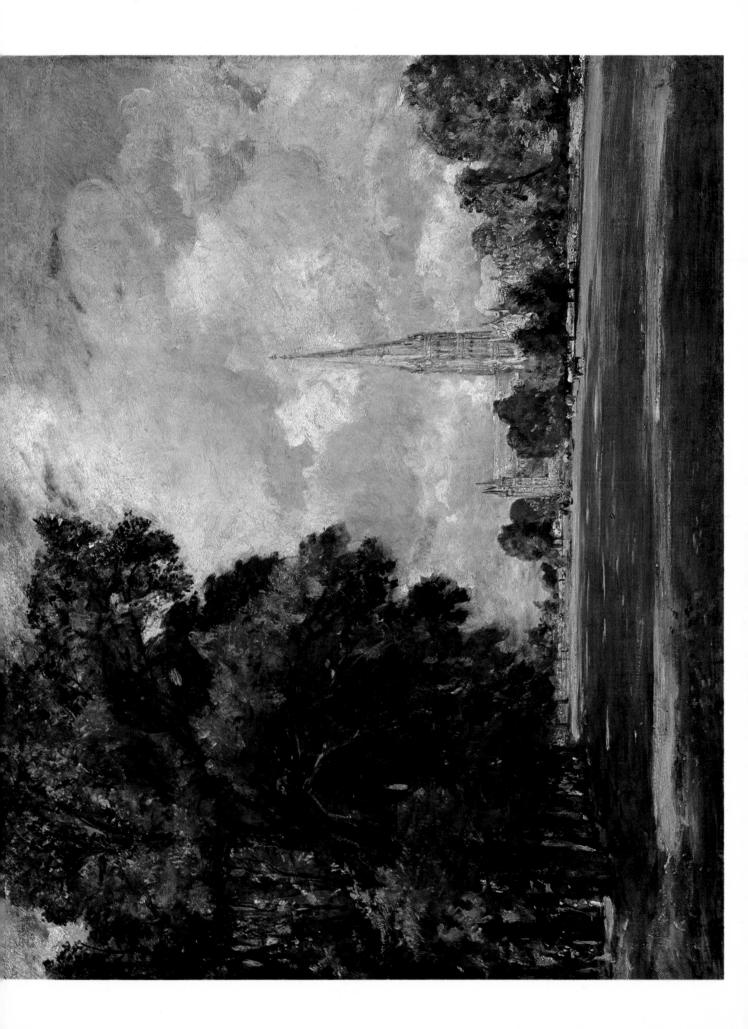

GEORGE INNESS
American 1825-1894

THE LACKAWANNA VALLEY
Canvas, 33⅞ x 50¼ in.
Gift of Mrs. Huttleston Rogers 1945

An important point to learn from this painting is that color in nature is usually not as varied as we think. For example, you think of a wheat sheaf as yellow, a clover field as green, a dusty road as brown-gray, and a summer sky as blue. Now, look carefully at the colors Inness has used. Although each area is distinctly different, all are saturated by an overall warm brown. This is what happens in nature. Colors may be strong and varied, but they are always modified by the light of the sky—usually silvery gray in early mornings, brilliant blue-white at noon, and reddish yellow towards sunset.

To appreciate how Inness has treated the light of late afternoon study the greens in the middle distance. A registers as a bright emerald green of mossy grass; B, as the cooler green of willow trees; C, as the more silvery green of beeches, and D, as the dark green of pines. The use of yellows and browns is equally delicate. There is one shade of yellow for the limpid sky (E); another for the dirt road (F); another for the railroad marshalling

yard (G); another for the field in the valley (H); and yet another for the more parched field in the foreground (J). If all these colors were isolated into equal squares and placed side by side, you would be surprised by how close they are. If in other sections of this picture Inness had used bright, intense colors—in the sky, for example —these subtle variations would have been deadened and lost their meaning. As it is, he used a bright color only for the figure in the foreground, and thus created a focal point from which the viewer can start on his optical journey through the Pennsylvania countryside.

Make a habit of observing and remembering the way colors are modified by different conditions of light. Whether or not you specialize in landscape, this is one of the best ways to train your eye to distinguish very fine shades. As an exercise, take three identical scenes—or abstract shapes if you prefer—and modify the color of each for: first, early dawn; second, high noon; third, sunset.

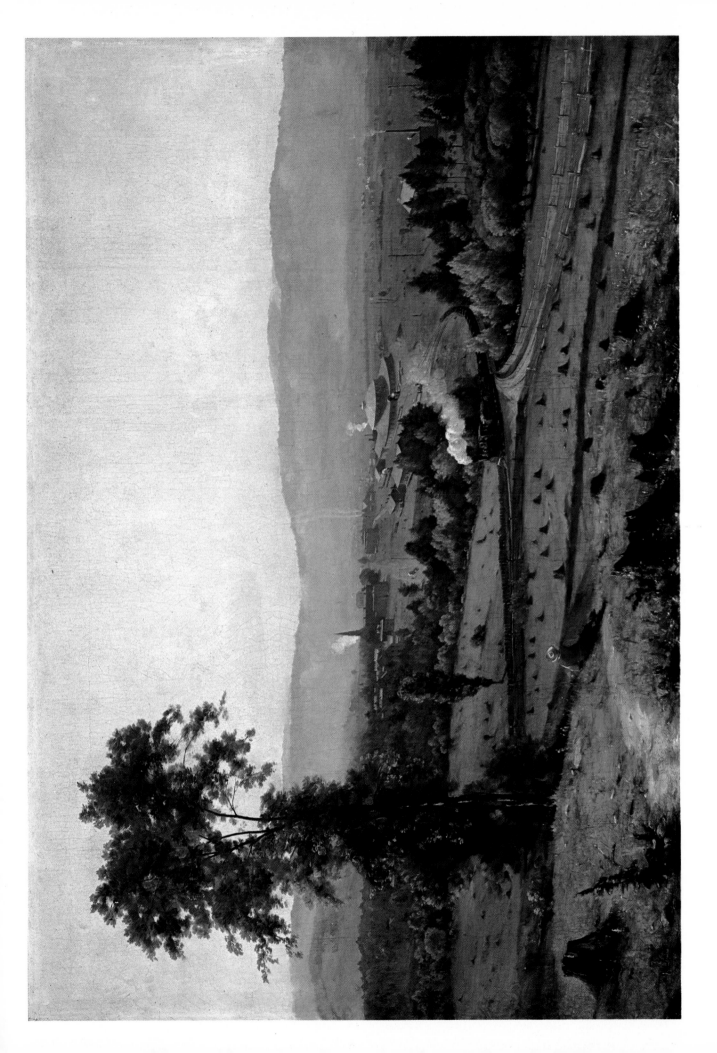

CLAUDE MONET
French 1840-1926

WOMAN SEATED UNDER THE WILLOWS
Canvas, 31⅞ x 23⅝ in.
Chester Dale Collection 1962

One of the lessons to be learned from nineteenth-century Impressionism is that flecks of pure color—whether or not they are contrasted with other pure colors—can give a sense of atmospheric light. In the detail, taken from the lower center foreground, the general overall tonality is pale green for the field and a pinkish white for the lady's dress. However, imbedded in the maze of flickering brush strokes are nuggets of pure pigment; brilliant green (A); blue (B); yellow (C); and red (D). These little flecks of color are like sparks. They give an aura of excitement

and tension to the surrounding areas.

Note the free brush strokes contrasting with the canvas (E) and how effective they are in conveying the impression of tall grasses moving in the wind, and the effect of heat shimmering over the summery landscape. Study this detail. It is very instructive. If you have a painting in the studio which has not satisfied you because the general effect seems dull, try putting very small flecks of pure color at strategic points in the design, and watch it come to life.

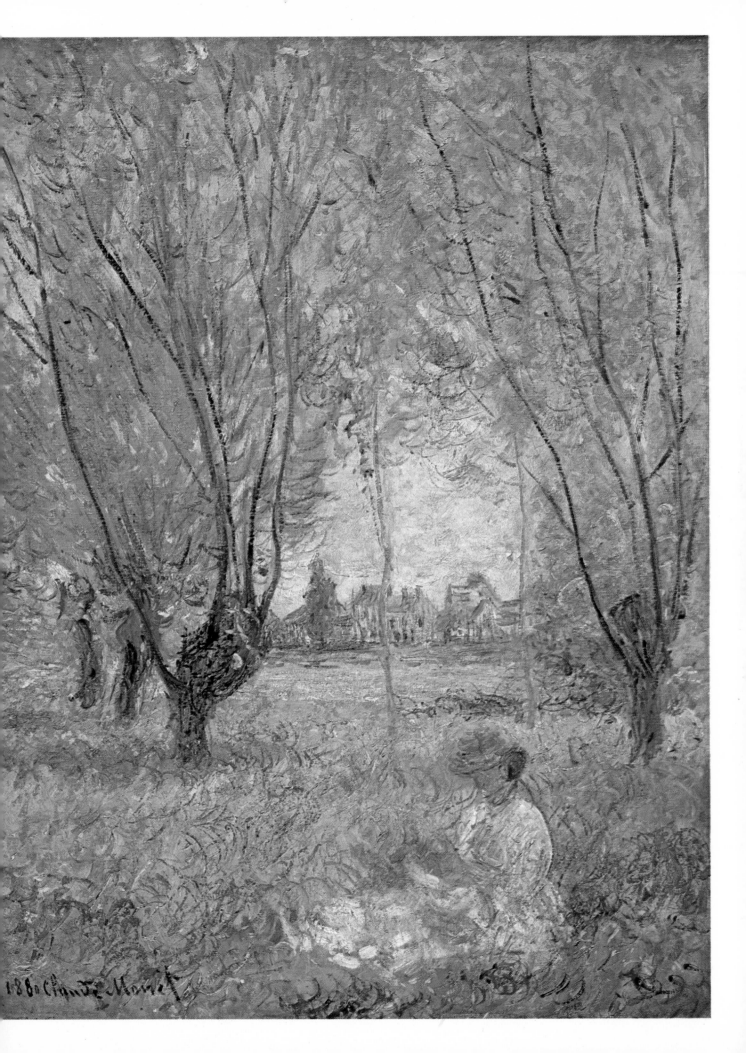

1880 Claude Monet

GUSTAVE COURBET
French 1819-1877

BEACH IN NORMANDY
Canvas, 24⅛ x 35½ in.
Chester Dale Collection 1962

Beginners usually have difficulty in realizing how drab most of the world we *see* really *is*. We tend to focus on areas of bright color; we magnify them in our imagination and then on canvas; and we wonder why we have failed to capture a convincing slice of reality. Courbet's picture illustrates this point. A beginner faced with such a landscape would have made the sky bluer (A), the ocean wider (B), the cliff steeper (C), the boats more detailed (D), and the sail drying on the beach (E) brighter. By so doing, he might have made a more attractive picture but not a facsimile of nature, as Courbet has done. The cliff is crumbling, the beach dirty, and the sky a nondescript gray-blue. However, these drab colors, all variants of gray and brown, serve a carefully calculated purpose. By contrast the sea is a breathtaking blue; without the neutrals, this blue would have had far less impact.

A French landscape painter, famous also as a teacher, once advised his students to look at the scene they were painting, upside down between their legs. He felt that this was one way to see things in their true relationship, without confusing overtones and associations. I advise you to try this method sometime if you are uncertain about color relationship.

Courbet, incidentally, was one of the very few masters in the history of art who did not recommend looking at the works of other masters, or copying in museums as a method of learning. However, he condemned this practice as a propaganda move against his arch-enemies the Romanticists, who tended to be too derivative. As a matter of record, Courbet spent years training himself by copying the works of seventeenth-century Spanish masters.

184

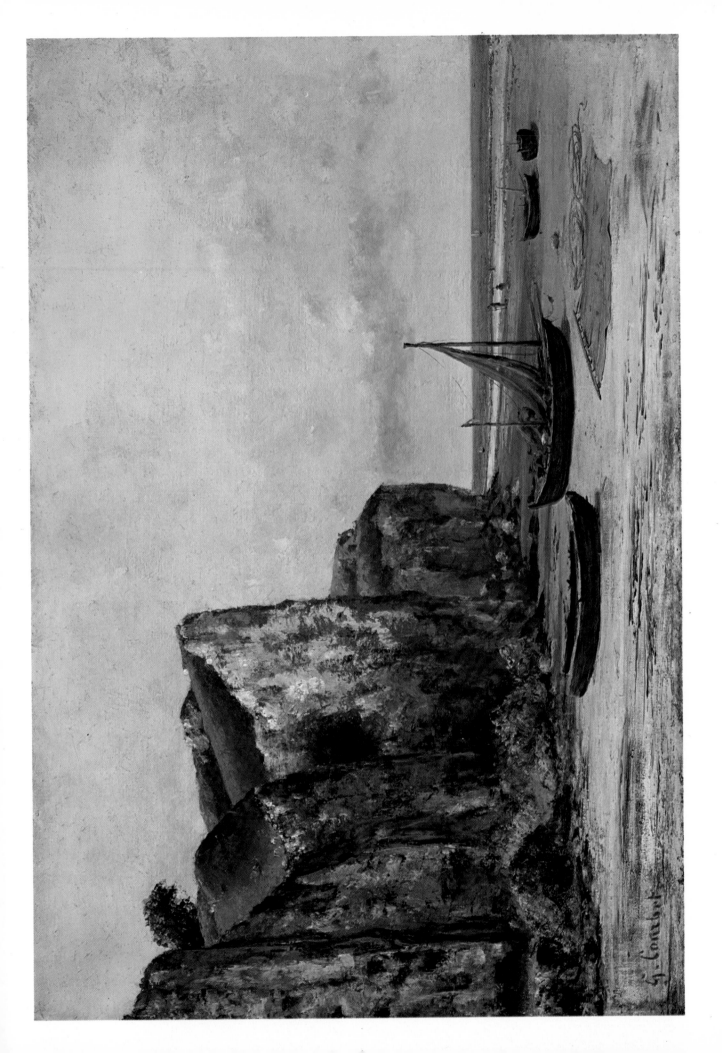

·Claude Monet
French 1840-1926

Palazzo Da Mula, Venice
Canvas, 24½ x 31⅞ in.
Chester Dale Collection 1962

Most people think that Monet was a romantic who grossly exaggerated the purple evening light of Venice in this famous picture. They refuse to believe that often at sundown the atmosphere is suffused with the blue of night which blends with the red of the setting sun to produce a violent purple. In fact, Monet was an uncompromising realist as far as color is concerned; he also had an incredibly accurate color sense. According to his biographers, he could tell the exact time of day by looking at the color of the wall opposite his studio window. During a long career, Monet learned to transpose exactly onto canvas his sensations of color, light, and atmosphere.

Scientific theorists of Monet's time had indicated that what our eye actually sees in nature is nothing more than a series of minuscule flecks of pure prismatic color. Monet was among the first to use this theory in painting, and thus he became one of the founders of Impressionism.

In this particular painting the theory has not been followed precisely. In the detail, A and B are flecks of pure ultramarine blue, surrounded by dark green. At C is a combination of dark blue and dark brown. The pole at D is again intense blue. The wall at E is a pale purple, and at F a pale pink. Most of the other areas which we would ordinarily think of as black or dark neutral are shades of green (G, H, and J). One of the great lessons to be learned from Impressionism is that deep shadows are usually not colorless, but, as in this picture, are laced through with intense hues which make the shadow areas as vibrant and luminous as the light sections.

Although Impressionism is no longer widely practiced, a student can profit greatly from looking carefully at Monet's work. A fact we tend to ignore is that very few people have trained themselves really to see true color. In order to do this, we have to throw away every preconceived idea, and be prepared to look at the world with the eye of a newborn child. Monet himself once said: "I wish I had been born blind, and that my eyesight had been suddenly given to me, so that I could see nature as she really is."

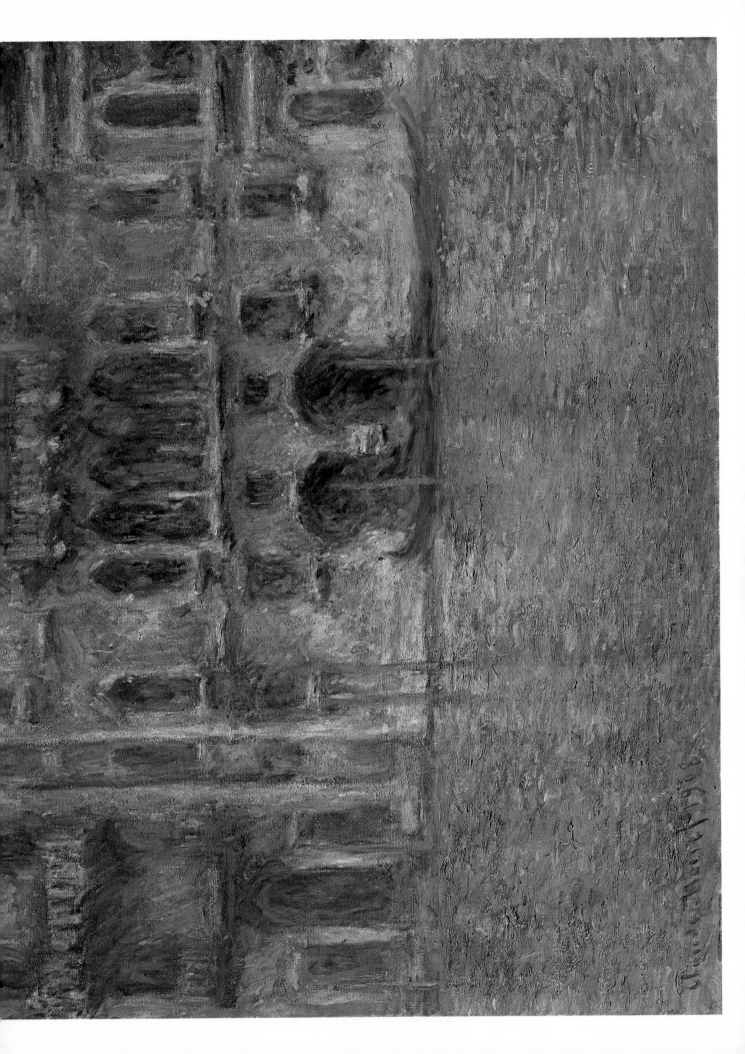

Detail no. 1

Detail no. 2

CLAUDE MONET
French 1840-1926

ROUEN CATHEDRAL, WEST FAÇADE, SUNLIGHT
Canvas, 39½ x 26 in.
Chester Dale Collection 1962

Although Monet's fame rests chiefly on his ability to transpose the effects of light onto canvas, the surfaces of his paintings are also dazzling exhibitions of paint handling.

Detail no. 1 shows the three figures in the lower left corner of this painting. Here note the use of canvas texture (A); pigment well saturated with medium—probably ordinary linseed and turpentine (B); almost pure paint straight out of the tube (C); and paint dragged over the surface when it was partially dried (D). This is Monet's handwriting, and there is no sign of weakness or indecision in any part of it. Although the color of this particular section is mostly golden yellow, pure prismatic colors are laced through this miniature lunar landscape. At E, notice the speck of pure ultramarine blue; at F, the bright purple; at G, the sap green; and at H, the cadmium yellow.

Detail no. 2, showing an area near the top of the door under the main arch, also reveals the intricacy and masterful control of paint.

As an exercise, take any four-inch square section of one of your own oil paintings, shine a spotlight on it from a raking angle, and see if the section has any of the appeal and authority of Monet's details. This is only one part of the painter's craft, but it is an important one.

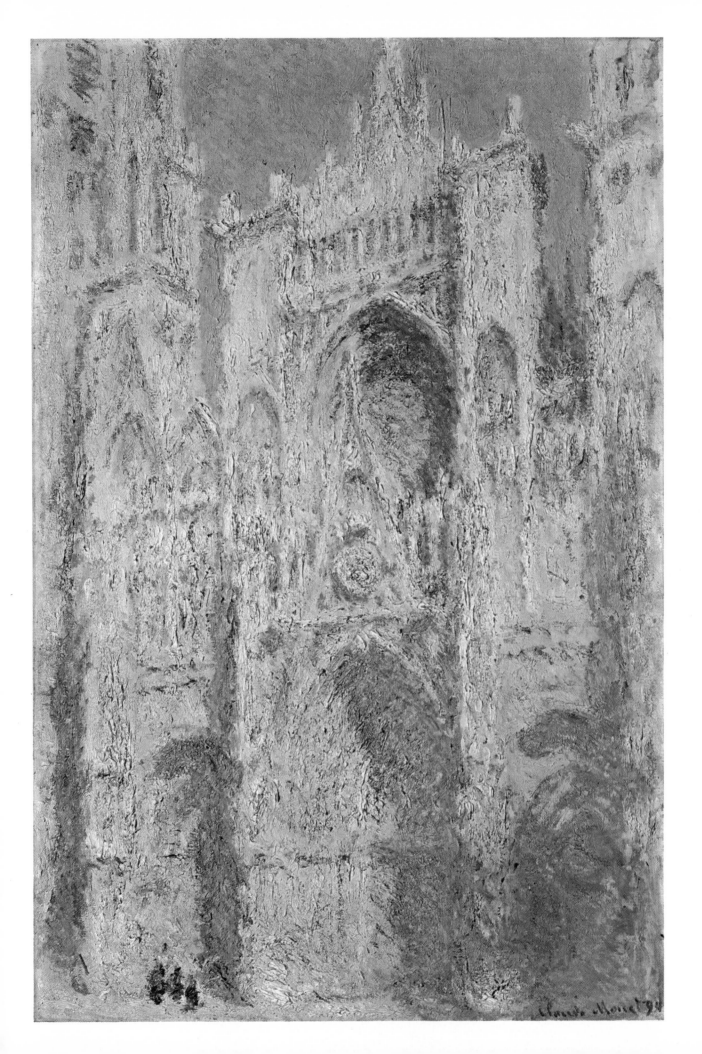

Detail no. 1

Detail no. 2

BARTOLOMÉ ESTEBAN MURILLO
Spanish 1617-1682

THE RETURN OF THE PRODIGAL SON (*slightly trimmed*)
Canvas, 93 x 102¾ in.
Gift of the Avalon Foundation 1948

These two details show the various stages in the process of Murillo's painting. The canvas was first primed with white lead; second, an *imprimatura* of warm brown was brushed over the whole surface; third, (see detail no. 1.) broad areas of the design were laid in, using principally lead white and probably umber; fourth, individual sections were built up, again practically in monochrome. The medium was probably a mastic-linseed-wax combination. Glazes were used for certain of the darker sections. Forms were indicated in general masses, and there was a deliberate avoidance of sharp lines or decisive accents. Everything was kept vague and changeable, and the individual parts were simplified into their basic elements. Thus, the head was blocked in as an egg-like shape, the eyes placed in with simple dark accents, and no effort was made to delineate exact contours or to pinpoint any of the features. A painting of this type *evolved*; it was not created at the first session. The forms were coaxed and cajoled out of a

misty background.

The final stage can be seen in detail no. 2. The dark areas have been glazed again and again. The brighter colors have been brought up to full strength and put on in their final form with bold brush strokes. Highlights also have been built up and, most important, accents which bring the action to life have been placed with deft, sure touches. The eye of the Prodigal Son, for example, has been stressed, and so have the fingertips of the father's hand. Placing these accents was probably done in the last stages of the painting, and it is in such master touches that an absolutely sure knowledge of drawing is so essential.

As an exercise, take a still-life composition of fruits. Follow Murillo's technique: start by painting everything vaguely in monochrome. As a second stage, try to deepen the glazes and build up the whites. And as a third stage, try putting in the highlights and the dark accents with sure brush strokes, like those of Murillo.

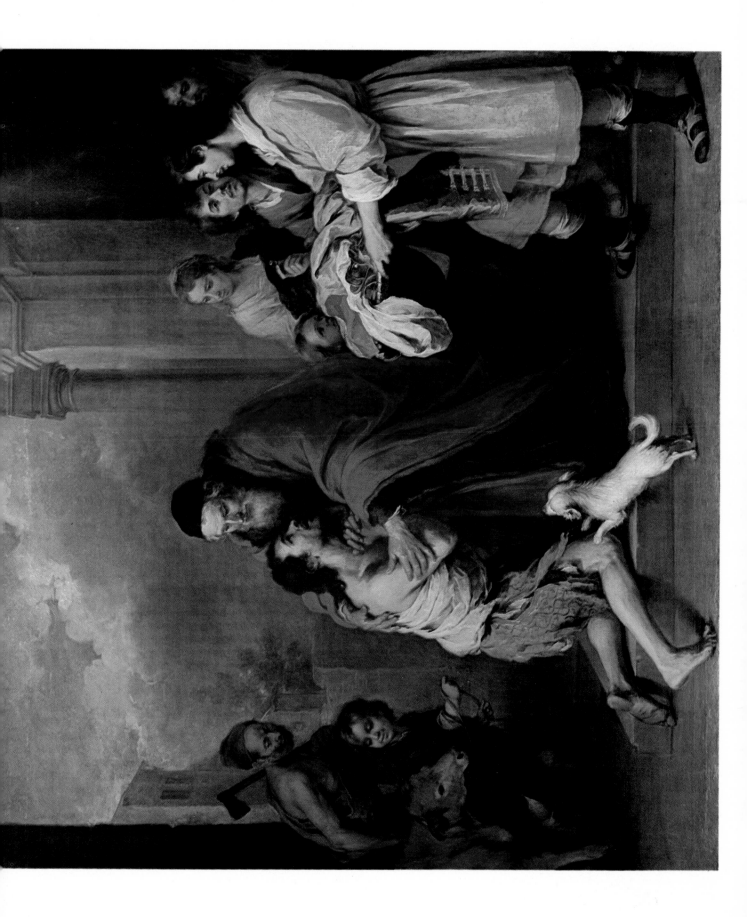

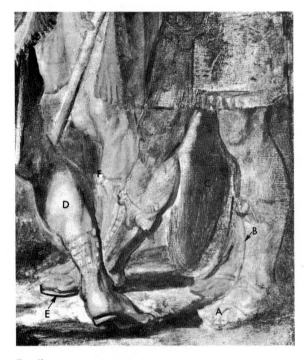

Detail no. 1

Detail no. 2

PETER PAUL RUBENS
Flemish 1577-1640

DECIUS MUS ADDRESSING THE LEGIONS
Wood, 31¾ x 33¼ in.
Samuel H. Kress Collection 1957

This painting provides a step-by-step demonstration of Rubens' technique.

First, the smooth wooden panel was covered with a layer of gesso or lead white mixed with oil (the surface was first smoothed down, probably with some kind of scraper or sandpaper). This was then covered with varnish—probably damar—thus leaving a smooth, white, non-porous surface. (See A in detail no. 1.) Next, a bed or thin layer of medium—probably consisting of thickened oil combined with a resinous varnish—was brushed in over the areas to be worked on, and with the same glazing medium the main outlines of the composition were drawn in with a round-tip flexible brush, using ivory black or umber (B). In the next step large areas of shadow were blocked in with a glazing medium and transparent paint (mostly ivory black and burnt umber) (C). Areas receiving direct light (D) were then blocked in using the same medium and lead white, probably mixed with some beeswax and a few colors. These sections are opaque, and are deliberately contrasted with adjacent transparent areas. Then, by means of a brush well loaded with ivory black and burnt sienna—or umber—additional accents (E) which emphasize the form and action were painted in. Finally, using lead white—probably mixed with some beeswax and the same glazing medium—the highlights were placed in with thick, heavy brush strokes (F).

In detail no. 2, the same six steps can be seen very plainly: G is the panel covered with a white priming coat; H is the first drawing; J, the transparent shadow areas; K, the opaque light areas; L, the dark accents; and M, the impasto highlights.

It is important to remember that the use of ordinary linseed oil and turpentine will not give these effects. You must have a glazing medium and some wax mixed with the pigments. There has been a great deal of debate among painters, historians, and chemists over Rubens' medium, and we still are not certain what exactly he used. However, the leading art material manufacturers are now marketing glazing mediums and jelly-like substances to mix with pigments, which will give the same effects that Rubens obtained.

As an exercise, place an apple lighted from the side on the table in front of you. Using a glazing medium and some wax mixed with your lead white, try to duplicate the processes described above.

192

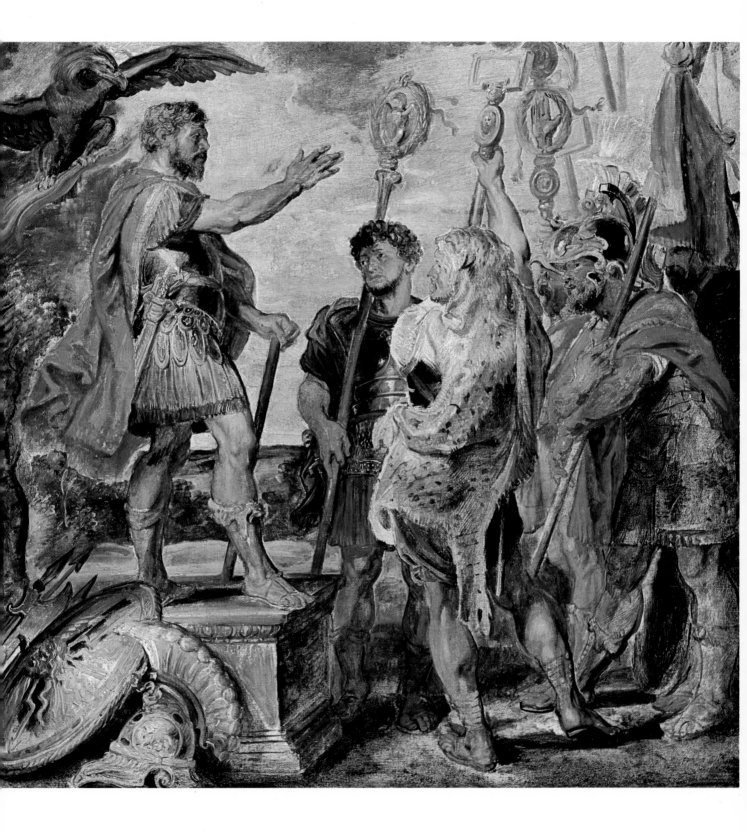

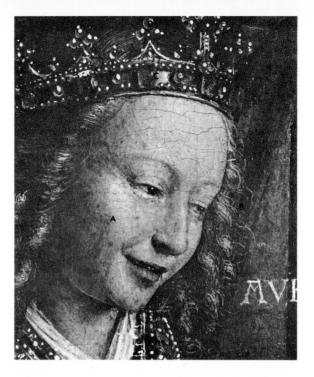

JAN VAN EYCK
Flemish 1380/1400-1441

THE ANNUNCIATION
Transferred from wood to canvas, 36½ x 14⅜ in.
Andrew Mellon Collection 1937

Although Jan van Eyck perfected oil painting technique almost five hundred years ago, a painter can still learn a great deal from a detailed study of his work. In spite of all the advantages of scientific analysis, we still do not know exactly how van Eyck achieved his effects, nor has any painter been able to duplicate his marvelous precision and luminosity. Perhaps an artist of this present generation will be able to discover the secrets of his wizardry.

The head of the angel in the detail is about the size of a pocket watch. The modeling on the face (A) was apparently done with an oil-wax medium, blended so skillfully that no brush strokes are visible. The strands of hair (B) were painted in probably with tempera, with a very fine brush, or possibly even a quill pen. Over this, van Eyck brushed thin glazes, probably mostly of varnish. The jewels (C, D) are more difficult to analyze. Apparently van Eyck took each color as a separate problem, and varied the application of each to achieve maximum brilliance. Thus, a deep red is most effectively achieved by glazing with poppy oil over a very white reflecting surface, so that the light is reflected back through the red veils. (See diagram no. 1.)

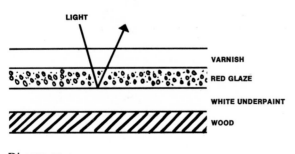

Diagram no. 1

Blue, for which van Eyck used pulverized lapis lazuli, presented a different problem, since the pigment was less intense and less transparent. To achieve this intense blue, it was necessary to use a blue underpainting and then use at least two thin glazes of blue on top. (See diagram no. 2.) Yellows and greens also required different treatment.

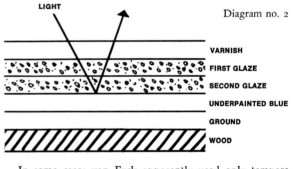

Diagram no. 2

In some cases van Eyck apparently used only tempera and then put oil on top so that the oil penetrated through the pigment, and thus achieved an effect of transparency.

So far, it has been impossible to copy van Eyck's technique. No successful forger of his work has yet appeared, probably because no painter has ever been willing to take the infinite pains necessary to make even a plausible facsimile.

As an exercise, take a piece of jewelry, and paint a small picture of it in oils as precisely as you can. Use only lead white and burnt umber. Over this underpainting, glaze transparent colors, repeating the glazes until you have built up several layers of translucent paint. The light should penetrate these and give an enamel-like luster.

194

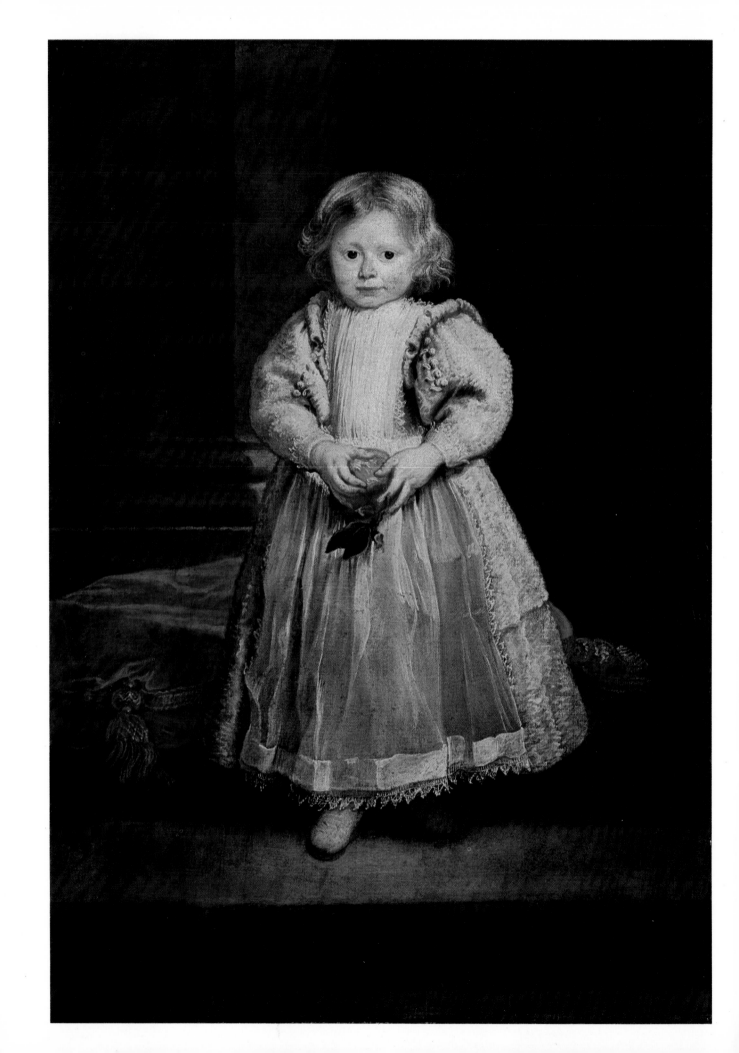

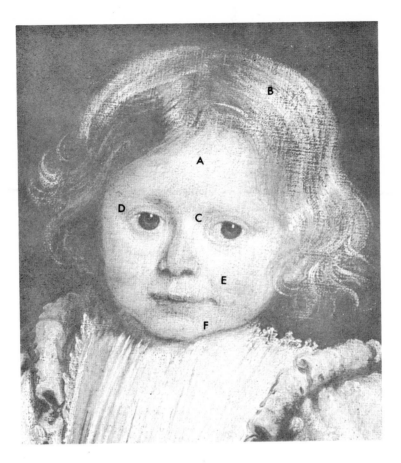

SIR ANTHONY VAN DYCK
Flemish 1599-1641

CLELIA CATTANEO, DAUGHTER OF MARCHESA ELENA
 GRIMALDI
Canvas, 48⅛ x 33⅛ in.
Widener Collection 1942

For over three centuries van Dyck has been acknowledged as one of the world's great portraitists, and a painter who wishes to work in portraiture would do well to study his work in detail. Fortunately, there is good evidence about what colors he used: lead white, Naples yellow, yellow ochre, vermilion, ultramarine blue, Titian green (emerald green is the nearest modern equivalent), raw sienna, charcoal black, red lake, and van Dyck brown.

In this portrait, first note that all the highlights on the figure are approximately the same golden color (A, B). This was probably obtained by using an underpainted white, and glazing a "veil" of yellow ochre, possibly combined with a trace of Titian green, over it. Next study the halftones on the face (C, D). To obtain this particular warm-cool tone, van Dyck probably first laid in a pale underpainting, using yellow ochre and possibly ultramarine or ivory black. Over this van Dyck glazed yellow ochre, and—after this had dried—another glaze of Titian green. As the color became warmer towards the cheek (E), he probably added vermilion to his glazes. In cooler areas, (F), he probably increased the amount of blue in the glazes.

The important point is that flesh tones like this can be obtained only by glazing. Skin itself is slightly transparent and, in order to duplicate the light falling on it, the painter must also make the surface of his paint slightly transparent.

As an exercise, take a simple model (one of your fingers, for example) and paint it in oils, trying to follow van Dyck's color schemes for flesh tones.

JAN DAVIDSZ. DE HEEM
Dutch 1606-1683/84

VASE OF FLOWERS
Canvas, 27⅜ x 22¼ in.
Andrew Mellon Fund 1961

Artists have been fascinated with flowers since time immemorial. In this painting, however, there is far more than an attractive bouquet. Seen from across the room, the design of bright colors makes an immediately pleasant impression. As you move closer, you begin to see the intricate curl and counter-curl of exotic tulips, blackberry brambles, and wheat stalks. Other plant forms emerge from the dark background. Finally, as you get really close, you see that there are worlds within worlds. Reflected in the glass of the vase is a window looking out to the infinite sky. On the shelf there is a universe in miniature. Look at the detail, an enlargement from the original. A lizard thinks about eating a spider; a snail probes unseen dangers ahead with its tentacles; a beautiful tulip lies wilting, and ants explore an opened pod. The cycle of life and death is presented in a miniature drama. Every section of this painting is equally interesting and beautifully painted. I have looked at it every day for five years, and always see something new to intrigue and delight me.

Another source of endless fascination is the variation in glazes. There are at least three levels of transparency. Study the diagram. At A the light strikes the white lead and bounces back directly; at B the light penetrates the transparent glazes and glows, as it is reflected back from the underpainting. At C the light is lost in layers of transparent glazes as it sinks into mysterious depths.

The continuous interplay of luminescent color in depth is one of the reasons a painting of this kind has such hypnotic appeal. Why so few contemporary painters are willing to learn and apply the lessons of Dutch still-life painting is one of the enigmas of our time.

As an exercise, go into the garden and pick a weed. Following de Heem's technique, paint a portrait of this weed, studying each leaf, and put in any wilted leaves, dewdrops, dust, or insects that may be on it.

Detail no. 1

Detail no. 2

FRANCESCO GUARDI
Venetian 1712-1793

A SEAPORT AND CLASSIC RUINS IN ITALY
Canvas, 48 x 70 in.
Samuel H. Kress Collection 1943

There is absolutely no reason why a landscape should represent a specific place. Often in the history of art landscapes are of subjects found only in the artist's imagination. During the course of his work an artist inevitably amasses a collection of drawings, sketches, and memories. Very often he combines these in imaginary or *capriccio* landscapes. In the eighteenth century no one objected to such a fantasy. Each element would have evoked certain emotional responses, and the combination would have been a nostalgic reminder of the beauty of Italy's past.

For Guardi, a painting was divided into two distinct and separate parts. The first stage was the designing, underpainting, and glazing which brought the picture nearly to the finished point. This part was regarded more or less like the orchestral part of a concerto: important, but basically background material.

The second part of the painting process was the flickering brush strokes which added action and shimmering lights to the points of interest. This was like the solo part of the concerto. The artist had to be in the right mood, free and limber, and inspired by his work; otherwise his calligraphic highlights would be dull, lacking vitality. Look carefully at detail no. 1. Probably the broad areas of light and even of the largest figures were put in during the first underpainting (A, B, C).

Now study the accents. Like the sword play of a champion fencer, the white paint flickers over the surface, adding light and life to whatever it touches. Think what the group D would be like without the highlights; or the figure at E, or the bow of the boat (F). Guardi adds the calligraphic touches which spell out the real character of each object. Look closely at detail no. 2. You can see how complex these accents (G) can become. Effects like these are easier with a flake white mixed with some wax and possibly thickened linseed oil and beeswax (ratio 1:2). With pure linseed oil a very thin line such as at G would probably tend to spread.

As an exercise, paint a *capriccio* landscape, combining elements that are familiar to you, and then use Guardi's accents of light to give a sense of sparkling light.

200

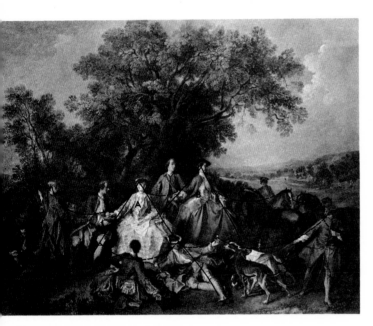

etail no. 1

Detail no. 2

Nicolas Lancret
French 1690-1743

The Picnic after the Hunt
Canvas, 24⅛ x 29⅜ in.
Samuel H. Kress Collection 1952

A painting like this was probably planned down to the last detail before it was even started. Lancret may have stretched his own canvas, brushed on several layers of priming (probably lead white mixed with linseed oil). Then he may have put on a toned *imprimatura* (a thin wash of burnt umber, mixed with burnt sienna); then he put on his drawing, probably with a fine brush, and built up his underpainting in a monochrome of burnt umber, burnt sienna, and white or a similar mixture. He then placed his local colors and, finally, added the highlights.

The overall design is very interesting. First and second focal points appear at the tops of the usual Baroque pyramids (A and B, detail no. 1). But interlacing through the figure group is a swinging design, interspersed at intervals with upright accents. This gives the impression of

a dance rhythm. Note that the swinging motif even runs through secondary elements (C).

The real appeal of this painting, however, lies in the sparkling brushwork, which makes the surface shimmer with unexpected accents. In detail no. 2, follow Lancret's hand as he flicks in the highlights, uniting his two principal figures. Scattered from D to M are a series of seemingly accidental flecks, strung like a necklace. In areas of secondary importance, like the coat of the man behind (O), there are no highlights to catch your eye.

As an exercise in the use of these highlights, take an old painting of yours, which you wish to discard. Using only highlight accents and repeats of design, try to unite the various elements together.

Detail no. 1

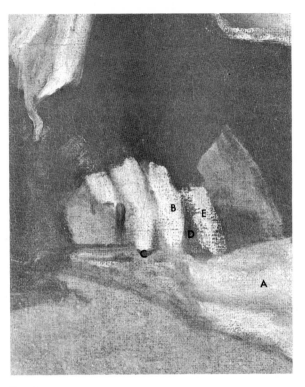

Detail no. 2

DIEGO VELÁZQUEZ
Spanish 1599-1660

THE NEEDLEWOMAN *(slightly trimmed)*
Canvas, 29⅛ x 23⅝ in.
Andrew Mellon Collection 1937

Velázquez is the painters' painter. For generations artists have made pilgrimages to the Prado in Madrid to study and learn from his canvases on display there. You can see some of the reasons for this professional respect in this sketch and in the details reproduced above. First, note that the texture of the canvas has been used most skillfully. Study detail no. 1. In the background, covered with dark glazes over a warm gray ground, the rough surface is not evident, but in the highlights Velázquez has deliberately dragged the paint, so that only the high points of the canvas are touched. This gives an effect of sparkling light. Note also the variations in highlights. The hand which holds the cloth (detail no. 2) is done with softly rounded forms and bland shadow areas (A). The fingers which are doing the work, however, have been outlined as sharply as a bird's talons (B). Dark accents of color (C and D) further emphasize the action and strength of the fingers. It is important to note that effects like this probably could be obtained only by using an underpainting. Obviously the finger at E, for example, was drawn in with rapid brush strokes, probably using lead white mixed with some wax. Such effects would be difficult to get with only cold-pressed linseed oil and turpentine. This underpainting was then glazed with at least three separate colors mixed with a glazing medium and probably applied in rapid sequence. We cannot be sure of the oil medium, but the colors used by Velázquez were few and simple. They are: red, yellow, brown, black, white. Again note: no blues or greens. Cool tones are achieved by the use of black.

205

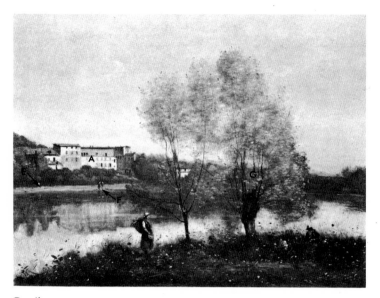

Detail no. 1

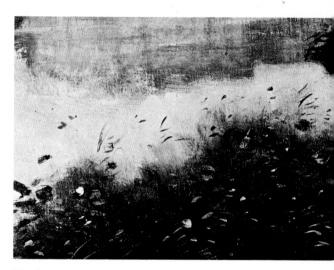

Detail no. 2

JEAN-BAPTISTE-CAMILLE COROT
French 1796-1875

VILLE D'AVRAY
Canvas, 19⅜ x 25⅝ in.
Gift of Count Cecil Pecci-Blunt 1955

Corot used more colors than you would think. His palette consisted of yellow lake, cadmium red light, cadmium yellow; lead white; Naples yellow; yellow ochre; raw sienna; burnt sienna; vermilion; Verona green; rose madder; Robert's lake; cobalt blue; Prussian blue; emerald green; raw umber; Cassel earth.

Although Corot studied and sketched from nature almost daily, practically all his major landscapes were painted in the studio. He probably started a landscape such as this by drawing in the rough outlines, and then blocking in the broad areas of neutral color. No details would have been included in the early phases. As the painting progressed, areas such as the row of houses, the darkest trees, and the figures would have been gradually defined. (See A, B, C, and D, in detail no. 1.)

In the last stage of the painting, Corot placed the accents of color which give the painting such sparkle and life. Although these seem to be scattered at random, in fact each is placed with great precision. Look at a typical section of this painting, the distant buildings (A), for ex-

ample. The dark windows are calculated to give interest, but not monotony, to the sunlit wall. Along the shore, the white figure at E and the two which are at F are placed precisely to relieve the monotony of the horizontal band. In the willow trees (G), there are flecks of light exactly counterbalanced to the dark tracery of the branches, which gives a feathery, light texture. Again, these bright spots are placed with extreme accuracy.

There are many fake Corot paintings in America; some of them are very precise in color and brushwork, but no forger has yet been able to copy his way of putting in these flecks of color. Look at these flecks more closely in detail no. 2. Like a great virtuoso on the violin, Corot always hits the right note.

As an exercise, paint a landscape in broad, flat, simple areas. Then, with a sable watercolor brush and pigments well saturated with medium, put in accents and flecks of brighter colors in order to give a sense of sparkling light and interest to the important parts of the composition.

206

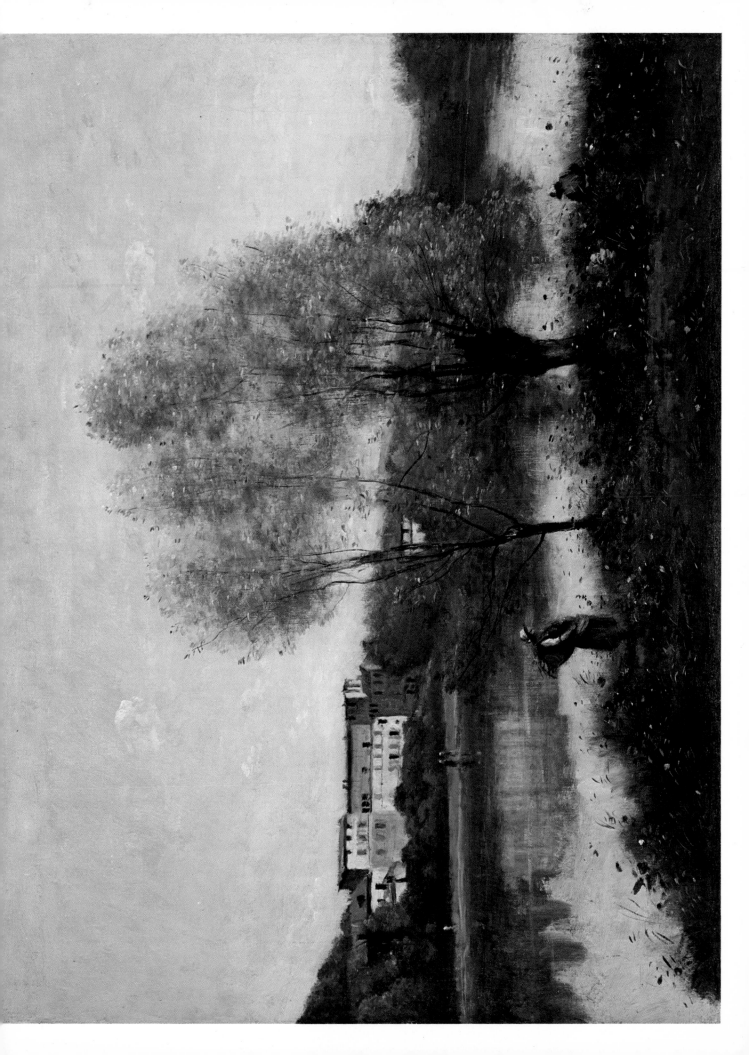

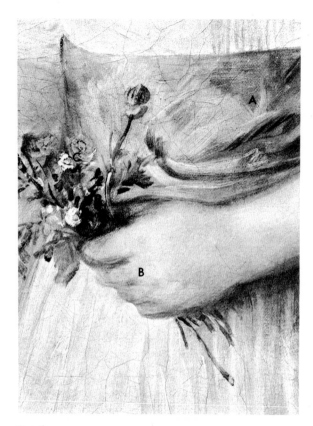

Detail no. 1

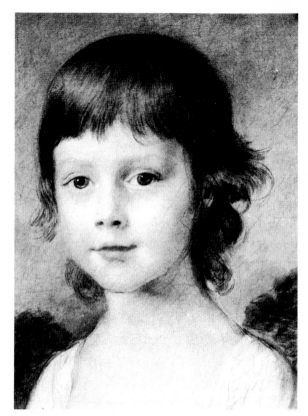

Detail no. 2

Thomas Gainsborough
British 1727-1788

Master John Heathcote
Canvas, 50 x 39⅞ in.
Given in memory of Governor Alvan T. Fuller by the
 Fuller Foundation 1961

Gainsborough's brushwork has fascinated generations of painters, and any artist can profit from analyzing his technique. From the records, we know that Gainsborough used brushes with handles up to six feet long. Presumably these brushes were used only for the first sketching in of the figures. In this picture it is possible to imagine that the trees in the background were painted with six-foot-long brushes. He used such long brushes for two reasons: first, to place his canvas the same distance from his eye as the model; and second, so that he would not be distracted or involved with incidental details during the first phase of his work. Most inexperienced painters tend to concentrate on painting the trees before they have painted, or even *seen*, the forest. Using long paint brushes is one way of helping a painter to overcome this form of myopia. After sketching in the general outlines and masses, Gainsborough evidently narrowed down the scale of his work, using increasingly finer, and presumably shorter, brushes. He isolated certain details for emphasis, and left the rest of the painting vague and indeterminate. In detail no. 1 there are at least three levels of definition, presumably representing three separate stages of the painting process: 1) the upper part of the sash (A); 2) the drawing of the hand (B); 3) the smaller details in the flowers (C). In the detail of the head (detail no. 2) you can see the same three stages. In this case the final details are done with extreme care and finesse, the highlights in the eyes, for example, and the fine lines around the eyelids, chin, and hair line. Cover up the line over the left eye, and note how this changes the expression and vivacity of the child.

As an exercise, get a bundle of small bamboo rods. Tie your brushes to the ends, and try painting with brushes four feet long. You may not like the effects, but it will be good practice for your eye and judgment.

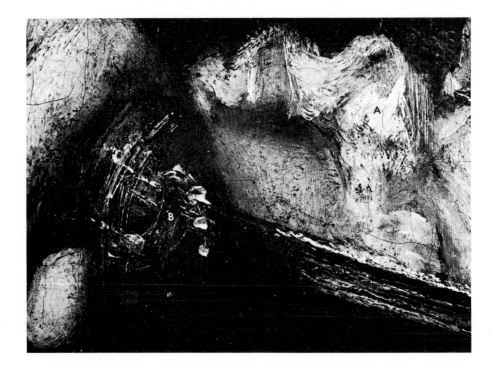

REMBRANDT VAN RYN
Dutch 1606-1669

LUCRETIA
Canvas, 47¼ x 39¾ in.
Andrew Mellon Collection 1937

We often forget that the great masters occasionally used coarse, irregular brushes. In this detail, the cuff (A) evidently was painted with a brush which must have looked like a miniature straw broom or a discarded toothbrush. The hilt of the dagger (B) was roughed in with an even more disheveled implement, perhaps not even a brush. I advise artists not to throw away old brushes, but to collect and treasure them. In both tempera and oil, brushes of varying stiffness and profiles can produce unexpected and exciting results.

There also is evidence that Rembrandt applied paint with an implement like a palette knife, which creates ragged, unexpected textures, and gives his painting such a fascinating variation in surfaces.

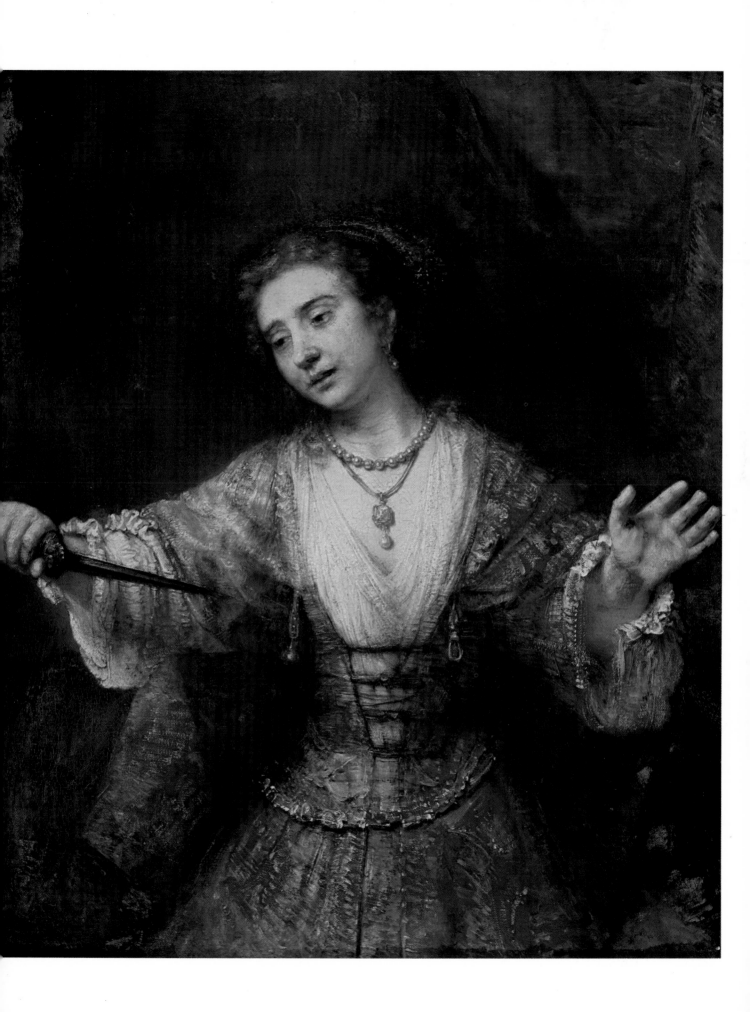

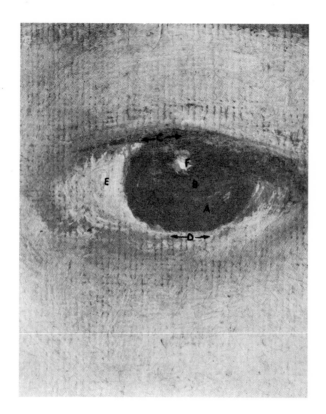

Francisco de Goya
Spanish 1746-1828

Señora Sabasa García
Canvas, 28 x 23 in.
Andrew Mellon Collection 1937

You can be sure that if you are ever recognized as a great painter, someone is going to make an enlargement like the one on this page, and will be able to interpret from it your character, mood, and painting methods. Every time you put a brush to canvas, you leave a miniature autobiography, more revealing than your handwriting or the lines on the palm of your hand. For example, study Goya's brush strokes, and try to reconstruct his methods. First, the iris of the eye was probably drawn in with a dark brown (A). Second, the pupil was filled in with a solid black (B), leaving a pinpoint near the center as a highlight. Third, the dark line of the upper eyelash was drawn in with a single quick stroke (C). The lower lid was indicated with lighter tone (D). Now comes the fascinating and revealing part. Evidently Goya was particularly struck with the flashing dark eyes of his model and the intensity of their direct gaze. To emphasize this, contrast was necessary. Therefore he increased the intensity of the white of the eye. In this section (E) there are no fewer than five

separate superimposed brush strokes, indicating that the painter strengthened this area five times. In other words, Goya arrived at the solution to his problem gradually, by trial and error. He went over the highlight in the center of the eye (F) three times, the last time with pure lead white. Note the quality of the brush strokes. They are extremely nervous and quick. In this way, it is not only the character of his hot-blooded model that Goya has shown, but his own impatient temperament. It is said that in his later life Goya was so impatient and quick-tempered that it was almost impossible to talk with him for any length of time without him losing his temper and beginning to shout abuse. A perceptive viewer can see this trait of violent irritability in these brush strokes.

As an exercise, take a hand mirror and paint a large picture of your own eye. Place a transparent acetate sheet over the painting and see how you can alter the expression of the eye by emphasizing different parts such as the lids, highlights, and size of the iris.

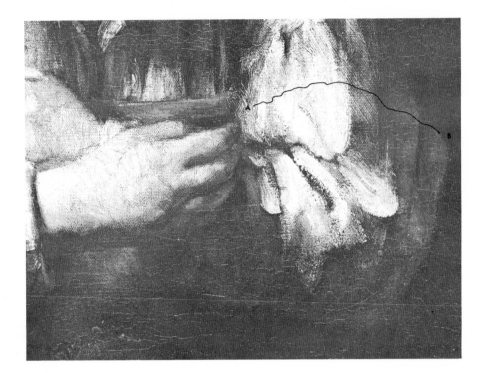

REMBRANDT VAN RYN
Dutch 1606-1669

A GIRL WITH A BROOM
Canvas, 42¼ x 36 in.
Andrew Mellon Collection 1937

Technically, no artist in history has been able to draw with the brush as well as Rembrandt. He could convey a sense of three-dimensional form, texture, weight, and movement with apparently casual strokes of the brush. As an example, study the folds in the sleeve. You have no doubt that the material is coarse, and that the shape of the folds is as outlined A to B. The character of the hands is equally clear: they are pudgy, chapped, and reddened by rough work. A sculptor could model these hands on the evidence which Rembrandt has given. Now study the detail closely, and you get an entirely different impression. The paint is dragged, scumbled, patted, and smeared in a way to delight the most demanding abstract expressionist. The feeling of form and texture dissolves, and you become fascinated with the paint quality. An important point to

remember is that the effect you see here was not produced in one single operation. We know that Rembrandt put colored varnishes on his paintings as a last refinement, and sometimes would smear on a faint tone with his thumb. These infinitely subtle differences in tone and color are what give the sense of solidity and texture to the whole.

As an exercise, take a canvas covered with an undercoating layer of ivory black and, using an underpainting of flake white and burnt sienna, paint a still life with a broad brush, concentrating on the strength and vitality of the brush strokes. When this is dry, take a soft brush and —with a glazing medium—try to modify the painting in a way that gives the different elements solidity and local color.

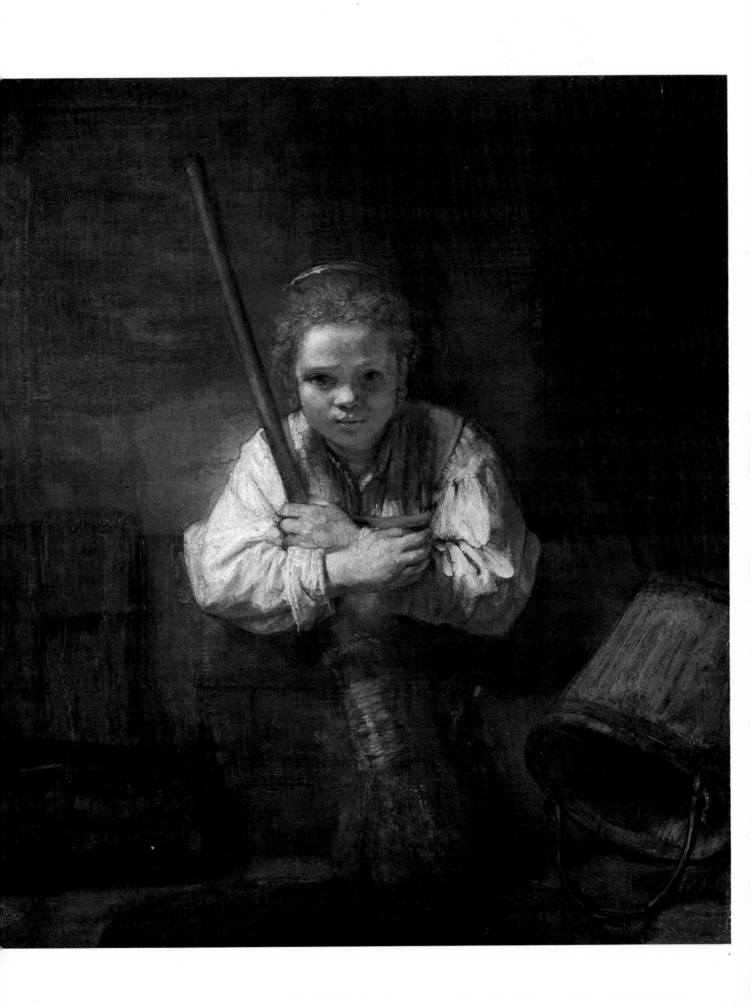

EL GRECO (Domenikos Theotokopoulos)
Spanish 1541-1614

LAOCOÖN
Canvas, 54⅛ x 67⅞ in.
Samuel H. Kress Collection 1946

The subject here is a man facing a sudden and terrible death for himself and his family. Obviously, a theme such as this one cannot be treated with carefully modeled outlines, subtle nuances of light and shade, and delicate color. El Greco uses all the power of his expressive brushwork to create a mood and to tell the story. To this he adds the violent contrasts between light and shade as a means of further creating a burning image of despair and terror. The old man's head probably was first blocked in with generalized forms, like the shoulder (A). Later, El Greco evidently decided to heighten the emotional content because he appears to have overpainted the face with furious passion. The brushwork seems to duplicate the throes of death and agony and to thrash helplessly in all directions, though held in a merciless grip. Note the difference between the brushwork around the mouth (B), the eyes (C), and the serpent's scaly head (D). It is as though El Greco had painted in abstract terms a prayer for mercy combined with a loathsome fate.

Brushwork can be used to express any emotion, but it takes a great artist to express a combination of emotions like this so forcefully and so clearly. As an exercise, paint a picture of a person drowning and make the brush strokes convey a sense of violence and anguish.

216

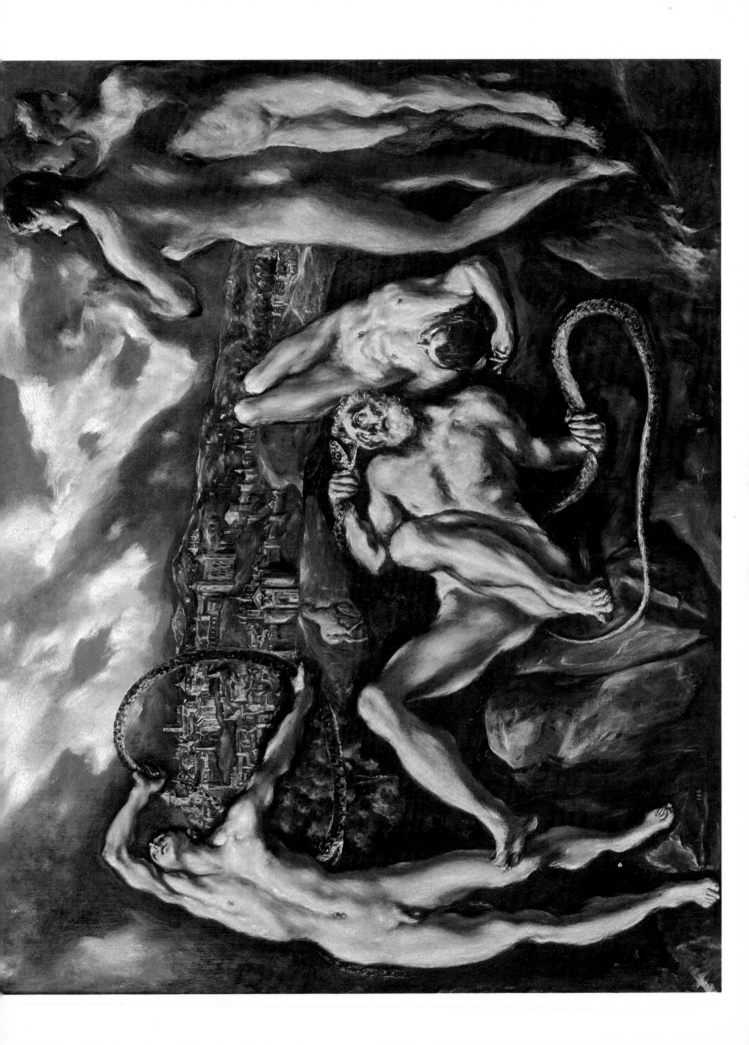

FRANS HALS
Dutch c. 1580-1666

PORTRAIT OF AN OFFICER
Canvas, 33¾ x 27 in.
Andrew Mellon Collection 1937

Painters who are interested in the expressive power of brushwork have invariably studied the work of Frans Hals. After three hundred years, he is still one of the supreme masters in this area of art. We know that Hals worked rapidly, without using elaborate preparatory drawings, and that he worked *alla prima* (directly, without the usual glazes and underpainting).

The detail of this painting gives a good idea of his method. Although from a distance the forms and details appear to be carefully studied, in fact the approach was almost impressionistic. First the broad areas of color were laid in, and then rapier-like brush strokes loaded with lead white, or a dark umber tone were used to define, accentuate, and bring to life whatever the painter touched. The final brushwork must have been painted very fast, with slashing strokes, usually following and defining the shapes. For example, the strokes along the forearm (A)

convey not only a sense of the round limb beneath, but of the stiff material and the way light catches the folds. Contrast this with the modeling of the buttons (B). Here the paint is dabbed on and twisted onto the canvas, again conveying a sense of the texture of the metal surface. The starched laced frill (C) is handled in a completely different way. Here the brush strokes are delicate and nervous, appropriate for the fragile, thin, and intricate material.

We are not certain what medium Hals used, but it is safe to suppose that it was relatively liquid and that there was some wax in it, so that the paint would stay where it was put.

As an exercise, take a handkerchief, crush it in your hand, and put it on a table in front of your easel. On a canvas with a dark priming coat, try to paint the handkerchief using Hals' slashing brush strokes.

GERARD TER BORCH
Dutch 1617-1681

THE SUITOR'S VISIT *(slightly trimmed)*
Canvas, 31½ x 29⅝ in.
Andrew Mellon Collection 1937

Note the very soft effects of the satin skirt. This softness is achieved partly by use of the "blending brush"—a tool which is still available, but which few contemporary artists know how to use. Generally, blenders are made of badger hair, and are round-ended. When the canvas—preferably painted with a resin-oil mixture—is still fairly wet, the blender is brushed quickly and lightly over the surface in different directions. The original brush stroke disappears, there is a slight transfer of surface paint across the canvas, and thus all contours become blurred and softened.

Excessive use of a blender gives an oleographic smoothness, which is disagreeable to most people. Used with moderation, however, it can give effects which cannot be obtained by other means. Here Ter Borch has used a blender to smooth out the various parts of the satin dress (A). Afterwards, he has placed a few bright accents to represent brocaded sections of the silk (B). These highlights also were probably blended slightly with a badger brush. The final result is a diffused, haloed luminescence which produces a convincing texture of satin.

The dog is an even more complex example of blending techniques. Presumably, areas such as C were painted in first and blended completely with the surrounding area. Second, certain more distinctive patches of hair were painted in and also blended—but less completely—so that the individual brush strokes are still discernible (D). Finally a few accentual highlights were put in (E, F) to differentiate the texture of metal and toenails from the soft fur of the pelt. Note, however, that the fur itself has different textures: the short coarse hairs on the fore-paw (G); the longer silky hair on the chest (H); and the comparatively coarse hair on the flanks (J). These effects are achieved almost entirely by skillful use of the blending brush at different stages of the painting. The blending brush, as I said before, is becoming obsolescent. This is a loss because, used with skill, it opens up a range of effects which cannot be realized by any other means.

As an exercise, buy a blending brush and paint a mouse, with the six different kinds of textures which you have seen on Ter Borch's spaniel.

220

REMBRANDT VAN RYN
Dutch 1606-1669

SELF-PORTRAIT
Canvas, 33¼ x 26 in.
Andrew Mellon Collection 1937

In the long history of art Rembrandt is supreme in his ability to make paint itself an exciting optical experience. The brush strokes seem so effortless—almost casual— yet each stroke conveys a lifetime of experience and understanding. Study the detail. The area shown—only an eye—is an incredibly skillful display of virtuosity and an endless source of fascination. "Keep your nose out of my painting," Rembrandt was quoted as saying, "the smell of paint is bad for you." In other words, don't try to look too closely at his paintings, to discover how he achieved his effects, because this is the mystery of the painter's craft. However, since this book is devoted to looking closely, we can at least be awed by Rembrandt's skill, even though no one can ever understand exactly how a painter like Rembrandt arrived at certain solutions. The eyeball itself (A) is built up of glazes upon glazes, so that the darker sections are unfathomable pools of transparent paint. In contrast, the highlight at B is a fleck of pure white lead, seeming to float on the glassy surface. The fold of skin over the upper eyelid (C) is a broad decisive brush stroke. The eyebrow (D) is a scratchy,

irregular series of dragged paint strokes. The corner of the eye (E) is a smooth area of flat paint, but the wrinkles at the corner are indicated by the brush stroke dragged over the surface (F), making an apparently completely non-objective pattern of raised lines and dots. Below this, the puffy flesh over the cheekbone is indicated by the rounded brush strokes of a heavily laden brush (G). An added wrinkle has been incised into the paint, probably with the end of the brush handle, or possibly with a fingernail (H). The pouch under the eye has been made with a single brush stroke, leaving minuscule gaps and holes (J).

Many excellent painters in the twentieth century have cultivated brush effects as an exclusive branch of painting, and there have been some outstanding, exciting practitioners of this form of art. But no one has approached Rembrandt in being able to conjure with the brush and express every form or shape, every type of light, every texture, every kind of motion, and, it seems, evoking every thought of both the artist and the subject.

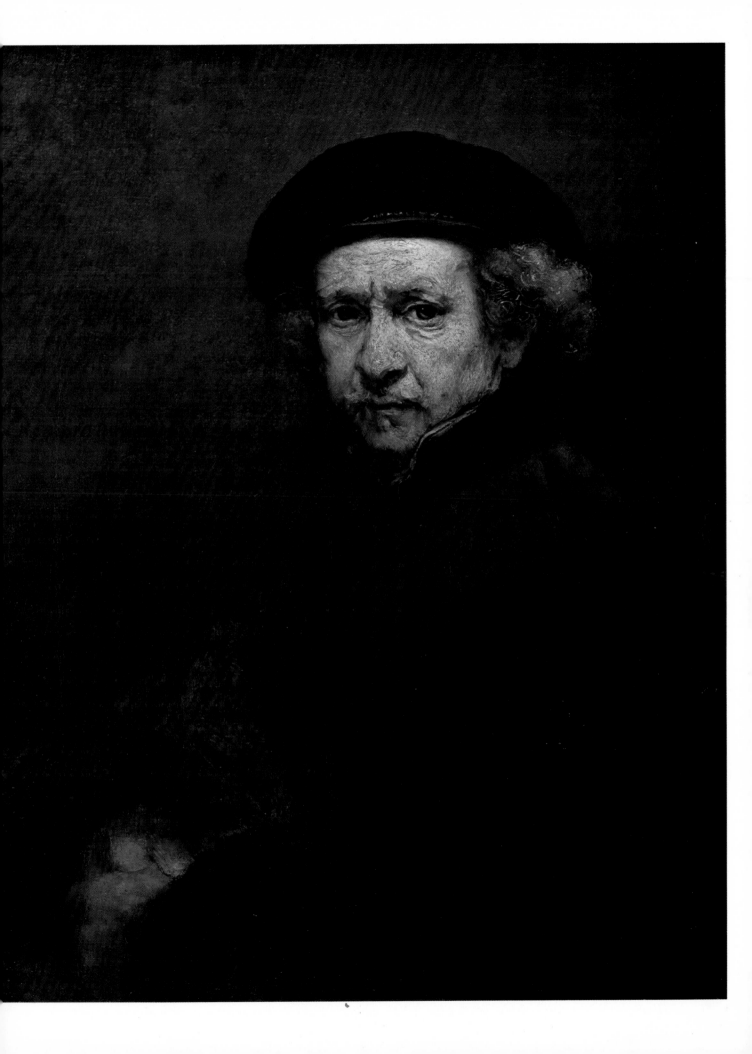

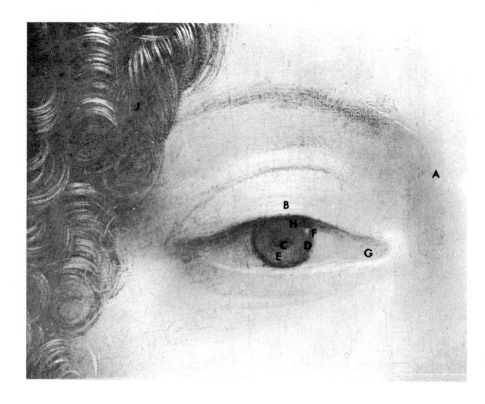

LEONARDO DA VINCI
Florentine-Milanese 1452-1519

GINEVRA DE' BENCI
Wood, 15⅛ x 14½ in.
Ailsa Mellon Bruce Fund 1967

Leonardo was a complex genius, whose greatness was evident in a number of fields. Technically he ranks among the most accomplished painters in history because of his supreme mastery of light and shade. In the detail, which is enlarged about three times from the original, some of his technical procedures are apparent. In areas of smooth skin, such as A, the modeling—presumably done with a fine sable brush and an oil-resin medium and possibly a very thin glaze—is kept completely smooth. At B, however, perhaps in order to emphasize movement and a more shiny skin texture, the modeling lines following the form of the eyeball underneath are clearly indicated. The eyeball itself is a masterpiece of precise rendering. The pupil (C) consists of several layers of transparent glazes, creating a well of darkness in which the light is absorbed and lost. The iris is darker along the right edge (D) than on the left, thus indicating that it is recessed from the outer white of the eye. Note also the pale shaft

of light at E, which is independent of the highlight on the cornea at F. Such minute and subtle refinements reveal an infinite capacity for observation and analysis. In contrast to the exact rendering of the iris opening, the other parts of the eye are treated in a relatively sketchy manner. The tear duct (G) is ignored. The eyelashes, both upper and lower, are simply left out. The eyebrow is only just indicated. Leonardo evidently wanted to stress that the eye is the window to the mind behind, and thus he concentrated all the emphasis on the central opening. To convey this even more forcefully he accentuated the dark shadow under the eyelid (H), thus adding to the impression of deep thought and mystery. In order to appreciate the incredible refinement of Leonardo's work, study the hair at the left (J). Each curl is a separate form, and each hair has a separate shadow and a separate highlight. In spite of this multitude of minutiae, the overall sense of unity never disintegrates.

224

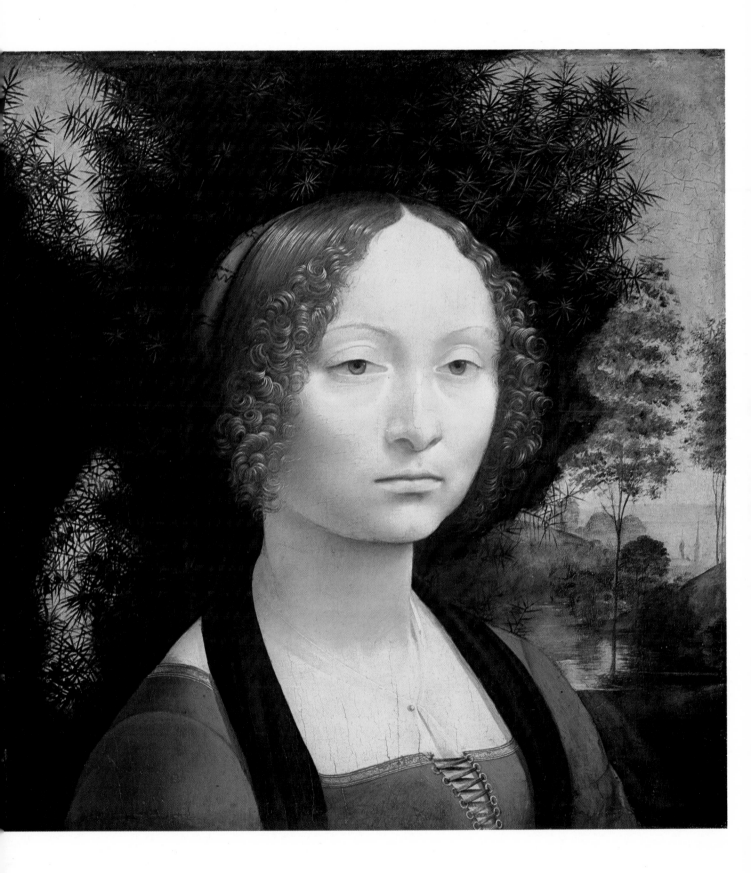

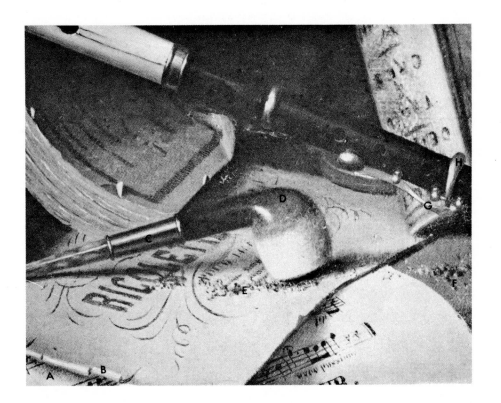

WILLIAM M. HARNETT
American 1848-1892

MY GEMS
Wood, 18 x 14
Gift of the Avalon Foundation 1957

Harnett's brand of realism is far more complicated than it appears at first sight. Look at the detail. Note how the cast shadow at A has been stippled. This puts it on a different plane from the dog-eared paper (B) painted with strong brush strokes of thick paint which seem to raise the edge away from the sheet music below. Study the contours of the pipe. The metal band (C) has a different contour and type of highlight from the softer meerschaum bowl (D), and yet both would be hard, smooth surfaces. The spilled ashes (E) are raised from the surface like grains of sand. To convey a sense of the nap of the beige cloth, the surface has been nicked with a knife or pin at F. A most subtle refinement can be seen at G: the sharp edge

of the piccolo key is contrasted with the book behind, making it stand out in space; it is also contrasted with the more worn surface at H.

These extremely fine subtleties would not have been recorded by photography; so—before you dismiss Harnett as an unimaginative realist—study carefully such refinements.

As an exercise, paint a small still life of a lighted cigarette in a glass ashtray. The highlights and contours on the paper, the glass, the ash, and the curling smoke will all be different. See if you can approach Harnett in the magic of his realism.

ALBRECHT DÜRER
German 1471-1528

PORTRAIT OF A CLERGYMAN
Parchment on canvas, 16⅞ x 13 in.
Samuel H. Kress Collection 1952

The word *realism* has different meanings in art. For most people Dürer's paintings represent the quintessence of realism because he shows everything, beautiful or ugly, and depicts each part with the same objective honesty and precise craftsmanship. In this picture the individual hairs are literally a hair's breadth in thickness, and probably were painted with the finest brush, or pen, available. The painting is on parchment, the surface of which has a fine, very even texture, ideally suited for extremely fine-scale work. The first drawing for this painting was probably a very faint outline in silverpoint. In the second stage, Dürer probably made a brown ink reinforcement of the drawing. Next, he modeled the details of the face, again probably using a very fine brush and ink, or tempera. Highlights, as on the hair and in the eyes, were added with lead white. Lastly, a glaze—probably of varnish tinted with appropriate colors—was brushed over the different sections, but no further modeling was attempted. In other words, this is essentially a tinted drawing.

This technique allows extreme finesse and accuracy, particularly in modeling. For example, study the left eye. Note that each plane is so precisely depicted that you could make an exact model of this section. Starting at A, you can follow the contour over the eyelid, eyeball, and cheek, without any ambiguity or doubt. Similarly, any line running across the face could be plotted with scientific precision. Follow an imaginary line B, and note that you are never left in doubt.

To achieve an effect like this is, of course, only possible for a master draftsman, but if you have a bent for meticulous accuracy, and an ability to draw, Dürer's work can provide very valuable object lessons.

As an exercise, take a piece of parchment, make a drawing on it with the finest and hardest lead pencil you have available. Reinforce this drawing with ink, and then use tempera to finish and model the individual parts. If you are satisfied with the work so far, finish it by putting a thin oil glaze on top. Your work may not look like Albrecht Dürer's, but you will perhaps have learned how to achieve effects of extreme fineness.

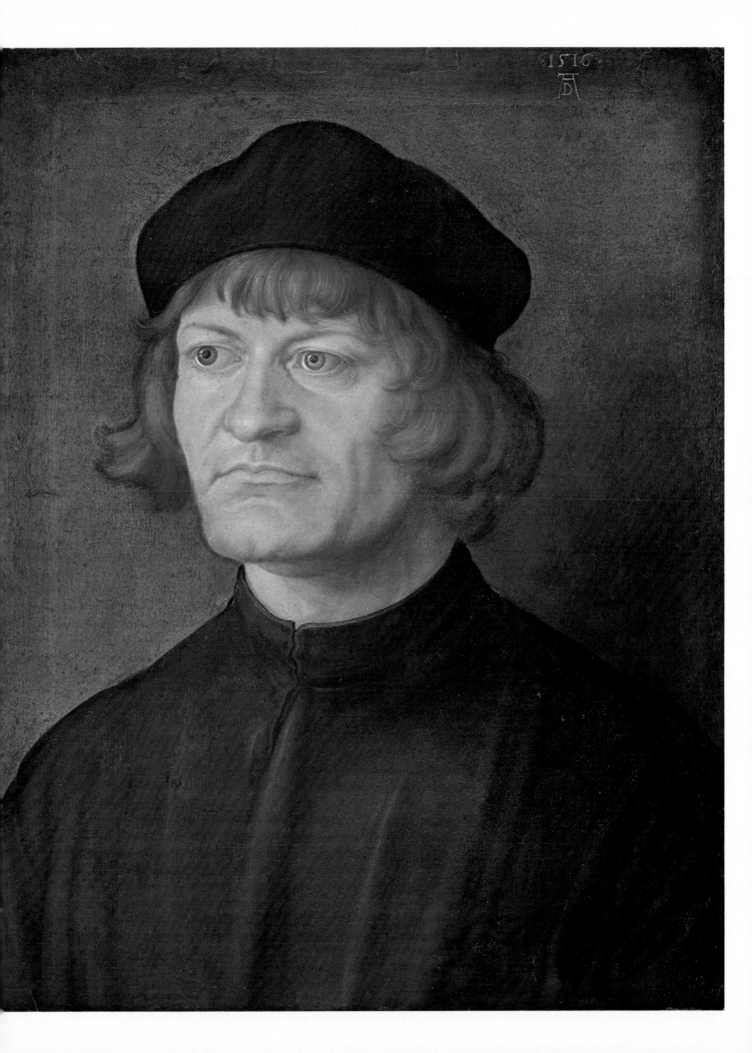

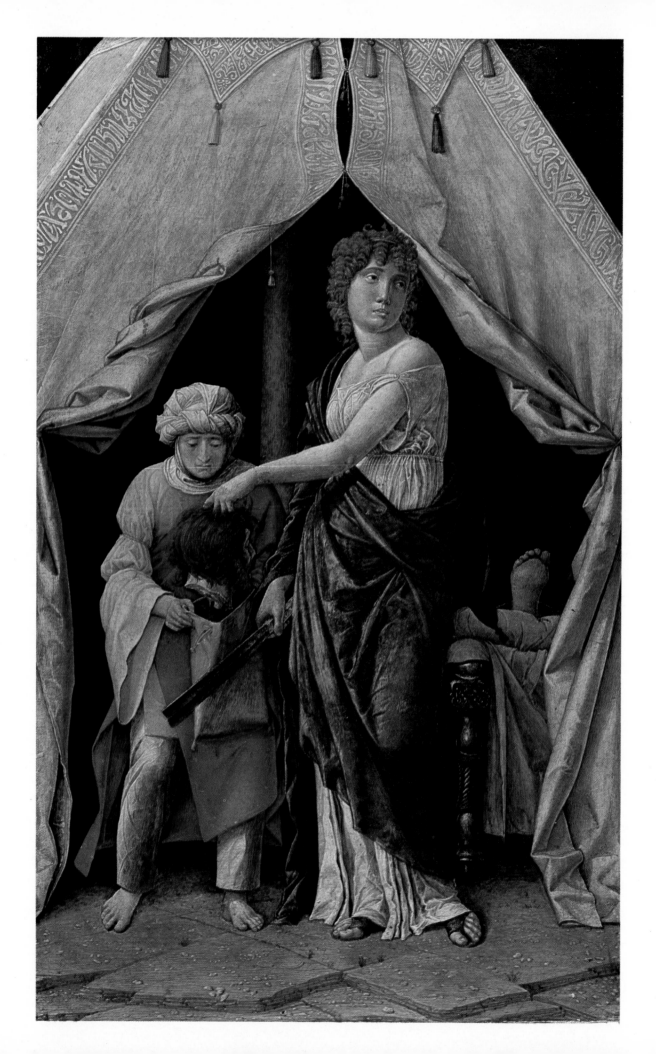

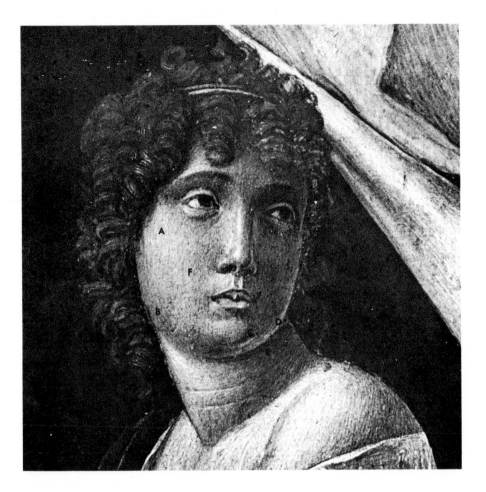

ANDREA MANTEGNA
Paduan 1431-1506

JUDITH AND HOLOFERNES
Wood, 11⅞ x 7⅛ in.
Widener Collection 1942

The tempera technique reaches its highest peak of perfection in a work such as this.

This color reproduction is about actual size, and the detail is enlarged about four times. The wood panel on which it was painted was first covered with several layers of gesso, scraped and smoothed until the painting surface resembled the texture of ivory. Presumably the composition was transferred onto the surface from a pricked drawing (i.e., a full-scale drawing made on thin paper, with tiny pinpricks outlining the main lines of the design. A black powder dusted over such a drawing will leave a dotted outline on the painting surface). The medium was made from egg yolk, mixed with water and possibly a little varnish or oil. The consistency of paint was like thin gouache.

In order to paint an area like the head in the detail, the artist would have mixed in advance at least six shades of flesh tone on his palette and kept them separate: highlight (A); halftone (B); shadow edge (C); reflected light (D); cast shadow (E); and a reddish tone to blend into areas like the cheek (F). These shades were applied in areas carefully mapped out in advance, using a very small pointed sable-type brush. Since tempera dries very quickly, the artist blended by hatching the lines. This takes patience, a sure knowledge of what the colors will be like when they dry, and an expert draftsman's ability to draw with the brush.

As an exercise, arrange a simple still life. Take a gesso panel and pre-mix five tempera colors for each object in the still life. Using a small sable watercolor brush, see if you can duplicate the techniques illustrated here.

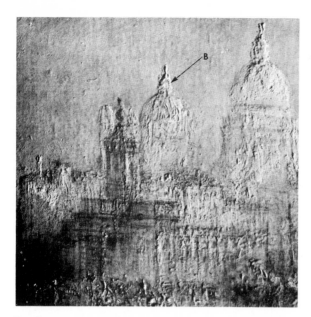

Detail no. 1

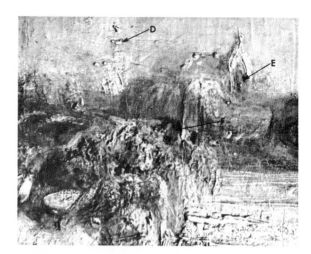

Detail no. 2

JOSEPH MALLORD WILLIAM TURNER
British 1775-1851

THE DOGANA AND SANTA MARIA DELLA SALUTE, VENICE
Canvas, 24⅜ x 36⅝ in.
Given in memory of Governor Alvan T. Fuller by the
Fuller Foundation 1961

Some painters have a natural aptitude for watercolor. By instinct they prefer to work fast, using a well-diluted medium, with washes of transparent color, and brushes that permit loose treatment and calligraphic expression. If you prefer to work in watercolor, a careful study of Turner's technique will pay rich dividends. Even when he painted in oils, Turner used a technique similar to that of watercolor.

Turner often painted from pencil sketches which he made in his travels many years before. In some cases these sketches consisted of only a few lines; he supplied the rest from his imagination and memory. A painting such as this one was probably painted in the following steps. (1) He prepared the canvas with a pure white lead base, leaving some of the brush strokes visible, but covering the canvas fairly completely so that only a slight texture of the weave was visible. (2) He brushed a very thin turpentine wash—probably only of golden ochre—over the whole surface of the canvas, which was lying flat to prevent much running and spreading. (3) Using a sable brush and again mostly turpentine as a medium, he drew in the main lines of the composition, probably with burnt sienna (see A, in detail no. 1). The principal masses of light, such as the dome of the distant church, were blocked in with lead white, probably mixed with some wax and a thin oil-turpentine medium. The paint was applied in fairly thick layers, giving the surface an almost bas-relief, sculptural effect (look closely at both details). This sculptural effect was used particularly in those sections where direct brilliant light was desired, in the cupolas (B), for ex-

ample. (4) He placed the local color areas, again using only transparent colors and a glazing medium. At B there is a very pale yellow glaze and at C a somewhat thicker glaze of yellow ochre and burnt sienna. (5) In the final step, Turner applied small accents of impasto—usually white —which are scattered like pearls over the lagoon, giving a sparkle of sunlight to the scene. (See the detail of the boat and wharf in the foreground in detail no. 2.) It is important to realize that in the two details only the small areas E and F are opaque. All the rest is transparent.

It is difficult to believe that Turner could have painted a canvas like this unless the painting were lying flat. Evidently, he kept the surface swimming in medium, but there is no sign of runbacks or spreading.

Turner was trained as a watercolorist, and a painting such as this is essentially a watercolor painted in oils. The handling, transparency, and fluidity are hallmarks of the watercolor technique, and Turner controls and preserves them all with perfect assurance. The greatness of his work lies in the luminescent quality which can be achieved only if the light is allowed to penetrate through the glazes to the reflecting white base, and is then reflected back to the eye of the spectator. The irregularity of the under-painting also adds to the shimmering effect of the reflected light.

As an exercise, paint a landscape or a still life entirely in white, building up the principal highlight areas with thick lead white. When this has dried, apply very thin glazes of transparent color, using a glazing medium. Finally, put in one or two strong accents of opaque color.

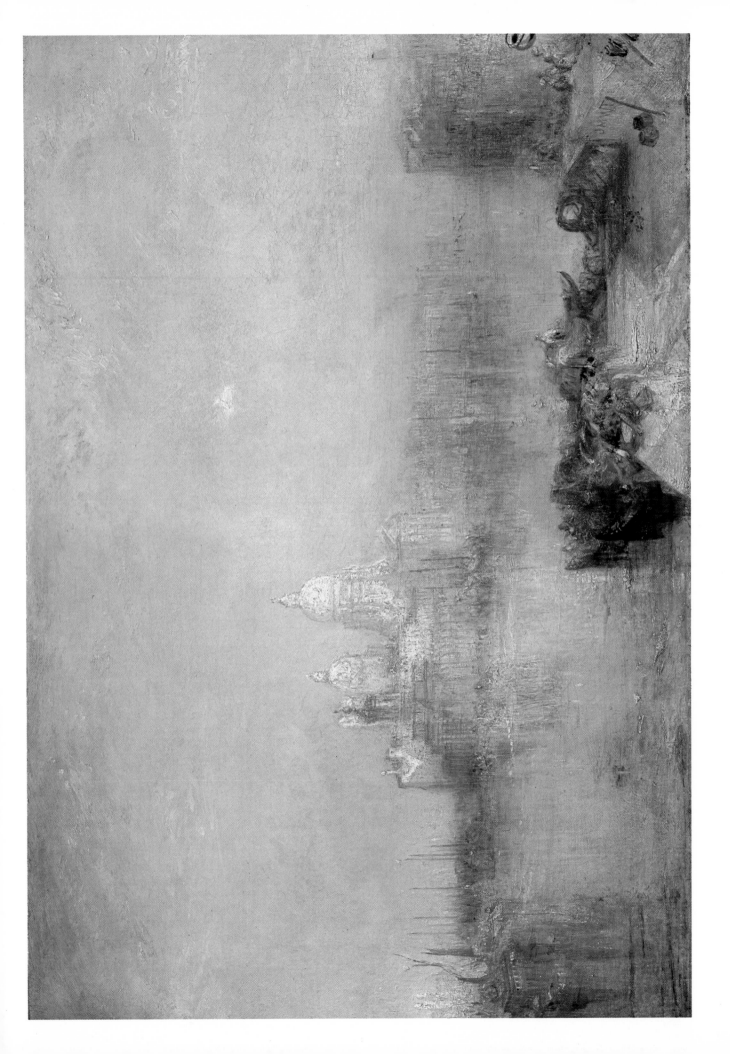

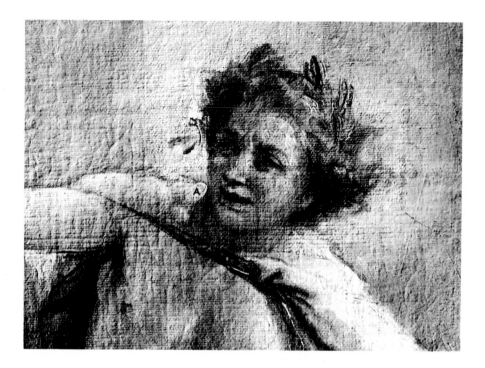

GIOVANNI BATTISTA TIEPOLO
Venetian 1696-1770

APOLLO PURSUING DAPHNE
Canvas, 27 x 34¼ in.
Samuel H. Kress Collection 1952

A painter can become frustrated by the difficulty of drawing with the brush when using oil paint. When a crisp, spontaneous effect is desired, the paint goes on in thick daubs, spreads or runs, and the desired effect is lost. Many times I have seen students who have a gift for drawing become disgusted with oils, because they can't produce the calligraphic qualities they want. There is no reason for this attitude. Oil paints, under the right circumstances, can give as wide a range of calligraphic possibilities as, for example, charcoal or ink. Study the detail. Tiepolo was a great colorist, but he was an even greater draftsman. With effortless ease he could portray a figure in any position, and a face with any expression. This he achieved almost entirely with lines and accents. In the detail, the anger and frustration of the sun god is conveyed principally by the expression around the eyes, in particular the lines along the eyebrows and forehead. Cover this section, and you will see the god merely looks out of breath. These lines are probably brushed in with a long-handled and long-haired brush, similar to today's lettering brush. The medium probably was an oil-resin mixture, and possibly some wax mixed in with the paint. Undoubtedly, Tiepolo painted into a "bed" of thinly applied liquid ground,

brushed over the area shortly before (see the section on underpainting).

Calligraphic brushwork is evident throughout this painting. Such freedom would be impossible to obtain by using a brush laden with linseed oil, or even linseed oil well thinned with turpentine. The paint would have run and spread in either case. Therefore, if you have an ability as a draftsman and prize your control of line, don't jeopardize it by painting with the standard oil media. Use an underpainting medium and save your lines.

The detail gives you an idea of how Tiepolo used the texture of the canvas to add a scintillating quality to the surface. Even in the highlights the paint is so thin that the weave of the canvas shows through. Occasionally, where a sharp accent is required, on the shoulder at A, for example, the paint is built up into a ridge which catches the light. Dark accents (B, C), on the other hand, were not built up, but were applied with an equal degree of flexibility.

As an exercise, try painting a tree in oils, putting in as many small branches and leaves as you can. If the paint starts to run together your medium is too liquid, and you should find one which will give better results.

234

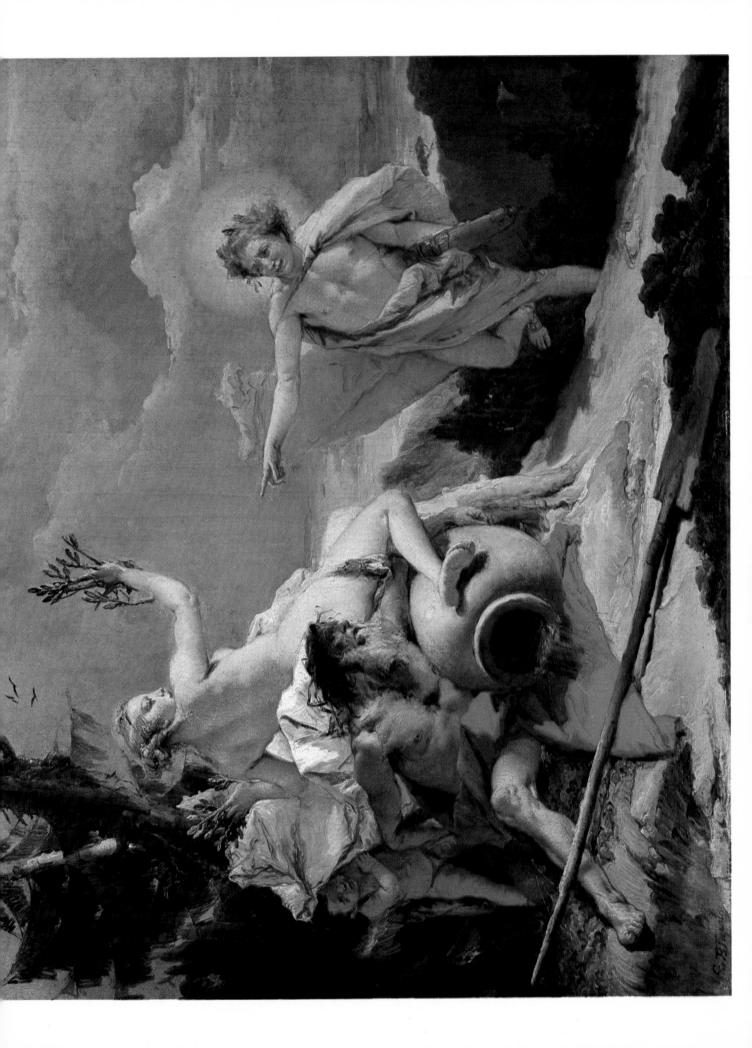

NICOLAS POUSSIN
French 1594-1665

THE BAPTISM OF CHRIST
Canvas, 37⅝ x 47⅝ in.
Samuel H. Kress Collection 1946

Any painting by Poussin is almost certain to be a lesson in composition. Probably no other painter in history has placed his figures, colors, and landscape details with such consummate skill. His pictures tend to be optical chess games in which we follow with pleasure the moves of the master; we are awed by his genius. Before I help you analyze this painting, study it carefully for about ten minutes and see how many of the lines and counterlines you can work out by yourself.

First, you must realize that this is the baptism of Christ, and that the picture must center around the act of John the Baptist, who pours water over the head of the Savior. The most important line of the composition is the gentle curve of the horizon (A). Note how it suddenly dips at B, pointing at the hand of the Saint. Note the second most important line—the undulating horizontal series of accents formed by the heads of the people to the left (C). This again points toward the hand of John the Baptist (D). Note the wings of the dove over Christ's head which point downward toward the act of baptism, and how this line is continued through Christ's body and into the reflection in the

water (E). A triangle is formed by the lines F, G, D, again with Christ's head at the apex. In fact, virtually all the lines of the composition lead your eye to the hand of the Baptist, except one—the line which follows the pointing hand of the apostle (H) and seems to end nowhere. Actually this line is one of the keys to the whole picture. Divine power was usually symbolized by light in the seventeenth century and this line is pointing toward the radiant light behind the trees—the unseen, all-powerful divine presence. Every figure, accent, cloud, and reflection in this picture has an essential part to play, which a seventeenth-century viewer would have understood. For example, the bright red cloak thrown casually in the foreground symbolizes the blood sacrifice which must be paid at the time of the Crucifixion.

The features described above are only the beginning. You can study a Poussin like this for hours and keep finding new rhythms, repeats, consonants, symbolic meanings, contrasts, and other subtleties. In your own painting, whether nonobjective or super-realistic, almost all of the principles described can be used with profit. There is nothing dated in these technical devices.

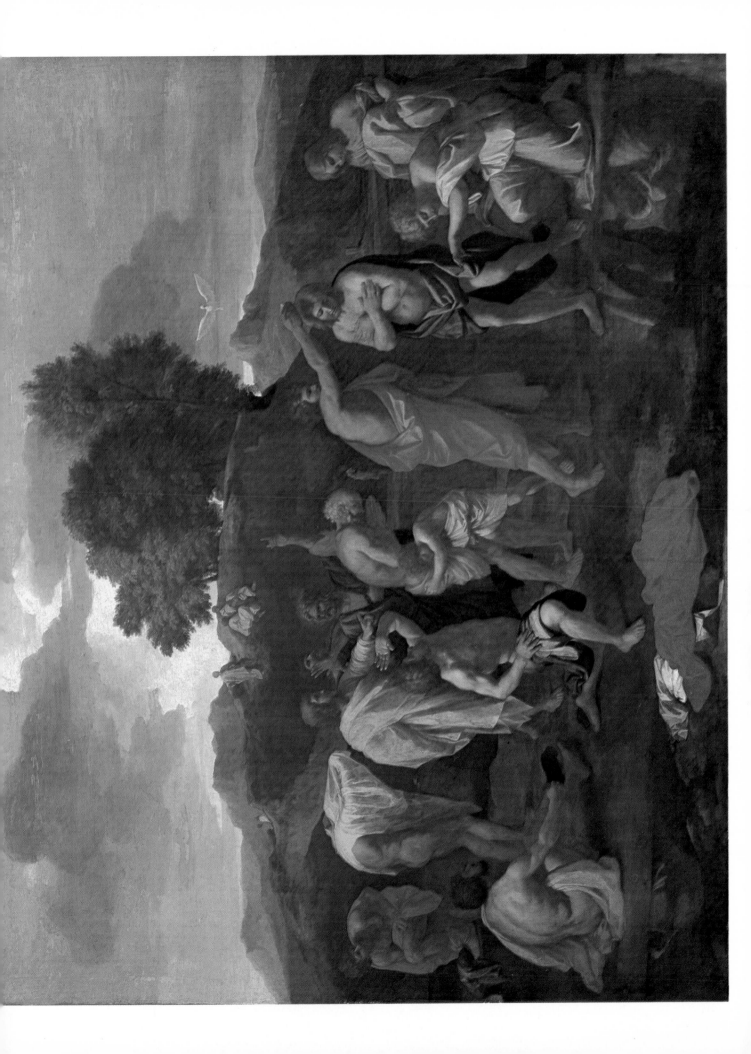

Mary Cassatt
American 1844-1926

Girl Arranging Her Hair
Canvas, 29½ x 24⅝ in.
Chester Dale Collection 1962

This picture was painted as an angry answer to a sneering remark made by Mary Cassatt's contemporary, the French painter, Edgar Degas. In general, Degas had a low opinion of women. Once, he told a group of friends that women could never become great painters because they could never grasp the basic principles of design. He implied that they might be able to produce pretty pictures by following simple academic rules, but that was all. Mary Cassatt, who today ranks almost as high as Degas among nineteenth-century painters, overheard the gibe and went back to her Paris studio to prove him wrong. She took the most unattractive model she could find—a buck-toothed Irish scullery maid—and posed her in the most awkward position possible. The model wore a baggy nightshirt; in the background there was a cheap washstand. The model also was placed far off-center and was represented as looking into the corner

of the canvas. Practically all of the academic laws of composition were thus violated. In spite of this disregard of all the accepted rules of good painting, Mary Cassatt produced a masterpiece.

Study the design. Without effort the curved lines A, B, and C lead the spectator's eye to the face of the model. The other sections of the design are brought into harmony by the consonant points D, E, F, and G. There are two very important lessons to be learned from this picture. First, there are no rules which cannot be broken by a painter of real ability; second, any subject—no matter how unattractive—can be made beautiful by a great painter. "I never believed a woman could paint so well," Degas muttered when he first saw this picture. He bought it for his own collection and refused to part with it during his lifetime.

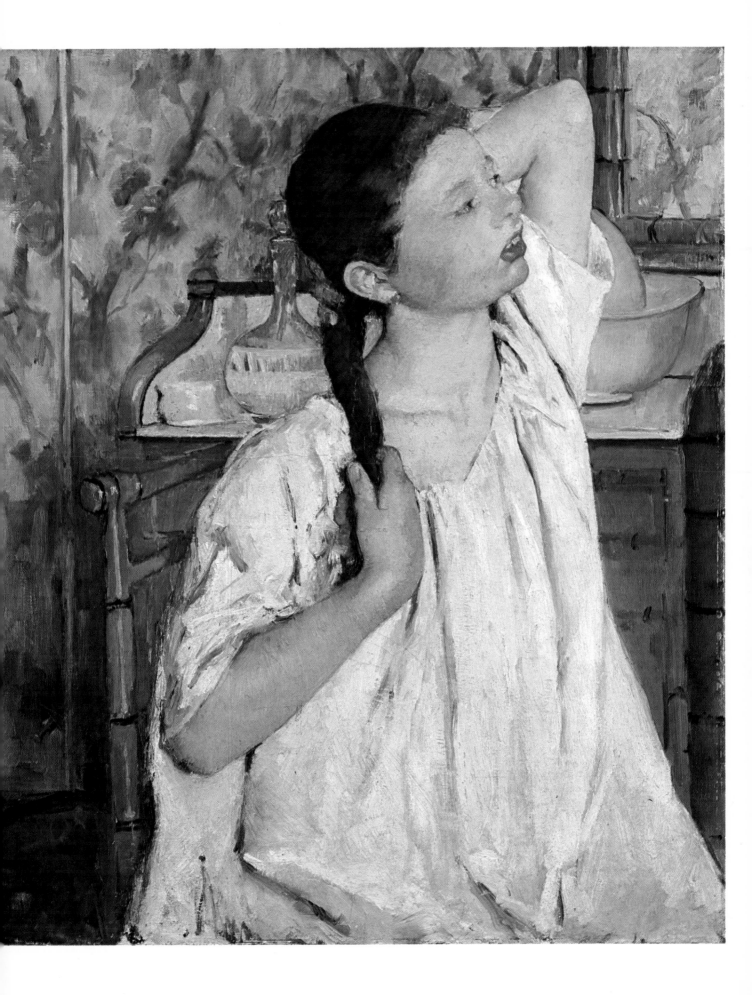

PABLO PICASSO
Spanish 1881-

PEDRO MANACH
Canvas, 41⅜ x 27⅞ in.
Chester Dale Collection 1962

Picasso is one of the great draughtsmen of history. In this work, done when he was about nineteen, his use of line is already masterful. You have no doubt that Picasso's sitter had a strong and decided character, as unwavering as the line (A) which surrounds his figure. In fact, Pedro Manach was a leader of the Communist party in Barcelona and played an important part in the events leading up to the war of 1936. We can be sure that Manach had decided views. This is conveyed by the clearcut and broad areas of black, white, and yellow, dramatically emphasized by his red tie. It is impossible to imagine this color scheme applied to a little old lady or a sweet-tempered child.

In this very early work, Picasso was beginning to show some of the hallmarks of his style which later made him the most influential artist of our day. Note for example the white shirt. Scarcely perceptible in the broad, white areas

are tinges of yellow, black, red, green, and blue (B)—in other words, pale and subtle reiterations of the dominant colors of the picture. The same is true of the yellow area (C). Examine it carefully and you will find a continuous interplay of the other dominant colors.

This use of color may seem obvious, but few painters today will study and refine a simple area of color until it becomes a work of art in its own right, having the power to appeal on a level quite separate from the object it covers.

As an exercise, paint a picture of a commonplace subject. Make an area of it a single color. Try to make the color of this area as complex and refined as possible, using the other colors of the composition. If successful, this area itself will become both interesting and meaningful.

240

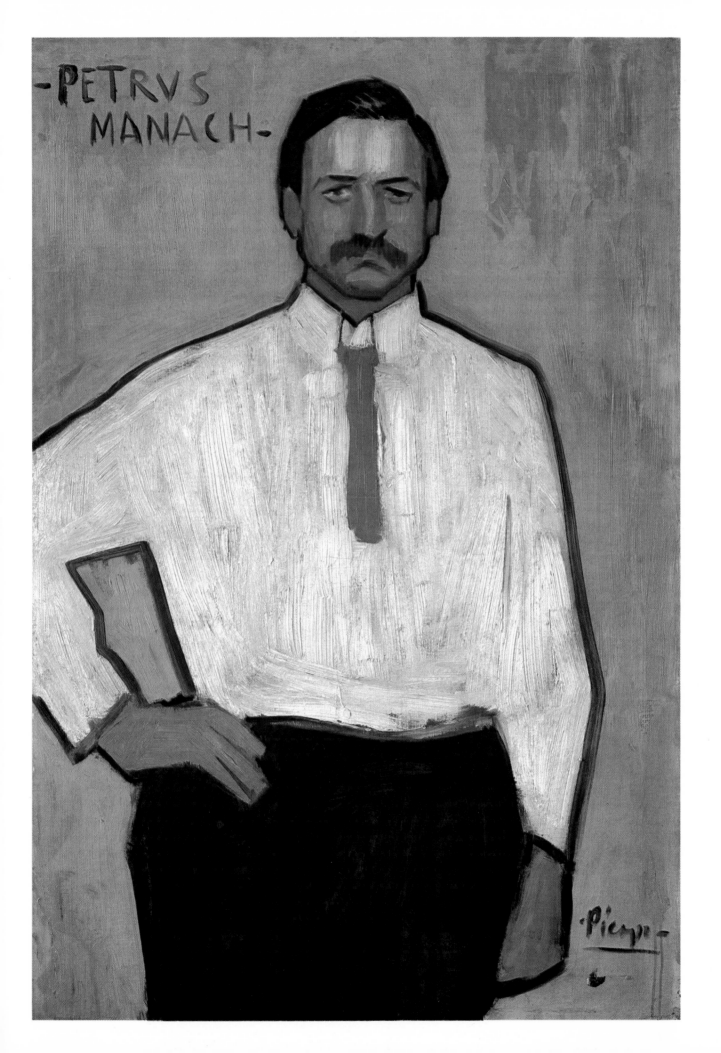

JEAN-HONORÉ FRAGONARD
French 1732-1806

THE SWING
Canvas, 85 x 73 in.
Samuel H. Kress Collection 1961

One of the ways to create harmony among the various elements in a picture is by repeating similar design patterns in different parts of the composition. This is known as *consonance*. As in music, a motif can be repeated which recalls other passages and so forms a bond within the composition. For example, in this painting the rounded top of the cloud (A) is repeated in the foreground tree (B), in the middle-distance trees (C), in the far distant trees (D), and even in the distant hill (E). In the left-hand foreground the same design is repeated in the lion's head at F.

Interlaced through these rounded forms are diagonal lines. The most important is the line made by the rope of the swing (G). This is continued by accents at H, J, K, and L, and is repeated like sympathetic chords in the small accents in the fountain at M, the telescope at N, and even the ridge of mountains at O. These links make a unified harmony of what otherwise might be a group of widely dispersed and unrelated elements.

Street scenes, in particular, lend themselves to the use of consonant designs. Draw a line of houses in an imaginary city street. By repeating small details—like the angles of roofs, the shapes of trees, the curtains in windows, the smoke from chimneys, etc.—try to unify your composition in the same way that Fragonard has done here so successfully.

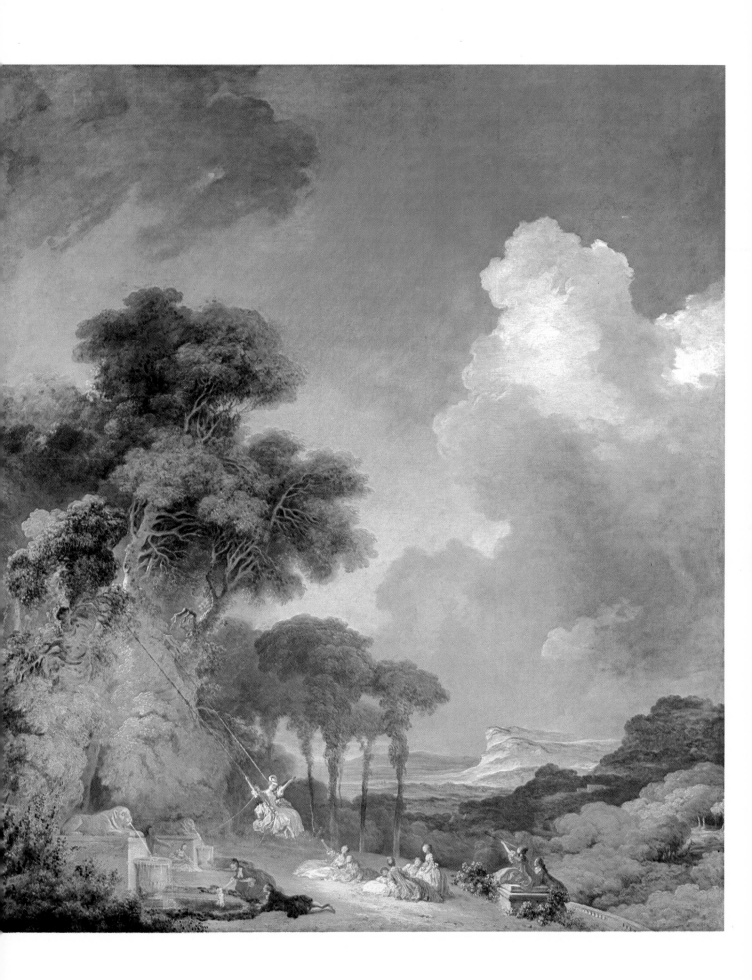

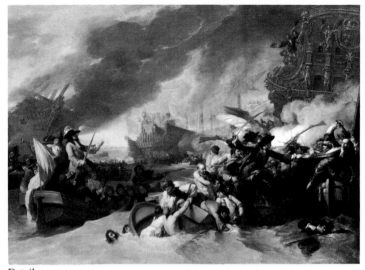

Detail no. 1

Detail no. 2

BENJAMIN WEST
American 1738-1820

THE BATTLE OF LA HOGUE
Canvas, 60⅛ x 84⅜ in.
Andrew Mellon Fund 1959

Warfare has been depicted by artists from time immemorial. Among the first works of art representing war were ancient Mesopotamian relief plaques. These plaques showed the king's bodyguard lined up in parade formation, hacking their foes to pieces without danger to themselves. Today we have TV coverage of the war in Vietnam in which the public, for the first time, has found a chance to participate (from an armchair) in war as it really is.

In the history of art, the Baroque conventions for representing warfare were perhaps the most inoffensive. Action was depicted much as it is on a stage. Of course, the right side wins, and the enemies are portrayed as cowardly rabble. Clouds of smoke billow in well-designed masses, and spotlights accentuate the important people and action.

In this painting, the Dutch commander, standing up in a skiff (which no seaman in his right mind would ever do), directs the attack (A). His English ally, being more heroic

(the picture was commissioned by an Englishman), has a French enemy officer by the coattails (B). At C, (and detail no. 2) a British tar punches a drowning enemy, and an ashen gray survivor is hauled from a watery grave at D. High on a hill the French king and his court watch the defeat of their forces (E). The essence of Baroque historical art was that once the action was over all the actors lined up for a curtain call. In Baroque battles no one was really hurt.

A scene which Americans must witness all too often is the havoc caused by a car accident. Applying the principles described above, paint a picture of an accident to include the wrecked car, the ambulance, the police officers, the victims, the insurance lawyers arriving on the scene, and the interested spectators. Light the scene with spotlights and remember that at the end of the act no one is really maimed.

JEAN-BAPTISTE-CAMILLE COROT
French 1796-1875

AGOSTINA
Canvas, 52⅛ x 38⅜ in.
Chester Dale Collection 1962

Students of painting tend to think in terms of parts rather than the whole. Thus, in a figure study they will finish the head, then the torso, then the legs, then the background, and then wonder why they have created five paintings and not one. Unity can be achieved by color, design, brushwork, etc. A variation on the design method is the *recall and key system* used by Corot. In simple terms, this is the technique of providing links and transitions between different areas in a painting. First, a design motif is repeated so that the eye recognizes and follows similar patterns; in this way the eye is not jarred unnecessarily by passing from one alien and dissimilar object to another. In addition, adjacent areas are linked together by means of optical bridges, or *keys,* which make it easier for the eye to go from one part to the other. This is like opening the doors in a house for your guest; the object is to make his visit proceed smoothly.

In this painting by Corot there are basically three elements: the figure, the sky, and the landscape background. Now follow his thinking as he fits the three parts into a unified whole. First, note that the line of the horizon (A-B) is continued through the figure along the top of the apron. If the arms (C) did not break this line, the continuity might be distracting and the figure appear to be cut in two;

as it is, you are not even conscious of the continuity. Also, observe the link between the dark mass of her hair and the deep brown of her dress. The shadow along her shoulder at D has been strengthened to help bridge the gap. The shoulder straps are like two raised arms which reach up to claim and embrace the head into the composition.

Some of the less obvious points should also be noted. The recall motifs are all diagonals which form a lattice-work knitting the whole composition together. The only major design elements parallel with the picture frame are the stone ledges of the walls at E and F, and the cliff on the right at G. All three have been deliberately subdued.

Now observe the keys, which open up areas and let the space flow. First, there are the branches of trees projecting out of the soaring cliff on the right (I). Without them, this element would be a forbidding barrier; as it is, you hardly notice it. The gap in the bodice, at H, breaks what would otherwise be a hard dividing line. Another key is the pattern on the apron (J). This floral design blends the dark brown of the dress and makes a contrast with the simplicity of the other areas. It also breaks down the optical isolation. Some of these devices Corot probably used by instinct, but some, as we know from his drawings, were deliberate.

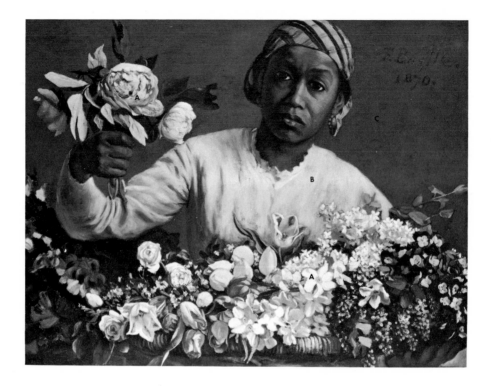

Frédéric Bazille
French 1841-1870

Negro Girl With Peonies
Canvas, 23¾ x 29¾ in.
Lent by Mr. and Mrs. Paul Mellon

The skillful use of contrasts is one of the most effective means the artist has to accentuate points of interest and thus control the viewer's attention. In this painting obviously the flower-seller's head is the focal point. To accentuate this, Bazille surrounds her face with flowers on three sides. The flowers (A), in contrast to the plain chemise (B) and flat background (C), are brightly colored and have profusely busy patterns. The real stroke of genius in the picture, however, is the head. A lesser artist would have used a light background to contrast with the dark skin of her face. However, Bazille, by what might be called a negative contrast, uses a background almost as dark as the skin tones and reserves his real contrast for the whites of the eyes which he further accentuates with jet black pupils. This device rivets attention on the eyes themselves.

Using these three types of contrast—color, mass, and a negative contrast of tonal values—compose a picture focusing attention on the mouth and teeth of a black panther in a jungle setting.

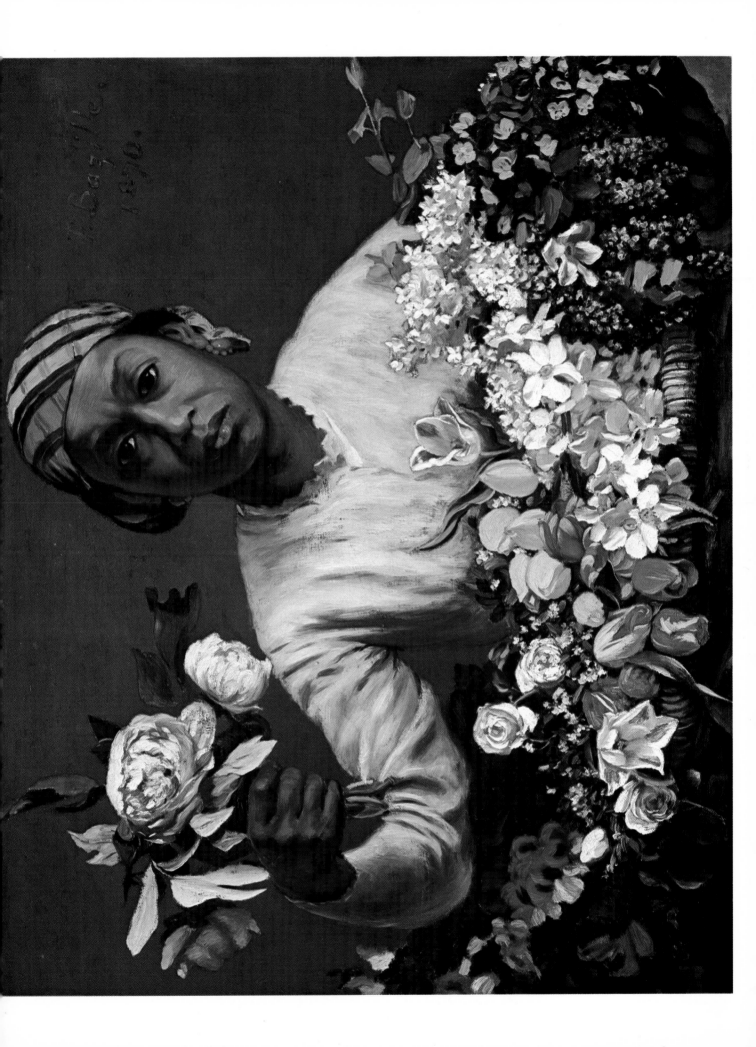

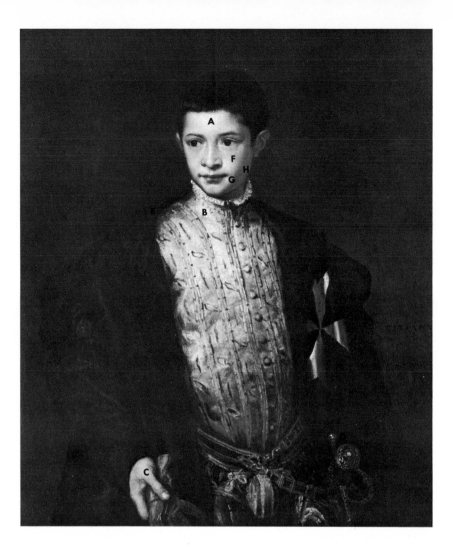

Titian has always been regarded as one of the great color-ists of all time. Rich, glowing, sumptuous, splendid are some of the terms usually applied to his colors. In this portrait note that like many great artists Titian's color range is not wide. Practically everything falls within the yellowish or reddish-brown color bracket. Even the dark background is basically a warm black. The single excep-tion to this is the cross on the sleeve which is silvery white and relatively cool. This cool touch acts as a contrast and foil for the rest of the painting. Without it, the harmony and character of the painting would be completely altered. Imagine the effect if this cross had been emerald green or vermilion red.

In addition, note that the highlights on the face (A), the embroidered vest (B), the hand (C), and the sword hilt (D) are all about the same golden yellow. Stronger colors appear at the edge as the form turns into shadow. Note,

for example, the shoulder (E) and the edge of the cheek (F). The shadow edge on the face is dull and neutral (G) but the reflected lights are marvels of transparent paint (H). The color in these areas is made up of many veils or glazes of transparent oil paint, through which light penetrates and is reflected back. We know from contempo-rary accounts that Titian used as many as forty superim-posed layers of oil paint to obtain the exact degree of brilliant luster. The effect is somewhat like that of an enameled metal or a stained-glass window. In contrast to the transparent areas are the highlights which may have only one glaze. In this way, there is a constant interplay between deep, transparent color and surface highlights.

As an exercise, try to copy in oils the colors in the face of this portrait using a lead white underpainting with glazes of burnt sienna, yellow ochre, ivory black, viridian green, and raw umber.

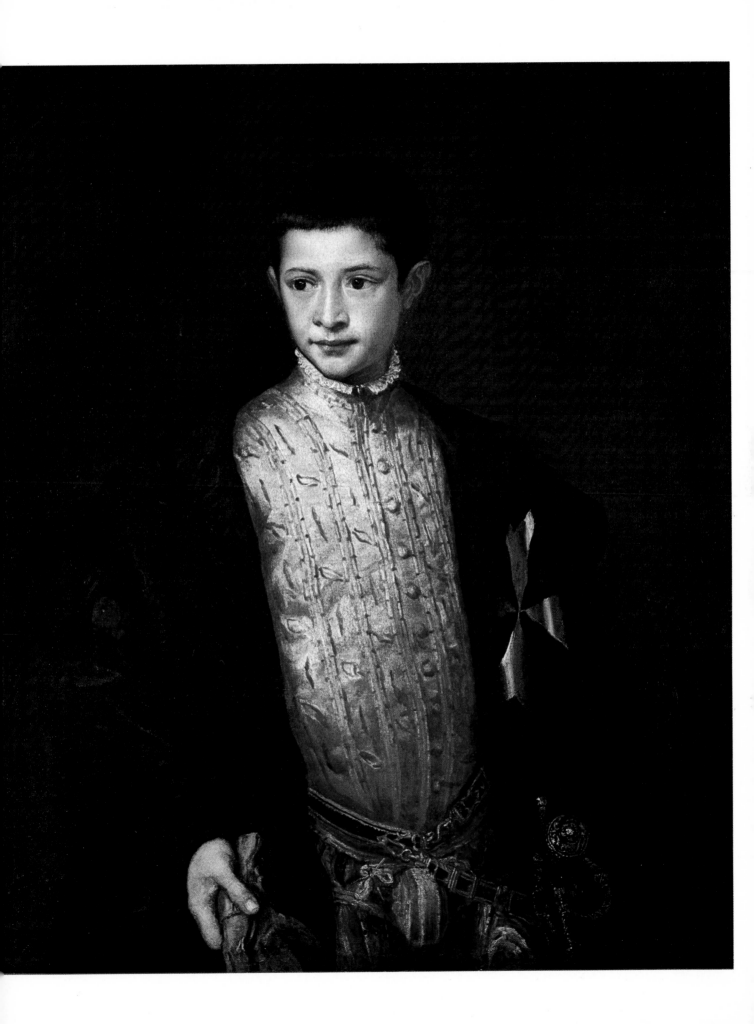

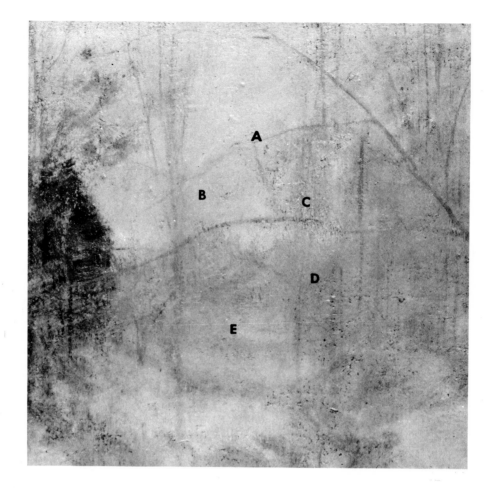

The subject of this painting is very ordinary—a woodland stream in winter. Most people would think such a theme so commonplace that they would pass by without giving it a second look; yet, an artist like Twachtman has found infinite beauty in the trees, snow, and mist and has converted the scene into a masterpiece. He accomplished this in part by searching out and slightly exaggerating the very subtle variations in color. For example, in the area at the top center, A is slightly bluer than the surroundings; B and C are slightly redder; D is slightly more purple; and E is slightly grayer.

A painter, or anyone who deals professionally with harmonies and contrasts in color, develops—like a wine taster —a super-sensitivity far beyond the capabilities of the lay-man. The amateur may sense slight variations in color but the professional can both see and record them. It is said that the professional painter can isolate as many as thirty shades of blue, whereas an amateur can distinguish fewer than ten.

As an exercise for testing your own sense of color, make a rough sketch in pencil or pen of Twachtman's picture. Then, for about ten minutes try to memorize the colors. Close the book and with pastels or crayons try to duplicate from memory Twachtman's colors on your own sketch. Then, open the book and discover how many you have missed. Try the same exercise two or three times and you will be surprised to find how many nuances of color you will have learned to discover.

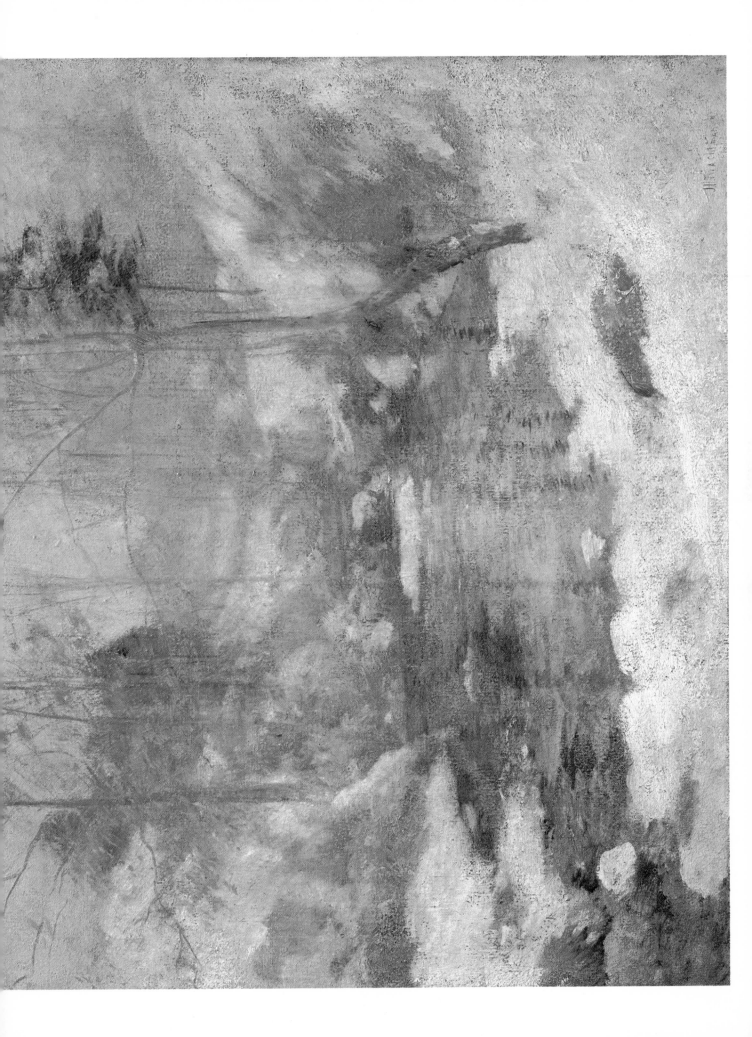

PETRUS CHRISTUS
Flemish c. 1410-1472/73

A DONOR AND HIS WIFE
Wood, each panel 16½ x 8½ in.
Samuel H. Kress Collection 1961

We often think of a portrait as a likeness of a sitter; if it is a good likeness, then it is a good portrait. However, there is much more to a person than just his or her physical appearance. Look at the information Petrus Christus has given us about the lady at prayer. We know she is devout. We know what the landscape is like around her home. We know who her father and mother are from the coat of arms on the wall. We know her first name is Ursula from the woodblock of her patron saint tacked to the wall. We also know that she is young, beautiful, and married.

The next time you paint a portrait try to add accessory details that give more information about the subject. If it is a woman, include her favorite jewelry. Perhaps her name can be woven into an inconspicuous corner. Her favorite flowers and hobbies can be included. Perhaps a small scale view of her home could be painted in the background. I've seen total information portraits which give horoscopes, handwriting analysis, and even palm readings.

Remember that one of the prime purposes of a portrait is to give information to other people about an individual. Therefore, no accessory fact is out of place or really redundant.

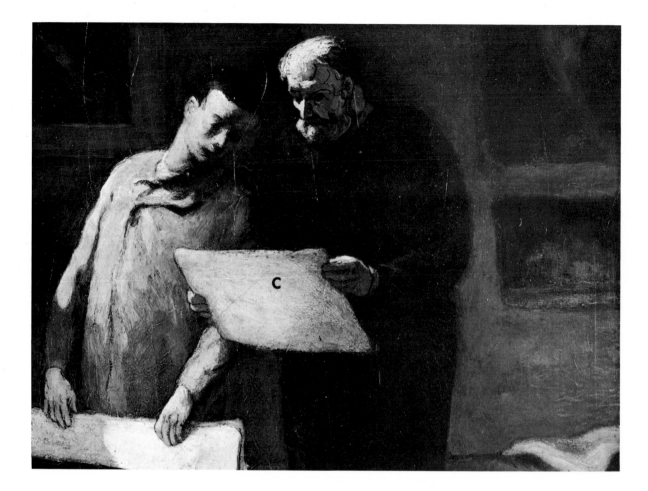

Honoré Daumier
French 1808-1879

Advice to a Young Artist
Canvas, 16⅛ x 12⅞ in.
Gift of Duncan Phillips 1941

Painters often forget that the human eye can clearly see only one small three-dimensional area at a time. Everything outside, in front, or behind this focal point is blurred. In Daumier's time photography made painters aware of this, but now photographic lenses are so good that the fact is being forgotten again. Yet, the human eye has not changed since Neanderthal times, and it is important for a painter to realize how his own, and his viewer's, eyesight works.

Obviously, the focal point here is the old man's head (A). To stress this Daumier uses strong black lines to emphasize expression and character. A second area of interest includes the younger man's head, (B). Although light-and-

shade contrasts and colors are relatively strong, it is clear that this is a secondary area. Now study the other parts of the painting. Only at C has Daumier created another focal point. In other sections—for example, the rest of the older man's figure—there are no sharp accents or strong contrasts. The background (D), in spite of its interesting subject matter, has been deliberately thrown out of focus to reinforce the old man as the optical and psychological center of interest. His wisdom, experience, and judgment are key factors in the situation, and Daumier left no doubt that this is what he intended to convey.

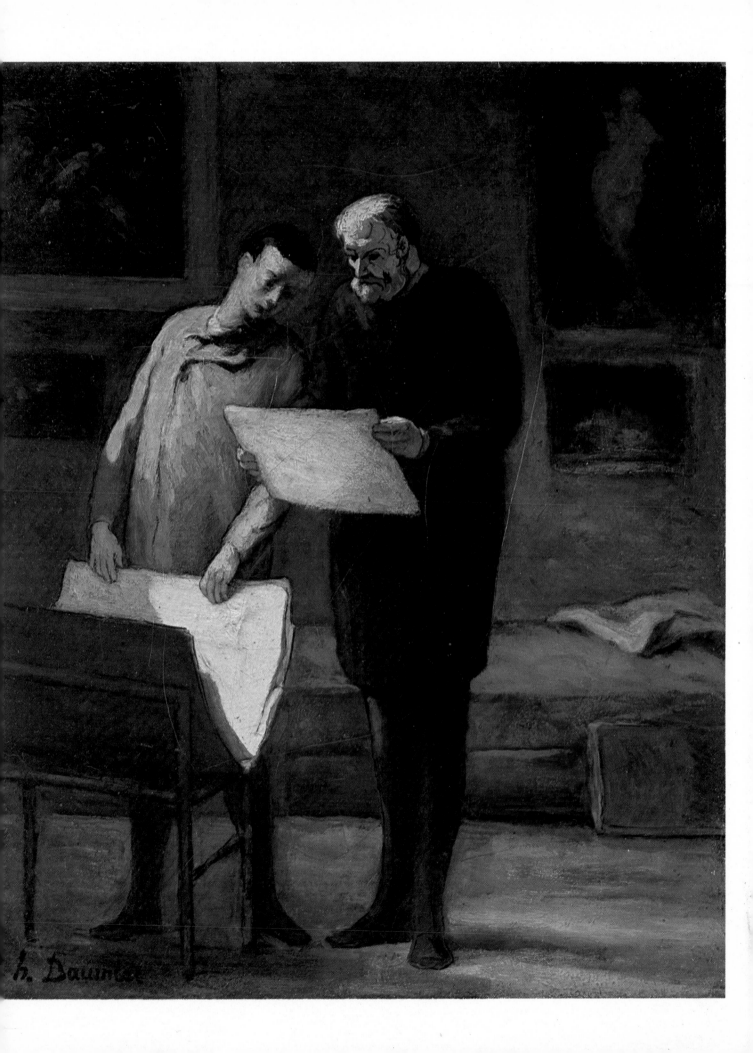

Detail no. 1

Detail no. 2

JAN GOSSAERT (MABUSE)
Flemish c. 1478-1533/36

PORTRAIT OF A BANKER
Wood, 25 x 18¾ in.
Ailsa Mellon Bruce Fund 1967

When trying to decide whether a certain painting has been done by a master, art experts will often study the unimportant details of the painting as carefully as its center of interest. A real master will not permit a picture to leave his studio until he is satisfied that every part is worthy of his talent and reputation; whereas a lesser artist will paint the center of interest with all the skill at his command and gloss over the secondary features.

The *Portrait of a Banker* is a good illustration of this point. Study the head (detail no. 1). Every plane, every reflected light, every millimeter of the outlines are rendered with great precision and skill. Even the collar is a miracle of exact observation and meticulous craftsmanship. Now look at the objects in detail no. 2. Observe the lead weight in the round tray (A). The highlights, cast shadows, and modeling are just as perfectly rendered as they are in the model's eye. Note the cast shadows on the book (B). Every variation in tone is rendered with an exact knowledge and a patient attention to the smallest nuances. Even the stack of IOU's tacked to the wall display every precise crinkle.

As an exercise, paint a portrait of someone you love seated at a table on which you have put a matchbox. Then, paint the matchbox with as much care as you would paint the lips of your model, without drawing too much attention away from your sitter's face.

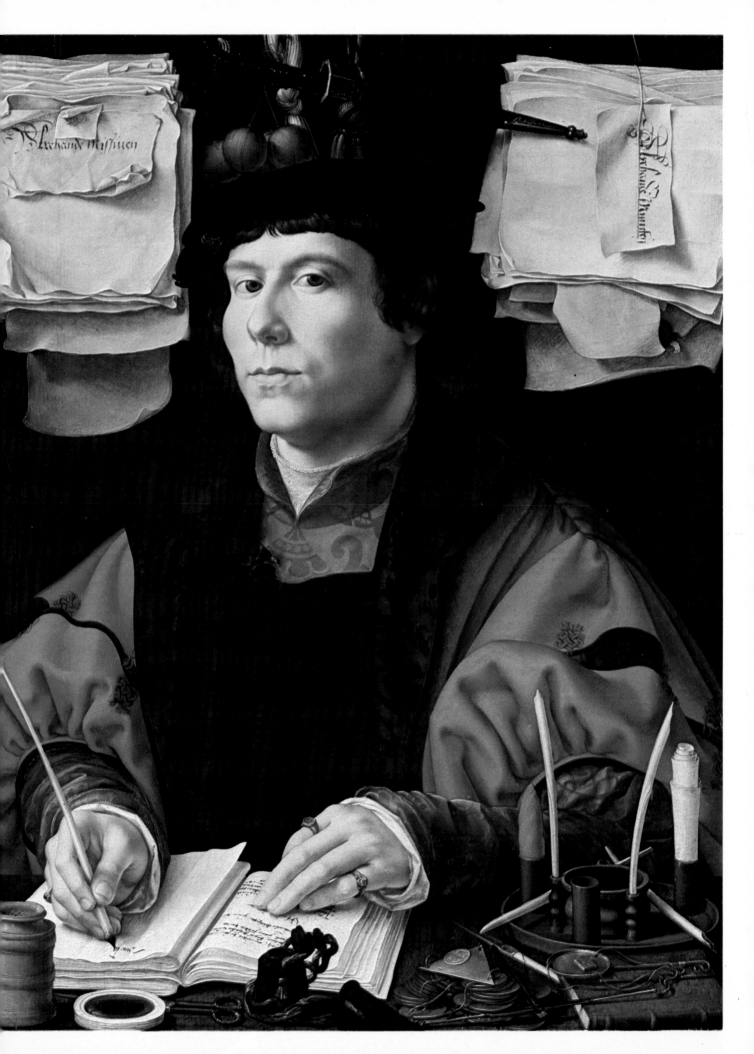

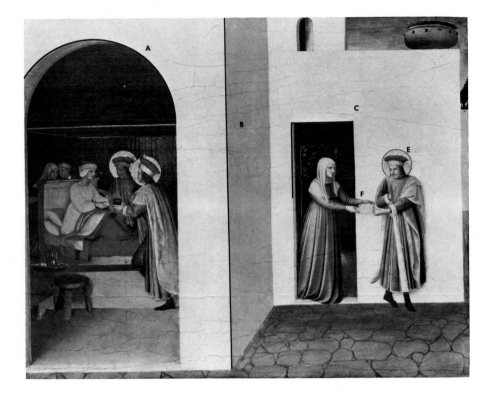

FRA GIOVANNI ANGELICO
Florentine 1387-1455

THE HEALING OF PALLADIA BY SAINT COSMAS AND
SAINT DAMIAN
Wood, 14⅜ x 18⅜ in.
Samuel H. Kress Collection 1952

A device which many painters have used to help emphasize the different elements in a picture and to divide up the action is a "frame within the frame."

From the accounts of his life, Fra Angelico sometimes has appeared to be a pious and talented painter but a somewhat naive technician. In fact he was a past master in the art of composition as this *predella* (small accessory panel) clearly proves. On the left, the rich lady is healed by the two Arabian physicians who are under oath not to accept any reward for their services. On the right, one of the two brothers breaks his vow and accepts a gift from the grateful patient. The scene on the left is framed by an archway (A), which seems to bring the group together in a community of thought and action. The angle of the wall down the middle of the picture (B) divides the

action into two areas categorically different both in time and place. On the right, the square angles express conflict and sharp tensions. The dark doorway frames the woman (D) and separates her psychologically from the doctor. The doctor (E), isolated against a blank expanse of wall, seems vulnerable and lonely. His outstretched arms (F), expressing the conflict between the man's greed and pangs of conscience, are the only link between the two people. Note that each person and group has a different type of frame which expresses a different type of thought and action.

As an exercise, draw a picture of a gunman holding up two pedestrians in a dark street. By changing the shapes of doorways, windows, and wall areas, try to express the action and the psychological tensions in your picture.

260

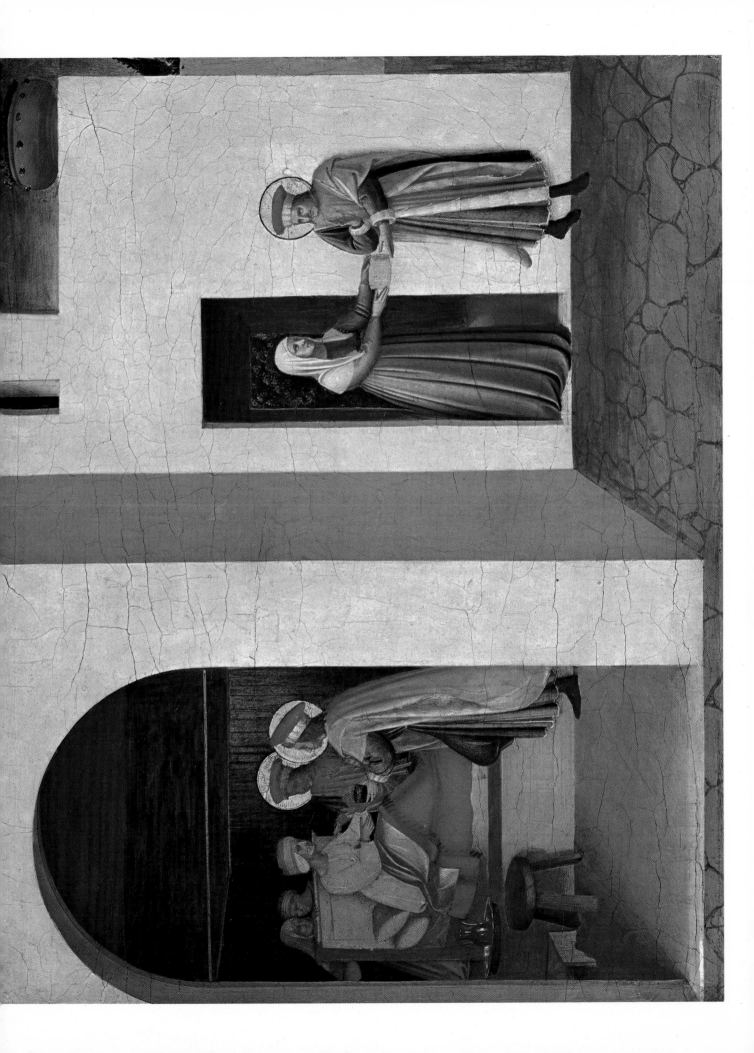

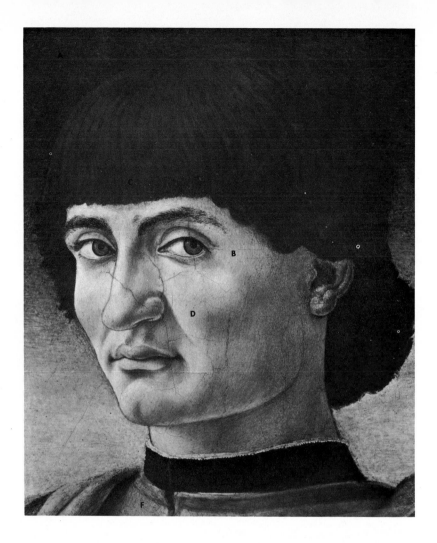

ANDREA DEL CASTAGNO
Florentine 1417/19-1457

PORTRAIT OF A MAN
Wood, 21¼ x 15⅞ in.
Andrew Mellon Collection 1937

A painter will often unconsciously reveal his own character when painting the portrait of another person. This is the result of an involuntary instinct which few portraitists can overcome completely. In this case, we know from biographical accounts that Andrea del Castagno was a man of violent passions whose life was marked by fierce hatreds and brutal actions. He was supposed to have murdered a rival painter whose artistic abilities had incurred his jealousy. The subject of this portrait is reputed to have been an equally violent man who came from a good family but degenerated into what amounted to a professional assassin. Although these facts are not indisputable, there is reason to believe that some of the information is well founded.

Study the face carefully and note how the artist has expressed both the sinister strength and untrustworthy cunning of his model. First, his head is placed high in the format; this has the effect of making the man psychologi-

cally above you, the spectator. Note the dark top of the sky (A); this gives the impression of menacing thunderclouds and impending storm. Also note the sidelong stare (B); this man seems to be holding a concealed weapon which he will use at the slightest provocation. Consider the fringe of black hair hanging low over his eyes (C); the man is not frowning but the bangs make him seem angry. Finally, note the accentuated lines around the nostril (D); the unknown man seems to sneer at you in utter contempt. The black collar and blood-red cloak (E and F) reinforce the sense of threat and danger.

As an exercise, take a large photo of someone you know. By using the devices outlined above, make your subject into an evil and dangerous character. Conversely, by using the opposite effects, see if you can convert your portrait into that of a kind and gentle person. A final remark—harmless people do not hide their hands.

262

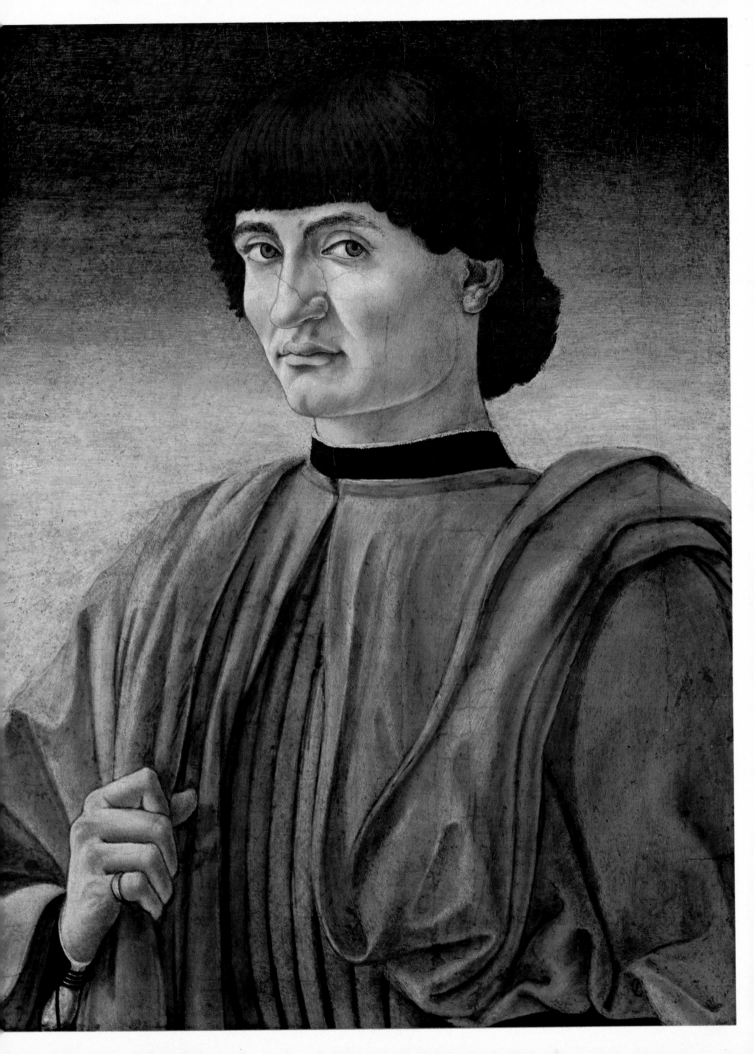

Detail no. 1

Detail no. 2

RAPHAEL
Umbrian 1483-1520

THE ALBA MADONNA
Transferred from wood to canvas, diam. 37¼ in.
Andrew Mellon Collection 1937

One of the secrets of Raphael's supremacy lies in his genius for design. By some mysterious power, he could take the most homely object and convert it into something graceful and beautiful. Study the plants in the foreground (detail no. 1). Every leaf is placed in exactly the right position to create a harmonious relationship with the next leaf and with the whole plant. Everything is clear, well ordered, precise, and peaceful. If this seems like an easy thing to accomplish, go and pick a weed from the garden and make a detailed drawing of it. The chances are that when finished it will look like a weed and little more, but in the process you may have learned one of the reasons why Raphael ranks among the great painters.

In this famous *tondo,* or round picture, the overall design is incredibly complex; it is a perfect example of this kind of composition. One of the most difficult problems for a painter is to design figures within a round format. If the balance is not correct, the picture will seem to roll like a wheel. If the design is too rigid, it will not harmonize with the circular format. Here Raphael has hung the composition on the horizon from A to B, and from this line the triangle of the main composition culminating at D seems to be suspended. Only at C does the composition touch the frame. Within the figure itself the flame-like patterns from the lower left harmonize with the round format and the spiritual quality of the theme.

264

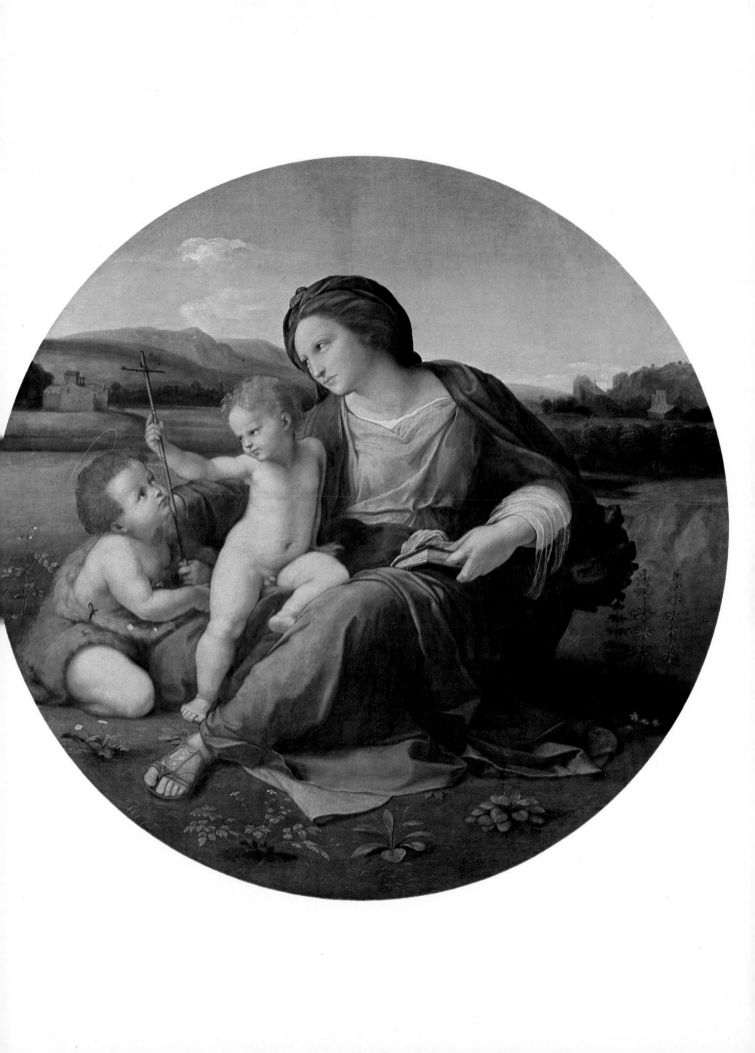

Bibliography

Bazzi, Maria, *The Artist's Methods and Materials,* trans. by Francesca Priuli. New York, Pitman, 1960

Birren, Faber, *History of Color in Painting.* New York, Reinhold Publishing Corporation, 1965

Cennini, Cennino, *The Craftsman's Handbook,* trans. by D. V. Thompson. New York, Dover Publications, 1933

Constable, William G., *The Painter's Workshop.* New York and London, Oxford University Press, 1954

Doerner, Max, *The Materials of the Artist.* Revised edition, New York, Harcourt, Brace, and World, 1949

Eastlake, Charles L., *Methods and Materials of Painting of the Great Schools and Masters.* New York, Dover Publications, 1960 (first published under the title *Materials for a History of Oil Painting.* Longman, Brown, Green, and Longmans, London, 1847)

Gettens, Rutherford J. and Stout, George L., *Painting Materials: A Short Encyclopaedia.* New York, D. Van Nostrand, 1942; reprinted, New York, Dover Publications, 1966

Hale, Robert Beverly, *Drawing Lessons from the Great Masters.* New York, Watson-Guptill Publications, 1964

Itten, Johannes, *The Art of Color,* trans. by Ernst von Haagen. New York, Reinhold Publishing Corporation, 1961

Kay, Reed, *The Painter's Companion.* Cambridge, Mass., Webb Books, 1961

Laurie, Arthur P., *The Painter's Methods and Materials.* Philadelphia, J. B. Lippincott Company, 1926; reprinted, London, Seely, Service, 1960

Massey, Robert, *Formulas for Painters.* New York, Watson-Guptill Publications, 1967

Mayer, Ralph, *The Artist's Handbook of Materials and Techniques.* Revised edition, New York, The Viking Press, 1957

Protter, Eric, *Painters on Painting.* New York, Grosset and Dunlap, 1963

Rowley, George, *Principles of Chinese Painting.* Princeton, N. J., Princeton University Press, 1947

Sirén, Osvald, *The Chinese and the Art of Painting.* Peiping, Henri Vetch, 1936

Taubes, Frederic, *Painting Materials and Techniques.* New York, Watson-Guptill Publications, 1964

Thompson, Daniel V., Jr., *The Practice of Tempera Painting.* New Haven, Conn., Yale University Press, 1936

Watrous, James, *The Craft of Old-Master Drawings.* Madison, Wisc., University of Wisconsin Press, 1957

Index

Edited by Susan E. Meyer and Diane Casella Hines
Designed by James Craig
Composed in twelve point Intertype Garamond by Atlantic Linotype Co., Inc.
Printed and bound in Tokyo by Toppan Printing Co., Ltd.